WINE'S HIDDEN BEAUTY

Barrett, Sondra
Wine's Hidden Beauty/ Sondra Barrett
p. cm.
Includes bibliographical references and index.

ISBN 978-0-578-02947-4
I. Wine and wine making. I. Title
2009937978

First edition 2009
Published by Mystic Molecules Media
Printed and manufactured in China

Cover and Book design: Catherine A. Greco, LimeLight Design Group
Editors: Bethany Argisle, Jessica Brunner, Marcia Starck

The illustrations on page 67, 89, and 91 are from Dover Publications Wine and the Artist 104 prints and drawings from the "Christian Brothers Collection at the Wine Museum of San Francisco" 1979 Dover Publications Inc 31 East 2nd St., Mineola, NY 11501

The illustration on page 81 used by permission from Cork Supply USA

All other images are owned and copyrighted to Sondra Barrett.
Limited edition prints are available by visiting www.SondraBarrett.com

Inquiries should be addressed to publisher:
Mystic Molecules Media
Post Office Box 305
Graton, California 95444
Websites www.SondraBarrett.com www.WinesHiddenBeauty.com

To Ted and Heather,

your love and support

are the joy and blessings of my life.

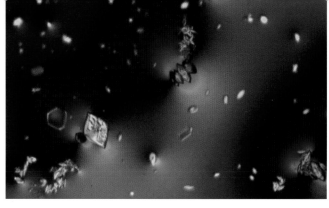

Above
Rudd Oakville Estate Proprietors's Red

CONTENTS

INTRODUCTION

- About the Book ix
- Author xi

Wine's Hidden Beauty

CHAPTER 1

DISCOVERING THE INNER GRAPE

- How it all Started 1
- Chemicals of Life 2
- Form and Function 3
- Wine Portraits, Expressions from Inside Wine 4
- Perfect Timing 5
- Art or Science? 6
- The Song of the Vineyard 8

CHAPTER 2

TRANSFORMATION

- The Beauty of the Invisible 11
- A Creation Story 12
- The Old Days: Meet the Alchemists 12
- Yeast, Wild or Cultured 12
- The Dance of Transformation 13
- A Youthful Burst Forward at One Year 13
- How Like the Grape are We? 15
- Birth, Life, and Death 15
- Towards Maturity and Elegance 16
- Getting Old and Losing Vitality 17
- Death 17
- Origins 18

CHAPTER 3

SHAPING TASTE

- What Shapes Our Taste? 19
- Chemical Sensibilities / Molecules: the Five Tastes 20
- Salty 20
- Sweet and Bitter 21
- Sour 21
- Savory Unami 22

- Food Sources of Unami 22
- The Alchemy of Food and Wine 23
- Taste + Smell = Flavor 24
- Dimensions & Vibrations of Smell 24
- Smell and Memory 24
- The Ripening Grape 25
- That Tart 27
- Acids and Wine 27
- Hang Time 28
- The Alchemy of Fermentation 28
- Secondary Malolactic Fermentation 30
- Tannic Acid and Tongue Touching Tannins 33
- Terrain and Terroir 34
- Survival of the Fittest? 35
- The Shape of Place 36
- The Winemakers: Shaping Taste and Tasting Shapes 36
- The Critics / Glasses Shape Taste 37
- Shaping the Language of Taste 38
- Pat Simon's Wine Shapes 39
- Smell and Language 39
- How to Taste 40
- Sensory Awakening 41

CHAPTER 4

WINE LEGENDS: *Art in the Bottle*

- Beaulieu Vineyards, Georges deLatour & André T 44
- Napa Valley Cabs 45
- The Ages of Inglenook Cask Cabernets 45
- The First Merlot 47
- 1979 Paris Tasting / Shaping Chardonnay: Mike Grgich 48

- Vines not Mines 50
- Jess Jackson: Making Chardonnay for the Consumer 50
- Noble Grapes 50
- Nobel Reds 50
- Pinot POWER 50
- The Legendary Robert Mondavi 56
- What Makes Our Own Lives Legendary? 58

CHAPTER 5

CULTIVATING WELL-BEING

- Hospitality Not Hospital 60
- What is Well-being? / Beyond the French Paradox 61
- The Heart of Community 62
- Health Benefits of Moderate Wine Consumption 62
- Wine and the Heart, A Molecular Perspective 65
- Wine and Romance 66
- The Sensuality of Wine 68
- The Bigger Romance, Sustainability 68
- Organic Wines are Rare 69
- Sulfites and Organic Wine / The Politics of Sulfites 70
- Cosmic Grapes? Biodynamics 71
- Jim Fetzer's Vision 72
- Mike Benziger – the Spirit of the Land 75
- Cultivating Health 79
- Survival: Our Own and the Earth's 81

CHAPTER 6

THE SPIRIT OF THE GRAPE

- Why the Grape? Molecular Legacies 84
- Spiritual Purpose of the Grape 84
- The Mythic Grape: How the Grape Grew Her Powers 85
- The Grape Escape 86
- Intoxication 88
- Intoxicants: Sacred Spirits 88
- Wine Gods and Goddesses 89
- Sacred Rituals. Wine Saved! 90
- Drunk in the Bible: A Look at Noah 91
- Wine in the Next Life 91

- Mystical Wine 91
- Spirits of the Vine Captured in Molecular Remains 92
- Intoxication with D'Vine 92

CHAPTER 7

THE SOUL OF WINE

- What is Soul? 94
- Soul Work - Renewing the Spirit 94
- Called By The Grape 95
- Does Wine Have a Soul 96
- The Soul of the Winemaker 97
- Molecular Soul 98
- Language of the Soul 99
- A Feminine Soul of Wine? 100
- Wine Toasts 101
- A Toast to the Great Grape 102
- Clink! Clink! A Toast in Many Languages 102

CHAPTER 8

SAVORING LIFE

- Seasons of Life 104
- Reflections in a Vineyard 105
- Dormancy 105
- Ideas Don't Evolve in a Vacuum 106
- Blended Senses 108
- Savoring 109
- How to Get Inside Wine 110
- Play Taste a Shape "Wine Rorschach" 110
- From the Beverage in a Bottle to our Inner Life 111
- Renewal 111

ACKNOWLEDGEMENTS

Resources

- Bibliography
- List of US Organic Wineries

INDEX

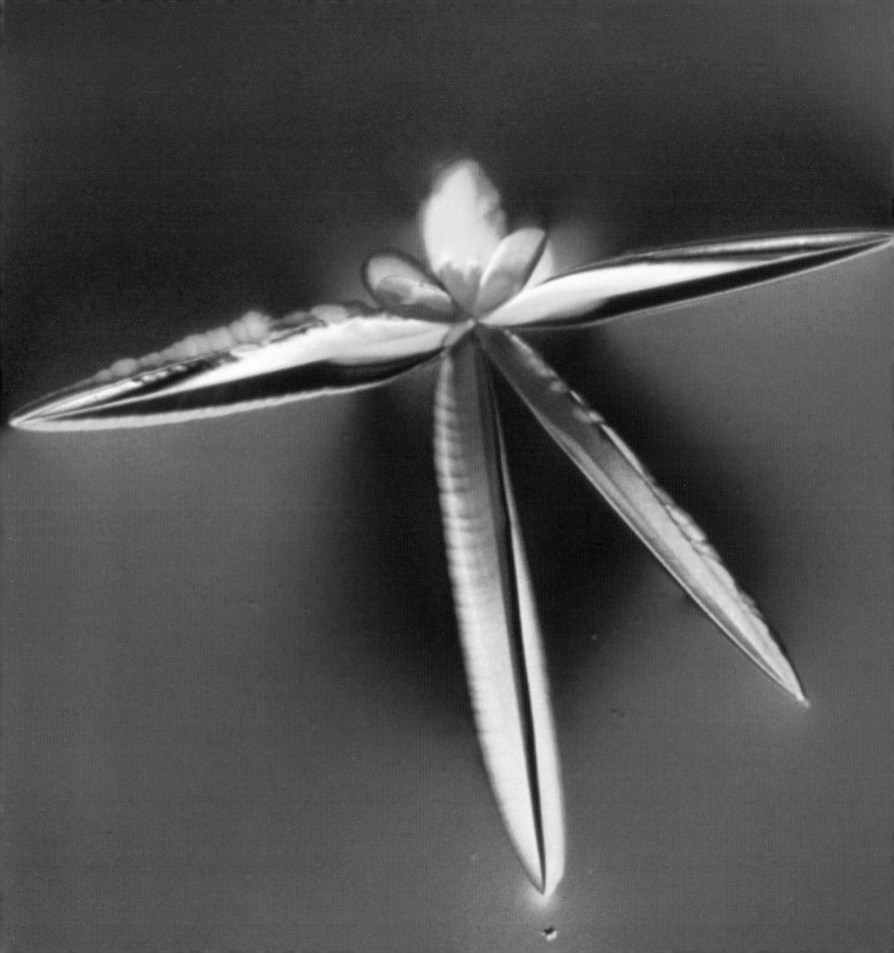

INTRODUCTION

*Molecular photography captures a world invisible to the naked eye...
It opens the mysteries to molecules and cells. It is art based on reality,
not an artist's imagined representation. Images tell a story or act as a
portrait. They may even communicate scientific information visually
so it is more easily understood, then it becomes a teaching tool.*

High Tech, High Touch: Technology and Our Search for Meaning –John Naisbitt

About this Book

A touch of Michael Pollan stepping into the *Da Vinci Code* and *Sideways*, **Wine's Hidden Beauty** explores the inner world of the grape. Scientist-photographer Sondra Barrett PhD builds a story - the hidden beauty of wine - around the discovery of intriguing microscopic images in a drop of wine. In searching for meaning among these 'mystical molecular congregations' Barrett finds clues to taste and stylistic expressions of wine. A wine code?

Wine's Hidden Beauty is a feast for the senses, a glorious celebration of the magic and mystery of wine and life. This book explores hidden beauty and the fascinating story of wine growing that brings us the spirited nectar in the glass. The tastemakers who helped build and sustain American winemaking are part of the legends of how the land, molecules, words and pictures broaden our personal experience of wine.

OPPOSITE PAGE:
Sauvignon Blanc, Sterling Vineyards

The book has two threads; one provides a more technical and historical background of winemaking and the language of taste. The second veers into the mystical, spiritual and the potential secret codes inside the grape and wine. Along the way, we reflect on how we are like the grape and wine. This book is only a beginning.

Chapter 1, Discovering the Inner Grape, takes you back to how this exploration into the beauty, heart and soul of wine began.

In the next chapter Transformation, we start with the vineyard and the alchemy of fermentation where the inner view of wine is uncovered. As we drink in from youthful juice to an old mature cab, we witness that juice's simple forms grow larger and more complex. A wine grows up, inside and out, and when it begins to lose its vitality, its appearance changes again. The microscopic landscape within wine reveals life and death.

Shaping Taste explores what informs and shapes our tastes, besides molecules and biology. How does the chemistry of taste and terroir, the winemakers, and critics play a part in our experience of wine and food? We discover clues to how to taste wine from award-winning winemaker Heidi Peterson Barrett. The chapter ends asking what shapes our language, the words we use to describe flavors, taste and smell.

Wine Legends: Art in the Bottle takes us to the people and wineries that launched the growth of American winemaking - Beaulieu Vineyards, Georges de Latour and André Tchelistcheff, Sterling Vineyards, Mike Grgich, and Robert Mondavi to cover just a few of the people who inspired winemaking to be what it is today.

In Cultivating Well-being we look beyond the French Paradox at the links between wine and health. Building on the framework of groundbreaking medical research, the author speculates that one key to wine's role in health is in creating community and ritual. How the vineyard is cultivated - organically or biodynamically, expands on the bigger picture of health for the vineyard, the people working there as well as our planet. Here we meet winemakers Jim Fetzer, Mike Grgich and Mike Benziger who are committed to growing wine in the most sustainable, and perhaps, spiritual ways.

The Spirit of the Grape asks, why the grape? Why has it survived centuries as the only fruit to enjoy a cult-like status? Does the grape have a spiritual purpose, akin to Michael Pollan's supposition in The Botany of Desire, that plants serve to fulfill human desires; that we have a purpose to fulfill a plant's destiny. Perhaps that underlies wine's role in sacred rituals, the ancient gods and goddesses of wine, and becoming intoxicated with Spirit.

In **The Soul of Wine,** a larger and more personal question is addressed – what is soul, does wine have one, and does a "Calling" to work with the grape answer our soul's purpose. Reflecting on symbolic language of the soul, winemaker Heidi Barrett looks at whether there can be a feminine soul or expression of wine. So imbued with the spirit and soul of the grape, we now toast this inspiring elixir while discovering how the ritual of toasting began. Clink! Clink!

The final chapter Savoring Life, rounds out our glass by viewing how this exploration of wine can remind us of our connections to land, spirit and the great mystery of life. What lies dormant comes alive again when the author is introduced to the spirituality of wine and reinspired by the beauty of Rudd Oakville Estate Wines. The book ends with how it began, asking can we use a pretty picture to help us enjoy and explore a wine's expression? Do the images provide hints to another dimension inside wine? You are given a playful game to discover for yourself, the "wine code Rorschach game," to enjoy with your next glass of wine. The game encourages you to sip in wine's delights while exploring your inner knowing. This permits even the person who doesn't allow wine to touch their lips, to enjoy the spirit of the grape. It takes the major theme of the book – what shapes our experience of wine and life – to savoring the moment, with wine, with an idea, with another, with NOW.

Before I met and developed a relationship with wine I was a medical scientist searching for causes and cures for leukemia. The grape seduced me away from cancer cells, dying children, and hospitals to discover merlot, pinot, and hospitality.

About the Author
Sondra Barrett PhD

As a research scientist my expertise was in deciphering microscopic clues to the health and aging of human cells. I soon would take that experience to the fermenting vat. You can imagine my surprise to discover beauty when I looked at a drop of wine through the microscope. Even more surprising, over time, was to sense a kind of language engendered by the patterns and shapes in a given wine. This 'pictorial wine alphabet' offered cues that helped me learn about, enjoy, and taste wine. I had fun matching the wine art to words used to describe taste and personality - sharp, soft, feminine, or bold. It was even more fun offering tastings with folks who wanted to play the game of tasting shapes.

What started more than twenty years ago, as preparation for my first art show became a compelling commitment to learn and share more of this fascinating story of life in the bottle.

My first discovery was at Sterling Vineyards when I was artist-in-residence documenting winemaking from the inside out. The winemakers gave me barrel samples and wines from all over Napa Valley. This extraordinary experience led me to uncovering distinct patterns and beauty in a glass of wine. Early on, a Napa grape grower, Rachel Balyeat, provided some financial support for me to delve further into the life of wine. She hosted a special dinner with acclaimed wine maestro André Tchelistcheff to discuss what these pictures could mean. André's first reaction - "They are the jewels in wine. Put them on silk scarves."

What I've learned since those first years delving into drops of wine has inspired a deep appreciation of the inner world of life, with wine as the protagonist. To some people, the designs within wine are interpreted simply as abstract beauty uncovered with a tool of science, the microscope. For others, these images offer insights into style and expressions of taste, texture and flavor. For all of us they can serve as a reminder of the exquisite world, which we inhabit and which inhabits us.

When I began writing this book more than a decade ago it was to use wine's inner beauty as a platform to talk about winegrowing, wine tasting, and sensory pleasures. By the end, after visiting vineyards, meeting numerous winemakers, wine lovers, and the "mystic grape," it was to reveal the grape's "sacred" purpose to sustain life and nurture community.

The pictures you will see are taken through a 35mm camera atop an interference light microscope. Interference microscopy breaks white light into its rainbow of colors. In other words, I "paint" what I see with this light. Many of the pure chemicals and patterns in wine would be transparent were it not for the interference prisms on the microscope.

In *Wine's Hidden Beauty* you will travel through vineyards, invisible vistas and molecules, feasting with your senses, a celebratory look at life. Come inside and let wine be your guide. ◊

Sondra Barrett PhD

ABOVE:
Inner grape leaf

Chapter 1

DISCOVERING THE INNER GRAPE

The real voyage of discovery consists not in seeking new lands but seeing with new eyes.

– Marcel Proust

How it all Started

Looking around in a wine shop you see hundreds of bottles of wine, each with its own distinctive label and design. Some bottles are adorned with pictures of chateaux in France; others have animals, flowers, or vines growing all around them. A rare bottle is etched, embossed, or abstractly painted. How do you choose? If you don't know the winery's reputation, or haven't met a particular wine before, how do you decide? What might the wine inside the bottle taste like? And, of course, how many bottles should you purchase?

The year is 1982. In my neighborhood wine shop, I am on a mission. A few friends, Bethany, Jim, and Shel, had gathered over to share a special bottle of wine because I had to photograph it. I was auditioning for a potential art show of my photographs and needed to produce a photo of wine. I chose a Sterling Vineyards 1978 merlot.

We enjoyed a lightly grilled flank steak, asparagus hollandaise, a big green salad, and of course, Hagen Dazs chocolate chocolate chip ice cream. We rated the wine with each course, and drank almost every last drop.

I didn't need more than a few drops for the photographs I take. To capture the beauty hidden in a drop of wine, I use a 35 mm camera attached to an Olympus interference microscope, which is basically a light microscope, equipped with polarizing filters or prisms. What a great opportunity! I enjoy the wine before I turn it into a creative project. I put a few drops on a microscope slide, once the water and alcohol evaporate, the remains provide me with an "inner landscape" to peruse with my expanded microscopic vision. This sounds strange I know, viewing drops of wine with a microscope. So how did I, a medical scientist, get involved in looking at the inner world of wine?

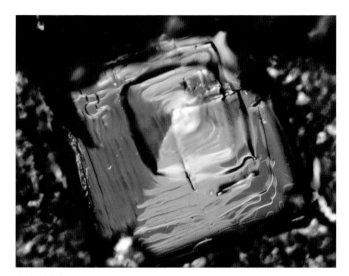

ABOVE:
Sodium Chloride, table salt

Chemicals of Life

As a research scientist, I used the microscope to help distinguish normal white blood cells from leukemia cells. The microscope has been my work tool, technology to explore the intricacies of human cells. I immersed myself in this invisible world until a fortuitous outing to the California Academy of Sciences at Golden Gate Park opened my eyes and heart to greater wonders of the microscopic universe. There I saw chemicals of the brain photographed with the same microscope I used to look at cells. The images were stunning and resembled visionary art. Inspired by such beauty, I began peering into the chemicals of life in my spare time. My life changed!

Looking for clues and cures for leukemia, I had entered into the lives of children and adults with this dread disease. I did all I knew as a researcher, took their blood and bone marrow to do my research. What could I give back to the kids? To ease

their hours waiting in the clinic for chemotherapy, I decided to create slide shows of the stunning chemicals of life along with normal and cancer cells. Every Tuesday afternoon I'd leave my lab and head to the pediatric oncology clinic at UCSF Medical Center and there I'd witness that these images of the micro world offered these children with cancer some solace and entertainment.

My lifelong wish and struggle surfaced-to become an artist. I liked seeing beauty more than sick, lethal leukemic cells. I dreamed about a life other than hospitals, dying children, and highly competitive medical research. An oncologist, knowing my struggle and seeing the pictures I was showing the children, arranged an interview with Valerie Presten, the tasting room and gallery director at Sterling Vineyards.

BELOW:
1978 Sterling Merlot

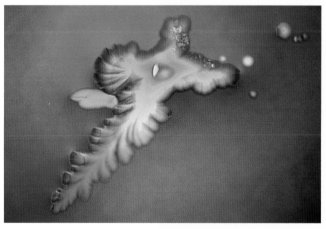

Until then, I had never photographed wine, only vitamins and minerals, medicinal plants and neurotransmitters. In those simple substances I had seen beauty but nothing that would compare to the inner magnificence of wine. When I photographed that first wine with my microscope, I was struck with the soft, rounded forms and "flitting butterflies." Who would have imagined that a wine showed a

visible "memory" that mirrored my tasting experience of the 1978 Sterling Merlot? When I showed the photograph to the winemaker Theo Rosenbrand, his response kindled an idea. "That picture looks like my merlot tastes." They invited me to be artist-in-residence at Sterling Vineyards for the spring of 1984. I had two years to prepare. Lots of photos of chemicals were in my portfolio, but only one of wine. Since the show was going to be in the celebrated Napa Valley wine country, a gallery of wine photos would expand and open a new world of molecules.

I began traveling to Sterling to meet with Theo Rosenbrand and the assistant winemaker Bill Dyer, and Joanne Spoto, the lab director. I followed them into the cellar with its 50-foot high tanks where they'd get samples at different stages of fermentation. My friend Bethany and I would sit and sip with Theo as he wrote his impressions of each wine sample in his gigantic black book.

BELOW:
A rose petal

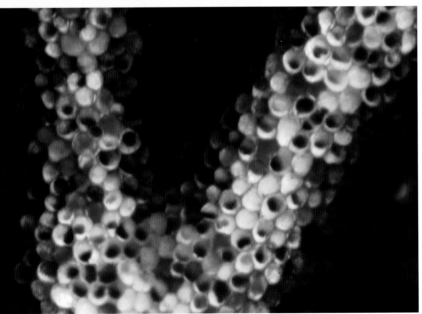

I lugged my microscope there, set it up in the lab and spent several weeks living at the Sterling guesthouse in one of their vineyards. It was a dream comes true. I'd wake up with the sun over the vineyard; workers might already be out tending the vines. I enjoyed my coffee on the patio overlooking the vineyard's splendor. Then I would drive to the winery atop the hill, no longer needing to take the tourist's gondola ride up now that I knew the "insider's" way.

Theo wondered if we could see differences in the pictures of individual components chosen for blending, or of wine filtered with egg white or bentonite. I knew nothing of these practices so I took lots of photographs. I walked the land with the vineyard manager tasting grapes from Diamond Mountain and from the valley floor. I'd sit in on tastings or be given bottles from tastings.

Wine and vineyards became my obsession. Saturday mornings I'd drive to Napa Valley stopping at wineries along the way with my box for gathering wine samples in the car. I'd get a few drops of wine from Robert Mondavi Winery, Beaulieu Vineyards, Inglenook, Freemark Abbey, and lots more. I learned and tasted. I photographed everything.

Form and Function

As a medical scientist, the concept that function follows form intrigues me. I see that in the cellular world; cells compelled to move quickly, like red blood cells, are shaped like flying saucers. Cells that stay still give the impression of blocks. The soft feel of a rose petal might be intuited through its cellular arrangement and the microscopic signature of its chemical aroma looks like a flower. The sour taste of a lemon, citric acid, appears angular and sharp, as does vinegar. Liqueurs that taste sweet are rounded, and the puckery feeling of tannic acid is evident microscopically.

Wine Portraits, Expressions from Inside Wine

To a novice like me, the language of wine is both comical and problematic. Where do the befuddling words to describe the flavor, bouquet and the experience of wine come from? Briary, steely, flabby or robust. How could you taste robust, and would your experience be the same as mine? My wine portraits began to reveal the gestalt or essence of wine better than words. I mused, "why not put the photos on a bottle instead of verbal descriptions." In fact, at one tasting event, world-famous restaurateur Narsai David quipped the same idea. Early on in my wine escapades I saw that sharp young wines showed little microscopic complexity other than jagged forms. The smooth old red had more than a little invisible help going for it with its many intricate rounds and 'softeners.' They looked like they tasted.

We can see it visually from the color changes in the bottle and from the microscopic menagerie of forms. Of course we can taste it, too. In the beginning, juice from the grape reveals tiny geometric forms that grow larger and more complex as it transforms and ages into wine.

Spring 1984

It was Opening Night. A dozen large wine portraits graced the walls of the Sterling Vineyards gallery. A cellar worker then, now a recent Cellar Master, looking at one of the images, quipped that it reminded him of Theo. To our surprise we learned that Theo, had, in fact, made the Beaulieu Vineyards cabernet when he was the winemaker there. Another idea crept into the "meaning of the art" - could a wine's portrait represent the signature of the winemaker?

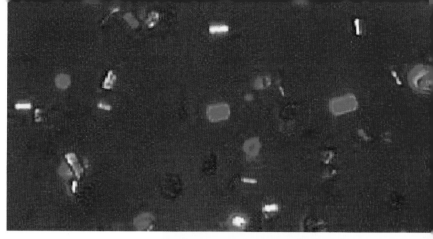

ABOVE:
Merlot Juice

BELOW:
Rutherford Hill Merlot ~2 years old

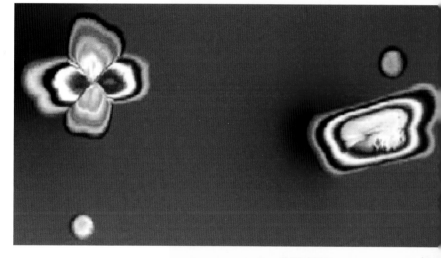

BELOW:
Merlot ~ 4 years old

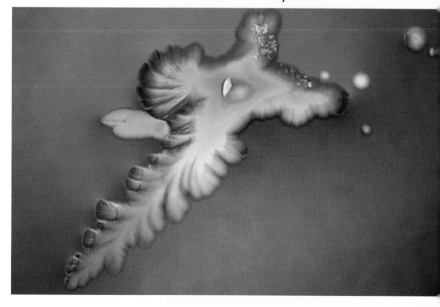

Discovering the Inner Grape **4**

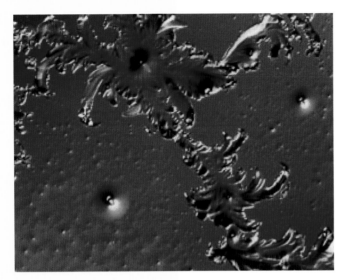

ABOVE:
Wine demise – old Sauvignon Blanc

Tim Mondavi, of the Robert Mondavi Winery, uses the term "winegrowing" to express his idea that the personality of a wine is a manifestation of the soil, climate, and the people involved. I believe that the photomicrographic images are a visual biography of the wine. They, too, express the personality of the grape - where it grew, how it was taken care of, and how it transformed into wine. Perhaps we can think of them as the "inner terroir."

After the Sterling event, I had many adventures in California wine country, each teaching me more. For the first "visual wine tasting" dinner at the Mount View Hotel in Calistoga, Chateau St. Jean had me photograph their wines. However, when I looked at my slides, one chardonnay had a strange "lifeless and lightless" form I had never seen before. It looked like a fallen leaf. I called the winemaker to find out whether anything was wrong or different with this bottle. He discovered that that particular batch of wine had just begun to lose its vitality He could taste the slightly off-flavor; I couldn't. A new bottle showed no such "dead" forms.

Such an accident, receiving the wrong bottle, translated into more information about life and death in the bottle. We now had an early visual clue, if it persisted in other dying wines or wines losing their vitality, even before we could taste the change.

Perfect Timing

Another valuable lesson about the life of wine came from an extraordinary evening at the old Inglenook Winery. The public relations manager commissioned me to photograph wines from a rare vertical tasting of 44 years of Cabernet Sauvignon. The year was 1985. All the 'who's who' in California wine were invited. The old bottles were opened and decanted. Newly fermented samples were taken from the barrels. And now, we had to wait for writers from the **Wine Spectator** to show up. We waited… and waited. Somehow the **Wine Spectator** had put the wrong date on the calendar and none of their writers showed up. In a corner of the vast room, I had already taken my samples and was ready to leave. Instead, the person in charge of the event asked me to join this illustrious tasting since there was now plenty of room for me to participate.

They seated me next to André Tchelistcheff, considered to be the mentor to California winemaking. He shared his private reflections with me as we enjoyed this marvelous experience. A year later, I would meet him to share my microscopic impressions of wine to ask for his opinion. The wines, too, shared information by revealing a new set of forms visible primarily in old robust wines. Thirty and forty year old wines, still drinkable, showed signatures not present in younger wines. They completed the wine alphabet that I was constructing. Below is a photograph of what has been called one of the outstanding wines of the last century, the legendary 1941 Inglenook Cask Cabernet Sauvignon.

Art or Science?

I am always asked, "What are these pictures?" Some wine experts told me that they must only be tartrates, the crystals you sometimes see on the cork or bottom of the bottle of a white wine. I then photographed tartrates to check out that likely possibility. You can see those images in Chapter 3. In young wines, I believe that some forms are related to tartrates but as wine ages, they disappear while more elaborate shapes come into view. Until there is more research I would guess that the more complex forms come from the tannins and pigments. Is this a new wine science or simply art?

"Make the pictures into jewelry and silk scarves. They are the jewels in wine."

– André Tchelistcheff

BELOW:
1941 Inglenook Cask
Cabernet Sauvignon at 44 years old

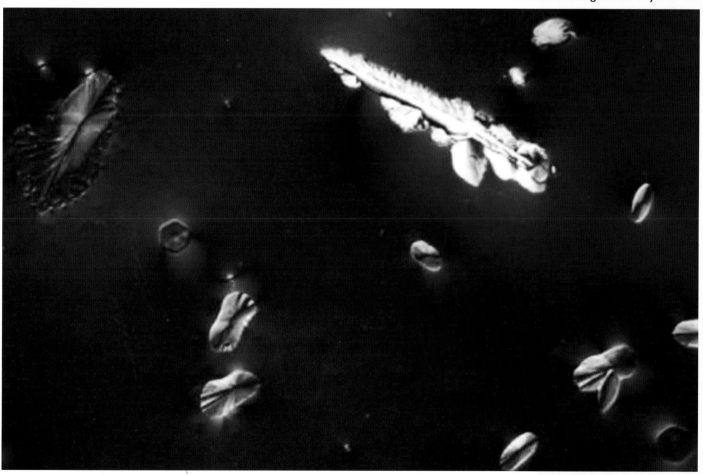

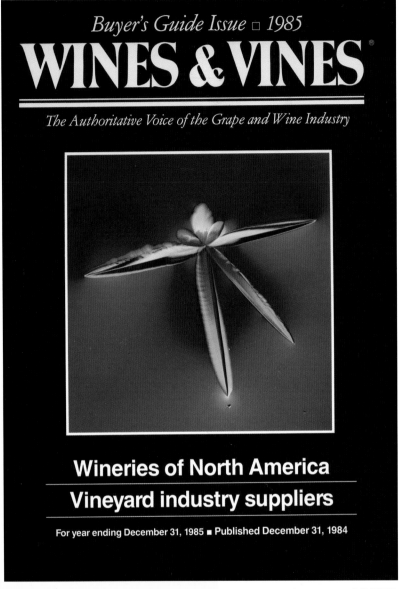

Buyer's Guide Issue □ 1985

WINES & VINES ®

The Authoritative Voice of the Grape and Wine Industry

Wineries of North America

Vineyard industry suppliers

For year ending December 31, 1985 ■ Published December 31, 1984

ABOVE:

1985 *Wine & Vines* cover

The late Phil Hiaring, publisher of **Wines and Vines**, saw my exhibit at the Society of Wine Educators, and invited me to present to Wine Industry Technical Symposium (WITS). He thought that there would be technical experts who could provide answers to some of our more scientific questions. Yet Phil didn't wait for scientific evidence before he used my wine signatures to grace the covers of his prestigious wine directory and magazine in 1985. He recognized the inner beauty, the gift of this inner art.

I worked for weeks creating a multimedia presentation for WITS. This was the original multi-media – multiple slide projectors linked to a dissolve unit and tape recorder. Several hundred people are in the audience. The lights in the room dim and I'm introduced. I offer a few words on how I began this unusual work and the questions raised by the photographic adventures. Then the rest of my show - images, music, and my recorded words filled the room with the wonders of wine. When the presentation was finished – absolute silence! Uh oh, what was wrong? A minute or so later, though it seemed like an hour, rousing applause. One winemaker came up to me saying that I was photographing beauty, that I shouldn't call it science. Yet another invited me to compare microscopic changes in his wines after fermentation in oak and steel. An attractive older woman approached, "I don't understand what I saw, but am deeply moved by it. Many of us were. That's why I suspect there was silence when you completed your presentation. You've captured some unique essence of wine and I want to support your research." Rachel Balyeat, a grape grower in the Napa Valley, became a patroness in the early stages of this work. She planned a small dinner with Andre and several winemakers to discuss what we were seeing. Andre's first words after viewing the slide show, "Make the pictures into jewelry and silk scarves."

With Rachel I learned more about making wine by following her zinfandels throughout the year. I was hooked. Before dawn I would drive to watch the sun rise on her vineyards. I could hear the spirits sing.

The Song of the Vineyard

Something indescribable happens whenever I am near or in a vineyard. Once, years before, when I lived in a tiny seaside town and was just beginning to learn about gardening and nature, I had a similar experience while standing in front of a fabulous garden. I felt a flutter inside and heard what sounded like tinkling bells, a sweet melody. But the sounds weren't audible. I was feeling the sound inside. I thought of these as songs of the devas and fairies who helped the garden grow.

Plant spirits?

"Music from a garden or a vineyard? This experience certainly did not fit into the vernacular of a scientist.

My point of view was being changed by the inner view of wine."

—Sondra Barrett

BELOW:
A Merlot Vineyard

Plant spirits? Music from a garden or a vineyard? This experience certainly did not fit into the vernacular of a scientist. My point of view was being changed by the inner view of wine. Perhaps hidden in wine are substances that could put a song or a flutter in our hearts. Could it be those invisible butterflies?

I am always amazed at my passion for the inner beauty of wine. Some would say it was a "calling." It certainly helped me discover a whole new way of life, yet I also discovered many other gifts of wine, its place in celebrations, in history, in religion. I see that wine, besides being a sensory pleasure, mirrors the spirit of life. What is this mysterious liquid that warms our souls, which we share with our friends?

Wine is the result of an art form that humankind has enjoyed for thousands of years. More than 6000 years! I feel that the art of wine through a microscope shows us a little more of the mystery of wine and life. Perhaps it gives us a peek into the soul or the spirit of the wine. ◊

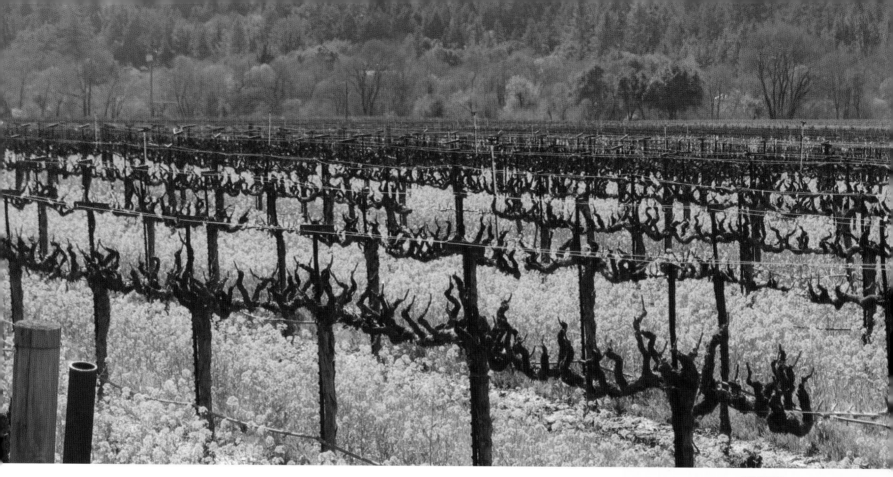

Chapter 2

TRANSFORMATION

Pasteur solved the scientific problem of fermentation, which had puzzled humanity throughout the ages... He showed that fermentation was due to life, thereby confirming an instinctive and almost universal belief that wine was not a mere chemical concoction, but a mysterious living organism, divinely appointed as the symbol of life.

H. Warner Allen – *The Romance of Wine*

Wine's creation story begins in the vineyard. Those of us who only see the bottle and pop the cork may forget all the months and years of tending that go into creating a vintage we enjoy for an hour or two. In my journey of discovering the gifts of wine, the vineyard intoxicates me. It is awe-inspiring that crooked old vines and small gnarled 'sticks' can bring a harvest of good tastes. After following the seasonal changes in the vineyard from the first crush, I became enchanted by the hidden stories told by wine's microscopic signature of shapes. The inner life and beauty of wine may guide us to our own hidden treasures. I believe that wine's microscopic mysteries have the power to enlighten and enliven us.

BELOW:
1977 Grgich Hills Chardonnay ~ 30 years old

The Beauty of the Invisible

The wonder of molecules, human cells, and wine attracted me like a magnet. Sharing the magic of cells and chemicals with children challenged by life-threatening illnesses, I learned through their eyes the healing potential of the mysterious microscopic landscapes of life.

You might wonder how images of wine through the microscope can be healing. Can they really bring people to a deeper sense of themselves? Can microscopic wine expressions help create a greater experience of the sacred nature of life?

As wine matures, the extraordinary forms change, filling with light and complexity. The quality of light changes when wine begins to lose its vitality. Perhaps there really is a link between light and life. While still a medical scientist, before my wine explorations, I spent the last few minute with a young friend before he died. When he took his last breath, it looked like the light left him. When I saw a similar thing happening with wine, I began to draw parallels between human life and death with that of the spirited grape. You, too, may begin to make similar observations as you embark on this journey. Let's take a moment to toast your heart being ignited with light, love, and wisdom. May wine be your guide!

Like a baby album, these pictures first show how a grape grows up. We certainly hear or read descriptions of a young sharp wine, a big wine, a giant of a cab. Through the microscopic expressions, we see forms and patterns that match verbal descriptions. We don't need to believe that a wine looks like it tastes; there's a lot more to our sensory experience than what's in our mouth and nose, or what's left deposited on a glass slide. We may be amused by a similarity of our verbal descriptors and a wine's portrait. Sit back and enjoy this myth of creation expressed by the grape. Witness, through expanded microscopic vision, the amazing changes in a wine's life.

A Creation Story

In the beginning, when the vineyard is finished with its work of growing, grapes are harvested at near perfect concentrations of sugar and acids. Once grapes release their juice, the magic of transformation begins. We begin this story with a look at beginning grape juice (also called *must*); it is filled with simple tiny geometric microscopic forms.

The Old Days:
Meet the Alchemists

In the ancient days of winemaking, fruit juice was set aside to 'do its thing' and miraculously, a potable, sometimes tasty, intoxicating drink was created. It is likely that our early ancestors enjoyed a change of mood and mind after a few sips of this primitive alcoholic libation. Naturally the search began to create a better tasting intoxicating potion. Though any sweet fruit is capable of becoming intoxicating, the grape offers the most amazingly unique repertoire. All that's required for fruit to become wine is the action of invisible change-making yeasts. Yeasts, the miniature alchemists on the skin of the grape, convert sweet juice into an alcoholic concoction.

Yeast, Wild or Cultured

Though early winemakers had to depend on the yeasts in the vineyard, in modern winemaking practices we have more options. Winemakers can add cultured strains to provide a more consistently reliable product than can be created by unknown wild yeast lingering on the grape's surface. Yet wineries that are moving towards a more natural approach, welcome the vineyard's wild yeast to create more complex flavors. Notice the visual differences between the uniform cultured Montrachet yeast and wild yeast growing on a Napa Valley chardonnay.

In the beginning
JUICE OR MUST

ABOVE:
Chardonnay

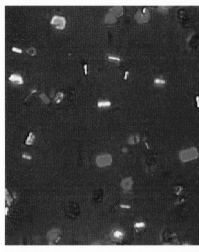

ABOVE:
Merlot

Wine is created by yeast's intervention and alchemical transformation.

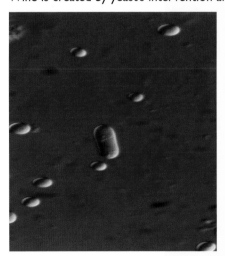

ABOVE:
Wild Yeast

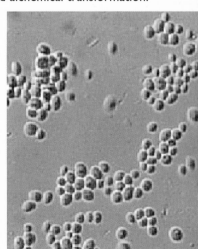

ABOVE:
Montrachet Yeast, cultured

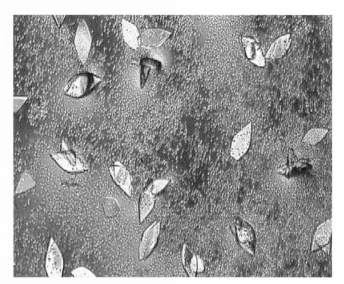

ABOVE:
Chardonnay fermentation with Montrachet yeast

ABOVE:
Pinot noir fermenting in the vat

The Dance of Transformation

Through grape's partnership with yeast, the alchemical transformation of fermentation begins. Yeast loves sugar in the sweet grape juice, chews it up and converts it into bubbly carbon dioxide and spirited alcohol. When grapes ripen from tight young green berries to plump juicy fruit at harvest time, sugar content increases. Typically grapes are harvested when the sugar reaches about 22-24%; percent sugar is also called Brix. The general rule, for every 2 Brix (2% sugar), 1% alcohol is produced. A wine label that says the alcohol is 12.0% also tells us at harvest the grapes were around 24 Brix. If the ferment reaches 15% alcohol yeasts' work often ceases.

Juice becomes wine

In wine's creation story, it is evident that yeast adds something essential to the mix of sweet juice, acids, tannins, and pigments. They not only transform sugar into other molecules and alcohol, they bring more light to the microscopic display. I interpret the light as reflecting spirit and vitality, though technically it's a lot more. Also evident in 'growing up' - the "footprints" of wine are now much larger than those of juice. To be visible the forms in juice must be magnified 125x; wine only 25x.

A Youthful Burst Forward at One Year

This image taken through the microscope is named 'birth' or 'free run.' The beauty in this photo was a one-year-old chardonnay crafted from free run juice. Free run juice flows freely; without any mechanical pressure,

OPPOSITE PAGE:
Free Run

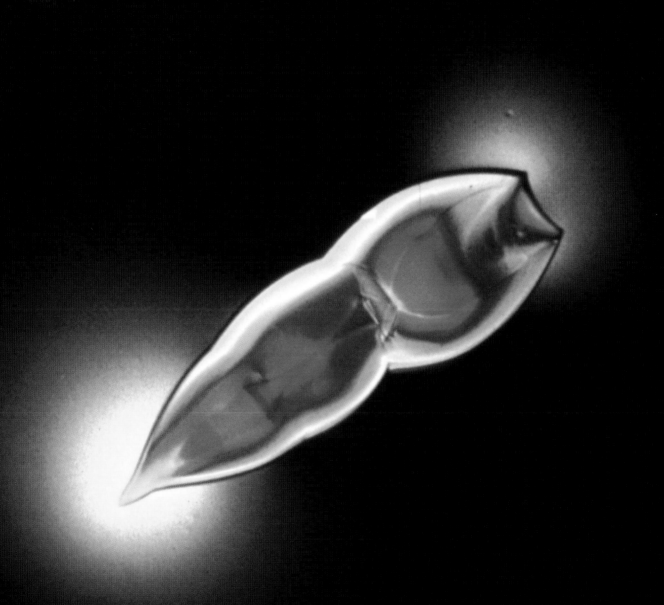

it squeezes itself out of the grape simply from the pressure or weight of other grapes. It is primo for creating wine and typically is fermented separately.

In the biological sciences, we often look at the relationship between form and function: form reflects activity. In the cellular world, red blood cells move quickly to carry oxygen to all our tissues; their actions are reflected in their flying saucer form. On the other hand, skin cells that stay put look like blocks. So immersed have I been in the idea that 'things look like what they do' I immediately saw that free run juice looks like what it had to do. After all doesn't 'free run' look like something that had to squeeze itself out of tight places? It also resembles a tiny creature emerging into life. What do you see?

How Like the Grape are We?

While spending time with the inner life of wine, we begin to appreciate just how much wine mirrors the similes of human life. Its journey, and our journey are entwined in the sacred and spirited. As we sip, sniff, and see wine, it guides us to living more fully. Using the image of free run wine as a symbol, we may recall our own times of running free.

> *When do we burst free of our limits, physical boundaries, or fears to go beyond what might be comfortable, with the potential of becoming delicious?*

> *When do we get pressed to do something requiring extra effort and support from others?*

> *Does outside pressure force us to become or do something we hadn't planned?*

> *Do we need the support of others to help manifest our greatest potential?*

When we struggle to squeeze through the skins of our many selves to birth our visions, dreams, and potential, how are we like the grape? In making wine, the struggle often shapes a more intense and luscious creation. What struggles force you into an innovative vintage?

Birth, Life and Death

In the beginning of human life, like wine, we, too, start as a tiny geometric form, the fertilized egg.

Only through partnership
with another life form,

for the egg, sperm,
for the grape, yeast,

can transformation begin,
and new life be created.

Our cycles are similar. We start tiny, uncomplicated, and grow larger. Becoming more complex we gain maturity. When we reach our peak, we leave our mark. During this later phase of life, as an elegant, wise elder, we may even bring greater wisdom and pleasure to another.

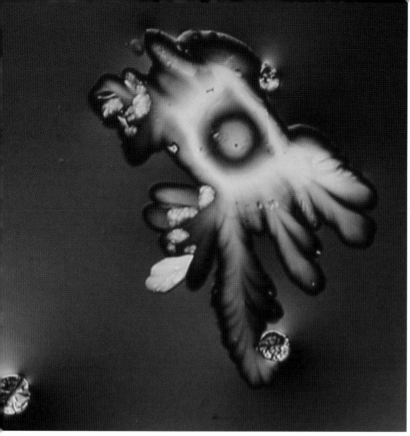

Towards Maturity and Elegance

To witness the microscopic mark of an elegant mature wine, rich with layers of flavor and softened tannins, look at the sensual inner beauty of the still vital older wine compared to the sharp force of youth. Both wines are from Inglenook Cask Cabernets, a luscious seventeen-year-old cabernet sauvignon (1968), and ts youthful counterpart – an assertive bristly two-year-old (1983).

ABOVE:
Cabernet Sauvignon ~ 17 years elder

BELOW:
Cabernet Sauvignon ~ 2 years old

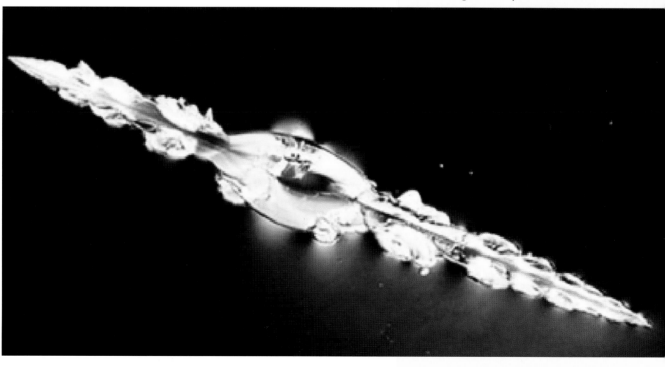

Getting Old and Losing Vitality

Ultimately we come to a point in life where improvement is no longer possible. Growth stops. Complexity reaches a max and vitality decreases.

Though humans may continue to mature and grow spiritually until our last breath, wine does not. Sooner or later, wine begins the declining phase, slowing down towards the end of life, as do we.

Microscopic impressions offer clues to a decline in vitality, even before our nose or mouth might detect deterioration. The 'light' begins to leave! Light leaves wine, just as light and spirit leave any living thing when it dies. Behold the evidence in this thirty-year-old Bordeaux (Chateau Lafite Rothschild) getting past its prime.

Death

For a wine to die, especially if it's one we have saved for a special occasion, is a misfortune. When a loved one dies unexpectedly, it is a great tragedy. Yet our cells die all of the time; sometimes it's explosive; sometimes it's a gentle death. Scientists call the gentle dying process of cells, *apoptosis*, a term from the Latin meaning fallen leaves. What a surprise to see forms in dying wine that look like fallen leaves! In the loss of vitality, we see that wine and human cells mirror one another. Who would have guessed that the gentle death of cells matches the microscopic demise of wine?

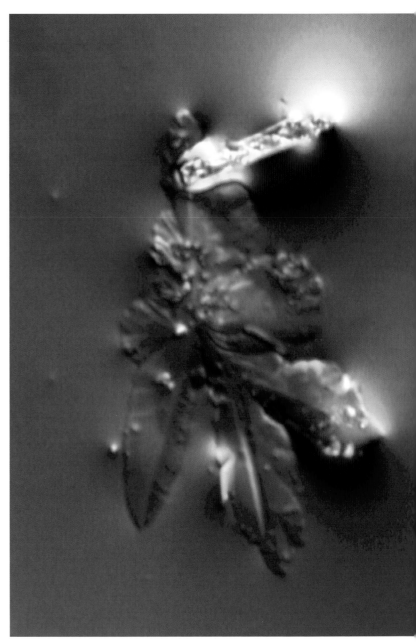

ABOVE:
1976 Chateau Lafite Rothschild ~ 30 years old

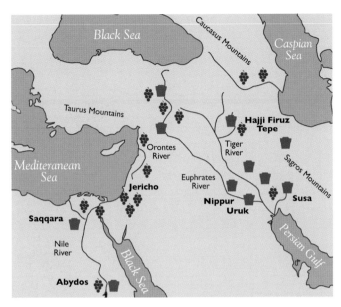

This map illustrates grapes and wine's beginnings.

🍇 The purple grape clusters indicate where grape were found.

⬟ The red wine jars indicate where wine was found.

Origins

The cultivation of grapes' gifts parallels the growth of human culture. Where humans lived and died, wild grapes grew and the three major religions of the world were born. Where grapes were staked and nurtured, winemaking and economies developed. When wine was intentionally made, it was recognized as a gift from the gods. This spirited beverage grew to help humans celebrate, sanctify, and enjoy life. Later in this book, we will look at the Spirit of the Grape and its mystic and mythic role in human survival.

The birth of wine and its eight thousand-year journey adds much to our modern culture. We use it to toast new life and remember the passing of those we love. Surely we should toast wine's very existence and say "Cheers!" ◊

The miraculous transformation of clustering grapes into a beverage that lives, breathes, and gently ages into mellow maturity is a mystery to which we might easily express awe in less scientific eras.

Robert Lawrence Balzer
– The Pleasures of Wine

LEFT:
Chardonnay "jewels' on wine glass

BELOW:
Lorenzo Chardonnay Vineyard, Russian River

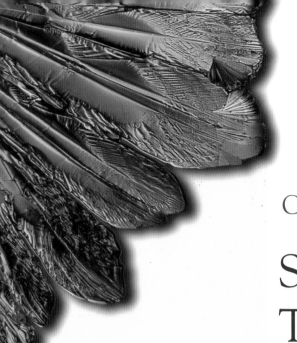

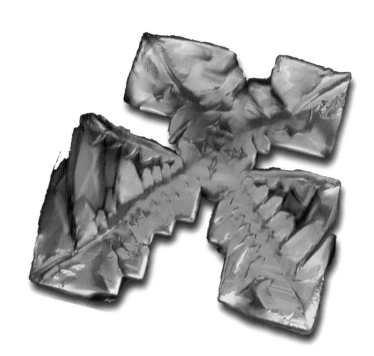

Chapter 3

SHAPING TASTE

Far too many people believe that unlike any other beverage, wine requires someone else's opinion before it's drinkable… the single most important thing to know is that it's what you like that matters.

Leslie Brenner – *Fear of Wine*

What Shapes our Taste?

Our families, heritage, education, experience, and mood certainly shape our personal preferences in food and wine. More basic to our social conditioning is our biology and chemistry. Molecules and our mouth's taste buds, of course, shape taste. Thus, we first discover taste in its most fundamental form – the molecules that deliver our five taste sensations.

What we taste depends on:

- *Chemistry and "Molecular Embrace"*
- *Taste buds in our mouth detect and recognize molecules in our saliva.*
- *Receptors on the surface of our cells recognize molecular shape and electrical charge like a lock and key. Shapes fit.*
- *Molecules recognize one another through intimate contact.*
- *Recognition requires molecules to touch in a "molecular embrace"*
- *Perception of a specific taste brings our brain into play. Molecules and Mind.*

Chemical Sensibilities

Our physical senses support survival through pleasure and pain. Biting into a juicy sweet succulent peach we are rewarded with the pleasure of its flavors and molecules. Its sweet sugar signals a source of chemical energy - **Yum.** Tasting a bitter food we are warned of potential danger - **Yuck.** Many toxic substances stick us by their prickly nature, a painful warning.

Our two "chemical senses," taste and smell, are orchestrated by molecules. In contrast, our other physical senses of touch, sight, and sound are set in motion by mechanical pressure and electro-magnetic vibrations.

'Tasteables' must be soluble in saliva. Taste-stimulating molecules, like salt or sugar, land on taste buds in the mouth and tongue. The message, transmitted to our brain is instantaneously translated into meaningful information: safe to eat, sweet enough to enjoy, or potentially hazardous?

BELOW:
Table Sugar

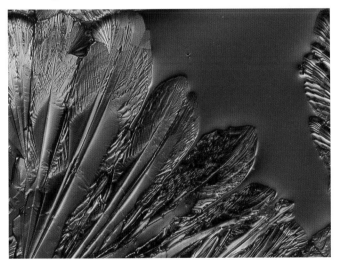

Molecules:
The Five Tastes

Most scientists agree that taste buds on our tongue are able to recognize only five tastes: salty, sweet, sour, bitter, and savory. Interestingly, molecules associated with each basic taste show distinct microscopic forms: salts and acids are usually square or angular; sweet tends to be meandering or rounded; bitters can be prickly, while savory is often rounded or undulating. Molecular geometry and electrical charge convey information about and beyond chemistry. Perhaps they also shape language.

Salty

Salty sodium chloride, the primary component of table salt, is essential for human life. It is part of our cellular makeup. It keeps our cells well hydrated by balancing fluids and blood pressure. Foods that taste salty signal that they are a mineral source. Next time you're running or sweating, taste a drop of your sweat. Is it sweet or salty? What about your tears?

 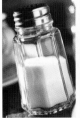

ABOVE:
Sodium Chloride • Table Salt • Sea Salt

Salt, a flavor enhancer, perks up other flavors while imparting a "salty" sensation. A bitter, tannic wine can be made more palatable by eating something salty.

Salt, a natural product of Mother Earth is mined or harvested from the seas. It's salty no matter what; yet

its solubility, overall flavor, and texture are influenced by where it comes from and how it's purified. Salt made by rapid evaporation forms hard cubes, like the coarse grains in the typical saltshaker. Crystallization that occurs slowly on the surface of a seaside pool forms fragile pyramid-shaped flakes. Flakes dissolve instantly and easily stick to surfaces. Coarse grains are usually added to food during cooking while fine fragile flakes are often added after cooking as a finishing touch. Delicate crystals of French fine grey sea salt (Velvet de Guerande), seen here, divinely season any dish with the slightest sprinkle. Its microscopic portrait reveals a finely textured surface. No wonder it clings well to food.

Sweet and Bitter

Humans have innate preferences for sweetness and savory umami. Our ancestors' first food, mother's milk, is rich in sweet lactose and umam. Ripe fruit is another early natural source for sweet. In general, 'sweet' signals 'okay' to eat, that the food is an energy source. Later in this chapter we look at sweet and sour as tart grapes ripen and change taste.

Toxic substances, on the other hand, often taste bitter. The chemical makeup of bitter substances typically includes a complex alkaloid nitrogen-containing

BELOW:
Caffeine, Bitter

structure. Bitter warns of danger. This taste tells us to go slow or not to consume in large quantities, if at all, as it may be a poison.

Contrast the form and experience of a pleasurable sweet energy source and an unpleasant bitter toxin. Bitters, when enjoyed, are taken in small doses.

Like all 'rules of nature,' there are exceptions: not every bitter food is toxic or lethal. Some bitter substances in small doses stimulate our taste buds, nervous system, and alter our state of mind. "Super tasters" are more sensitive to bitter because they have more taste buds on their tongue than "tolerant" tasters. Hypersensitive or super tasters typically dislike bitter tasting foods or beverages. Tim Hanni developed a "Budometer" test for personal taste sensitivity based on a person's food and coffee preferences. The photograph of bitter caffeine found in coffee suggests why it might stimulate too many taste buds. Its microscopic structure mirrors how it' prods' us awake in the morning. Do you love coffee, black, or with cream and sugar? Or is it too aggressive to tolerate at all?

Sour

In contrast to a sweet energy source, sour warns that the sweet fruit may be unripe, spoiled or fermented. Acids are sour and the sour taste is an electro-chemical response. The degree of acidity or sourness is measured by the concentration of positively charged hydrogen ions. The scale ranges from 0 to 14; the lower the number the more acidic. The measurement is called pH. Pure water gives a measurement of 7, battery acid zero, vinegar about 3, and alkaline ammonia is 12. The pH of wine ranges from about 3.2 to 3.7. A wine with too much acid, tastes sour and tart; not enough acid it's flabby. Later in this chapter you will discover more about the acids specific to wine's development and character.

Savory Umami

Curious about complicated flavors in foods such as tomatoes, meat, and Japanese soup stock that didn't fit the four defined taste qualities of sweet, sour, salty and bitter, Japanese scientist Dr. Kikumae Ueda, in 1908, discovered the fifth taste, savory. He named it *umami*, from the Japanese word for 'taste sensation.' The Japanese characters (旨味 or うまみ) literally mean "delicious flavor." Researching the biochemical nature of deliciousness associated with a basic ingredient of Japanese cuisine, the seaweed Kombu, Ueda discovered the savory-tasting ingredient to be an amino acid, glutamate. Savory tastes signal a nitrogen-source and are usually associated with proteins, amino acids and nucleotides.

BELOW:
Umami **Savory MSG**

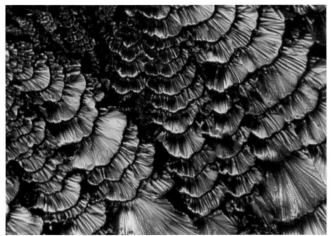

However, it took until the 1980s, after much research, for *umami* to be considered a legitimate fifth taste sensation. Glutamate, MSG, other amino acids and several nucleotides are the key chemicals that elicit the taste of *umami*.

Monosodium glutamate, better known as MSG, has a strong *umami* taste. Ueda's discovery opened a whole new industry in Japan - the commercial production of MSG to enhance flavors of food or give a meaty perception to protein-poor foods. Next time you're at the grocery store, read labels and notice how many prepared foods contain MSG. In fact, it's difficult to find packaged foods without it.

Food Sources of Umami:

Roquefort, Parmesan cheese, oysters, ham, tomatoes, walnuts, mushrooms, soy sauce, seaweed, grape juice, seafood, hydrolyzed vegetable protein, and yeast extract.

Considered to be the western "swami of *umami*" Tim Hanni learned of *umami* in the 1990s when he was exploring wine and food pairing. Tim, with more

BELOW:
Mushrooms

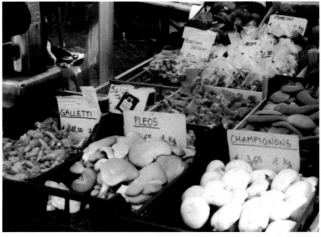

than 35 years in the wine and food industries was one of the first two Americans to successfully complete the prestigious Master of Wine exam in London. His passion is to help consumers learn how to balance the tastes of food with wine. He posits the concept that when two items with the same taste are experienced together or sequentially, that particular taste is lessened while accentuating the other tastes present.

The universal Pleasure Tastes are Sweet and *Umami*.

The Alchemy of Food and Wine

Sweet foods that are paired with food with lots of *umami* make wine taste more bitter, acidic, and astringent. When you have a glass of hearty tannic red wine and eat something sweet, the wine will taste extremely bitter. Hanni explains it this way: sweetness in food cancels any sweetness in the wine, exaggerating the bitter components. Sweet taste amplifies the perception of sour and bitter within the wine, making it taste less sweet, less fruity. When a wine is consumed with salty or high acid foods, the bitterness and acidity from the wine disappear while accentuating sweetness and umami tastes. Acidic and salty foods make wine seem richer, sweeter, smoother, and mellower. Salt suppresses bitterness while acidity reduces perception of sourness in wine.

I was surprised when I photographed MSG to see that it shares similar shapes to sucrose. It was even more interesting to discover that sweet and umami share a taste receptor on our taste buds. Perhaps we can understand the alchemy of taste of food and wine this way. We eat sweet or umami and all the receptors are blocked in our mouth for any more of these tastes to make their presence known in wine. All that's left to our tongue and palate are bitter, salty and sour. To diminish the now overly sharp bitter wine we can add salt or lemon to our food. Now

BELOW:
Universal Pleasures: Savory umami and sweet sugar

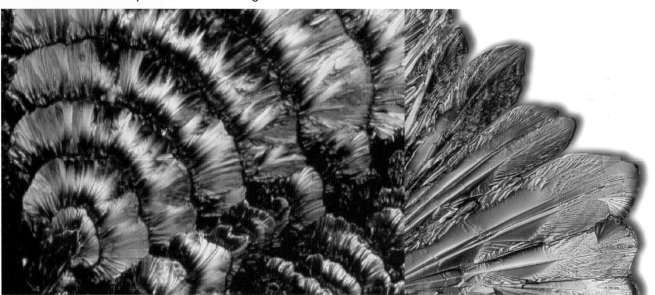

let's look at the yin-yang of these relationships. Sweet and *umami* offer rounded or branching qualities while sour and salty provide the 'yang' angular forms. This helps me remember how to remedy my tasting experience – too many rounds in my mouth, add a little square to better the flare of the wine.

To explore the phenomenon of 'sensory adaptation," Tim suggests a few exercises:

- *First, take a sip of strong red wine, like cabernet sauvignon. Then eat a sweet seedless red grape. Taste the wine again. The wine will taste more acidic and very bitter.*

- *Now, take another sip of the same wine. Taste a bit of salt and some lemon. Then taste the wine again. You should notice that the wine tastes milder.*

Next time you find yourself confused about which wine will complement your food, just remember a few of Swami Tim's key principles. "Drink any wine you want. Eat delicious, flavor-balanced food. If the wine tastes out of balance, put a squeeze of lemon juice and a dash of salt on the dish. That is what they would do in Italy or France!" Now see if that's what you want to do.

Taste + Smell = Flavor

We savor food, or a good glass of wine, through the nose as well as the mouth. What we call taste, when we're enjoying that garlicky roast chicken or a Napa Valley cabernet, is actually flavor, a combination of taste and smell.

Through the nose we experience flavor.

Remember the last time you had a cold? You couldn't smell anything, food tasted bland and flavorless. The tongue's sensory responses are limited to one dimension of flavor. When the nose gets into the act, smell and aromas surround the experience of taste – global memory.

Dimensions & Vibrations of Smell

In contrast to our limited five taste sensations, our olfactory sense responds to thousands of different molecules. Like taste, odors are recognized through receptor sites. Nobel Prize winners Drs. Linda Buck and Richard Axel in 2004 found that the human nose contains a thousand different olfactory receptors, each able to detect a particular set of chemicals. An odorific chemical stimulates a pattern of responsive neurons, creating a pattern dictionary for both smell and language, according to Jaron Lanier. Lanier hypothesizes that the cerebral cortex grew out of the olfactory system, smell informs language. A popular theory on smell is based on shape of molecules and receptors.

Smell and Memory

A whiff of Estee Lauder perfume and you're instantly in your grandmother's embrace. And speaking of perfume, the "Emperor of Scent" Luca Turin, a known nose of perfume, claims that vibration makes a scent or odor unique, not the molecular shape. Turin's theory rests on the fact that some chemicals with different shapes share the same smell and vibratory wave number, the bond energy between the atoms. I believe that it's both the energetic field of the molecule and its shape that influence how it is interpreted by our brain. Turin's language describing his experience of a rare perfume is sensual poetry.

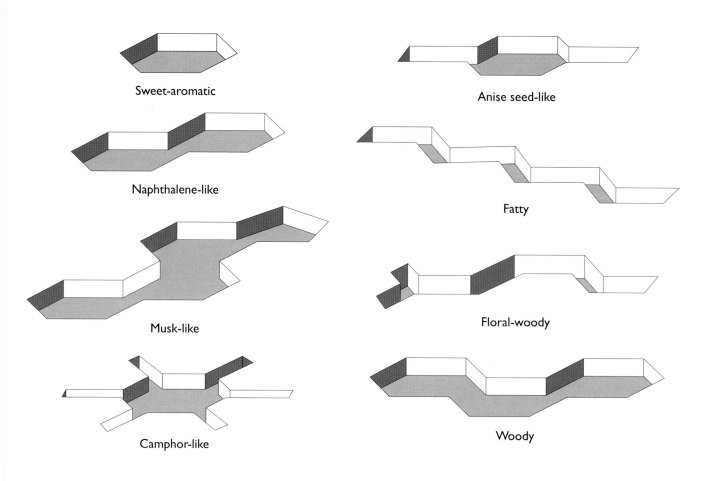

Sweet-aromatic

Anise seed-like

Naphthalene-like

Fatty

Musk-like

Floral-woody

Camphor-like

Woody

ABOVE:
Adapted from *Scientific American's "Molecules"*

The aroma of freshly baked chocolate chip cookies reminds me of my college roommate's care packages while the aromatic bouquet of viognier, an elegant French Condrieu white wine, takes me back to a special New Year's Eve, and my biggest splurge on wine. Smells of the grape harvest permeating wine country tell us autumn has arrived. What aroma carries you to another place and time?

The Ripening Grape

From the tiniest green berry to the ripe red grape, the sour taste changes to sweet bursting with flavor. Changes that occur during ripening provide great experimental territory for our taste buds.

Taste a tight green berry off the vine, if you dare, and your whole mouth puckers. An unripe grape is full of malic acid, which gives it sharp tanginess. When you bite into an unripe green apple you meet malic, one of the most widespread acids in nature.

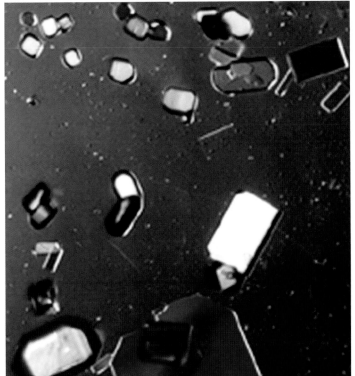

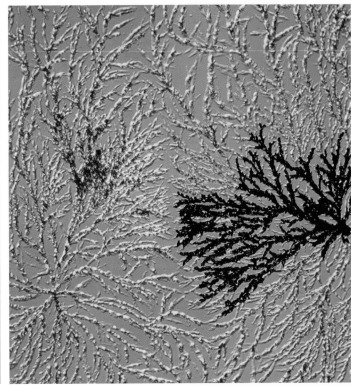

A microscopic look at malic acid reveals mostly angular shapes and sharp edges. In the young grape, malic acid dominates. As the grape readies itself for harvest, malic decreases. The amount left in the picked grape influences acidity and lively tartness of the finished wine. If there's too much assertive malic acid in a wine, its taste is hard and sharp. By harvest, the predominant grape acid is tartaric acid.

The relative amounts of malic to tartaric acid help grape growers gauge ripeness of the grape. So does the amount of sugar.

With only their senses, our ancestors determined the ripeness of the grape. With their eyes they saw changes in color that correlated with a change in taste. The change in color, called *veraison*, begins as sugar increases. Even now we check for sweetness by seeing and tasting.

The primary sugars in the grape, glucose and fructose, are transformed during fermentation to spirited ethanol and bubbly carbon dioxide. Notice the difference between images of glucose, sucrose and the acids. Does the image give clues to stickiness? As sugar increases during ripening, the acids change. The amount of sugar determines how much alcohol is produced.

LEFT:
Veraison

REFRACTOMETER
MEASURING SUGAR IN THE GRAPE

In general, for every 2% sugar, 1% alcohol is formed. To quantify sugar in the field, measurements can be made with a refractometer, which assesses density. Sugar adds weight to the watery pulp of the grape, so an increase in density or specific gravity roughly reflects increasing sugar. In North America, sugar content is measured in Brix. Harvested between 21- 24 Brix, grapes turn out 11-13% alcohol in the wine. During the 1970s in Napa, grapes were typically picked around 20.5 Brix. By 2000, grapes were being harvested at 24.5 Brix making wine spirited with 14.5% alcohol. When I worked the 2004 harvest in the Russian River Valley, grapes were picked at 30 Brix! To lower the concentration of ethanol, many winemakers add water to the fermenting vat. Yeasts stop working at 15% alcohol. We stop way earlier.

That Tart

Tartaric acid, unique to the grape, increases as grapes ripen. Of all the fruits, only the grape contains tartaric acid. This hard, tart acid shows photomicroscopic beauty and complexity.

When grape juice ferments, tartaric acid declines. Too much tartaric acid in wine leaves an aftertaste in the back of the throat. If you see crystals in a wine bottle or on the cork, they're salts of tartaric acid (tartrates) that precipitate out, particularly in wines not cold-stabilized. Tartrate crystals in vessels uncovered at archeological digs proved wine was made early on in human civilization. Flasks with tartrate crystals discovered in Egyptian pharaohs' tombs showed that wine was not only made thousands of years ago, it was so highly esteemed that it was included for the royal afterlife.

Acids and Wine

In general, acids in wine add tartness, crispness, and liveliness. They influence balance, taste, bouquet, and ageability. A wine with good acidity is called refreshing, crisp, dry, and invigorating. Too much acid gives an overly tart or sour taste; not enough and the wine tastes flat or flabby. The higher the acid content, the less aromatic the wine. Acid content also influences the intensity of the color.

Sugar, color, and acid content are not the only signs of ripeness. Another indicator in the vineyard is to taste the seeds. Crunchy pips or seeds, not soft, are signs of maturity.

Some winemakers are becoming highly technical to test the juice. In the lab they can measure tannins and polyphenols as well as color. In the end, to decide when to harvest, the winemaker must use her or his senses to taste for balance of sweetness, acids, and potential flavors. Through experience, a "guesstimate" is made by tasting the grapes to predict what the finished wine might be like. That indeed, is magical vision.

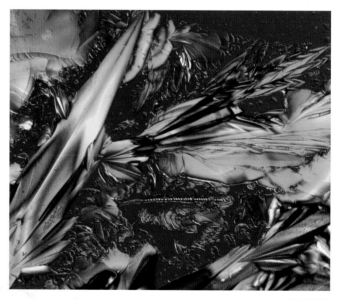

ABOVE:
Tartaric Acid

Hang Time

When grapes hang beyond 'sugar ripeness,' flavors concentrate and intensify. The longer grapes ripen, the more sugar they contain; sugar converts into alcohol giving 'hotter' wines. Longer hang times also produce more fruit flavors and fewer 'green' ones. However, harvesting late in the season is risky. Though more aromatic flavors can develop, there's increasing danger of dehydration, crop damage by rain, and consumption by ravenous birds. For the grape grower who's selling grapes by the ton, harvesting later can result in a substantial financial loss since grapes lose weight as their hang time lengthens. For this reason, many growers sell their crop by the acre rather than by the ton. A balance must be reached which is equitable for both grower and winemaker. In Northern California we see longer hang times than in France, with grapes harvested above 25 Brix. Our warmer temperatures and longer growing season produce grapes with more sugar and wines with more alcohol.

The Alchemy of Fermentation

Molecules in wine come from what's innate in the grape, from the yeasts' fermentation, the container and aging process. Primary fermentation converts sugars to carbon dioxide and alcohol. Sugar left unfermented is called residual sugar. In dry wines, residual sugar is usually less than 0.2%. Most of us won't taste sweetness until there's more than 1% sugar. Though the wine may contain no sugar, some people name a fruity taste or smell, sweet. The perception of sweet depends on our taste sensitivity, the kind of sugars, alcohol, acids, and tannins as well as what else we're eating or drinking. Alcohol gives wine its body. When balanced with adequate acidity, a high alcohol wine tastes richer and softer than one lower in alcohol.

BELOW:
Merlot Vineyard

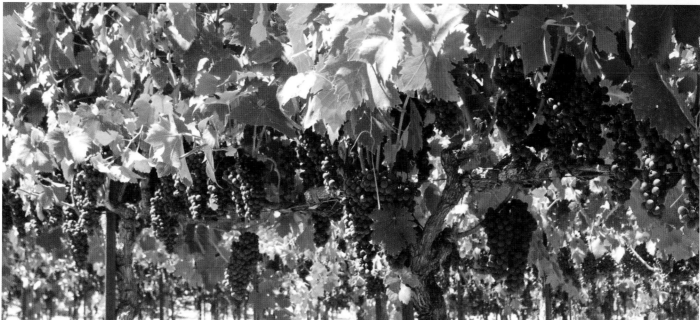

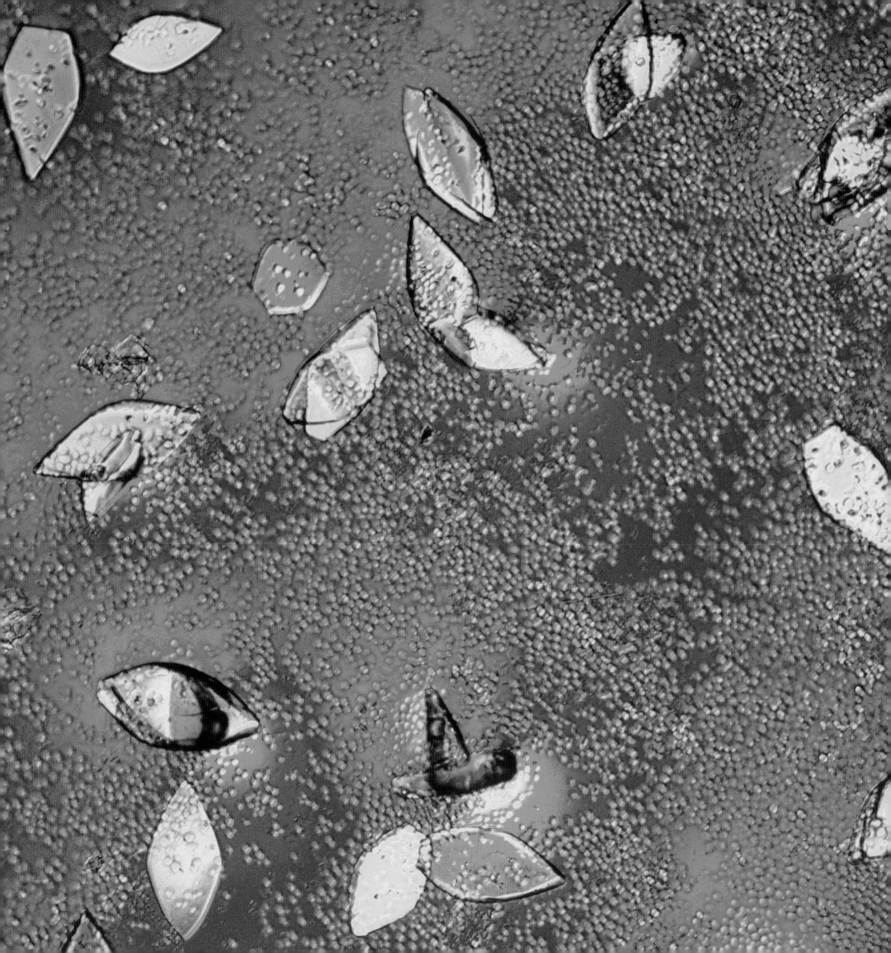

Secondary Malolactic Fermentation

To soften wine and add complexity, a common winemaking practice, especially for reds is "secondary or malolactic fermentation." After primary fermentation is complete, specific bacteria are added to convert harsh aggressive malic acid to the softer creamier lactic acid. Malolactic fermentation (MLF) gives a buttery feel and lush taste to a wine. The photo of lactic acid shows a smaller acid than malic or tartaric.

Malolactic fermentation, typically used for red wine, may be avoided for white wines. In white wine like chardonnay it clearly affects style. Compare Grgich Hills (No MLF) and Kenwood chardonnay (100% MLF) to see microscopic differences that seem to correlate with wine style.

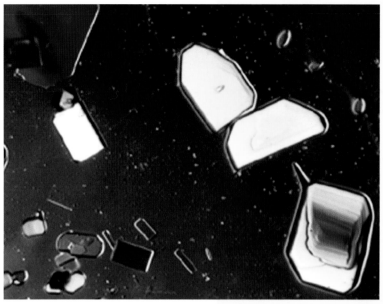

ABOVE:
Malic Acid

BELOW:
Lactic Acid

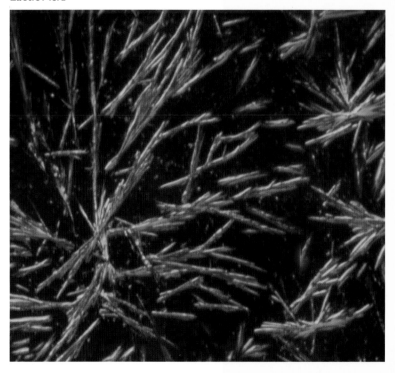

NEXT TWO PAGES:
Chardonnay of different styles:

Left side: Grgich Hills -
No malolactic fermentation

Right side: Kenwood
100% malolactic fermentation

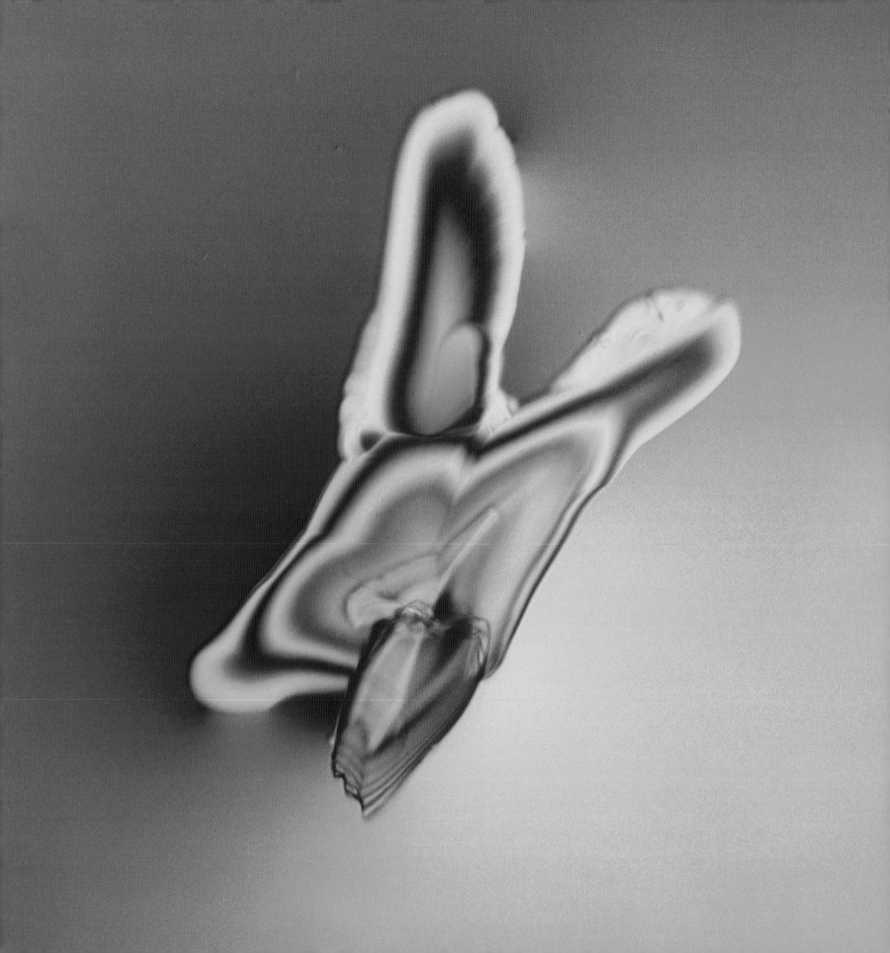

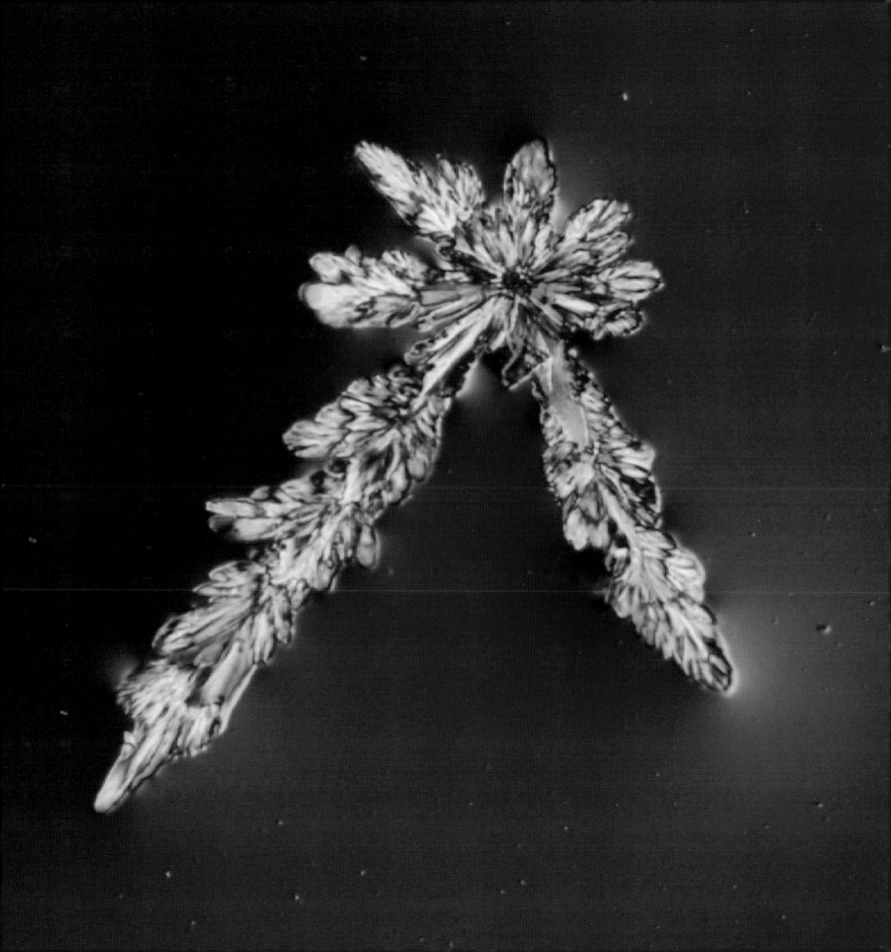

Tannic Acid and Tongue Touching Tannins

The tannins are another important molecular family adding structure, ageability, and aromaticity to the wine. Wine tannins come from two places: the grape (skin, seeds and stems) and the oak barrels used for fermentation and aging. What makes a great red wine is the quality of its tannins. The late Baron Philippe de Rothschild called tannins, "the soul of the wine."

Tannins from young wines taste bitter and cause a sensation of astringency that dries the mouth. However, an astringent or biting young red wine may foretell its future. The more pucker, if all the other components are balanced, the more likely the wine will outlive a bite free, low tannin potion. White wines, typically fermented in the absence of skins and seeds, have less tannin and don't live as long as red wines. As wines age, tannins soften. Take a look at the portrait of pure tannic acid; no wonder it feels prickly. If you've ever bitten into an unripe persimmon or sipped strong black tea, you've met tannic acid.

Spending time in oak barrels, wine tannins soften, and new tannins are added. Oak barrel tannins season wine with aromatic overtones of vanilla, roasted hazelnuts, cloves, or caramel depending on how the barrel was toasted and where the wood came from. During barrel aging, tannins in the wine polymerize, increasing in size and complexity. Winemaking wizards must know "how

ABOVE:
Tannic Acid

BELOW:
1978 Franciscan Cabernet Sauvignon

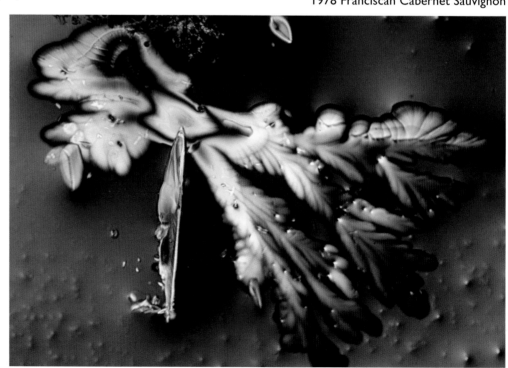

much oak is enough" and if oak will overpower or enhance the wine's own aroma. They determine how long a wine should spend in oak, where the oak comes from, the toast level of the barrel and what combination of new and used barrels to be used. Fermentation or aging in oak barrel adds considerable expense to the wine as each barrel can cost around $800. Winemakers producing inexpensive wines often give a touch of oak to wine by adding oak chips during aging in steel vats. I speculate that many larger softer microscopic forms reflect complexed aged tannins as seen in the photograph of this Franciscan cabernet.

A quality of touch associated with taste and wine, though not actually taste, is the tactile sensation. This includes what we physically feel – touch, temperature, texture and tingles of astringency. "Tongue weigh-in" with wine, informs us about its body or 'weight.' Does it feel heavy or full, voluptuous or lean? Astringency gives us oral clues to the presence of age promoting tannins. An easy thing to remember about tannins is that they influence the touch and texture of a wine. Too tannic and the wine is abrasive.

When we come across a wine that's too tannic, it can be softened on the palate by eating something salty. Notice what happens to the taste of a wine after you eat some cheese or meat. Molecular alchemy!

Terrain and Terroir

The location where vines are planted helps create the wine's distinctive personality. Like where you grew up helped to shape your personality. Growing up in the Alaska tundra will give you a different point of view from growing up in the Deep South. So, too, with grapes. Different flavors develop where it's warm and sunny or in cool climes. Grape growers worldwide are learning that certain varietals such as pinot noir flourish better in cooler climates. Though vines are hardy, they won't grow just anywhere. If it's too cold, the grapes won't ripen; if it's too hot, they won't develop fruity flavors. Grapevines are happiest between latitudes 30-50° N & 30-50° S. The green areas on the map show the predominant wine producing regions in 2007. Where will they be in 2050?

BELOW:
Green areas show major grape-growing regions.

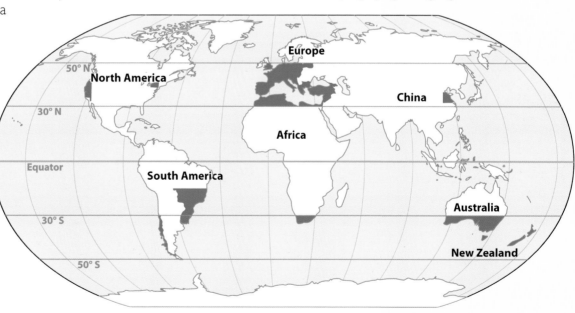

ABOVE:
Hilly vineyard, Russian River Valley

Terroir is a unifying theory . . . that encompasses the almost metaphysical circle of soil, nature, appellation and human activity.

Jamie Goode — *Wine Anorak*

The French term *terroir* reflects the qualities of place. Where the grapes are grown shapes their character and flavors. Historically, wines are known by their place of origin – Bordeaux, Burgundy, Rioja, Chianti. The names of the grape varietals were not even mentioned! The French once believed (and still may) that only wines grown on their unique soils were worthy of expressing terroir.

Terroir definitions and details vary widely, yet universally agreed upon, terroir is PLACE. Many winemakers diligently work to have their wine express the "taste of place."

"TERROIR" encompasses
· Vineyard terrain and condition
· Geography and topology: aspect, slant, height (the shape of the place)
· Soil composition, drainage and micronutrients
· Climate, weather and water
· Sunlight and moon beams
· Cycles and seasons, rhythms and timing

Survival of the Fittest?

Grapevines are hardy and while they require warmth and water to survive, they can thrive under dry-farmed conditions. It's said that the more stressed the vines, the better the quality of wine. Vines dig down deep with their roots searching for nutrients and water. How are we like that vine? When stressed, do we dig deeper into ourselves, or our support system, to create more flavor in our lives, or do we wither and become tasteless or soulless?

BELOW:
105 year old zinfandel vineyard, Ridge Lytton Springs

The Shape of Place

The flavors developing in the grape are influenced by the contours of the land, the angle at which vines face the sun, and hours of sunlight. For many growers, the ideal site is a sunny slope with good drainage and dark soil. Slopes receive more hours of sunshine, light and warmth than flat areas. Proximity to water – rivers, lakes, or oceans, also provides light to the vines. The natural setting of the place and the design of the vineyard - how closely the vines are planted, how they are staked and nourished - all impact the raw material of wine. The land is essential to the taste of the grape. Call it terroir, if you like. Yet it is talented people who cultivate the expression of terroir. Without human perception and intervention, the concept of terroir would not exist. My interpretation of 'terroir' is that it is everything involved in the growing of the grape and wine.

The Winemakers: Shaping Taste and Tasting Shapes

Who tastes shapes? In doing research for this book, I learned that the great mentor and "maestro" of American wine, André Tchelistcheff, tasted shapes!

Common knowledge in the Napa Valley, André typically smoked cigarettes before tasting and evaluating wine. Dorothy, André's wife, tells this story in Michael Chiarello's book *Napa Stories*. André, who lived into his 90s still consulting to many wineries, smoked until the last few years of his life. Weeks after he stopped, he noticed a surprising change in how he tasted as he assessed a new shipment of wine. When he smoked, tastes came to him in the shape of a pyramid. Once he stopped smoking,

tastes came to him like a fan. The new shape expanded the tastes available to him.

Dubbed "the first lady of wine" by wine critic Robert Parker, Heidi Peterson Barrett is one of the few winemakers to have produced four wines that he rated a perfect 100 points. *Time Magazine* named her "Wine Diva of Napa" and one of the world's top winemakers. Her fine reputation, plus sharing a last name, though not related, made Heidi my obvious first choice to interview about how she makes and tastes wine. She told me her goal is to create beautiful balanced wines with "no sharp edges." I photographed many of her current barrel samples of syrah and cabernet sauvignon. The pictures expressed what she felt the wines expressed – the Napa Valley syrah was larger than syrah from the Santa Ynez Valley, similar to the images of syrah at two different ages. Wines bigger to her palate expressed larger shapes.

Mike Grgich, the winemaker who brought acclaim to Napa Valley in the famous 1976 Paris tasting with his prizewinning Chateau Montelena chardonnay, says that he makes chardonnays that taste elegant,

balanced, and round. "Round like a bowl, so nothing stands out but the pleasure." Here's another esteemed winemaker using words about 'shaping wine.' The print on page 30 shows you Mike's 2002 Grgich Hills chardonnay at three years old, not a bowl but rounded with nothing 'sticking out,' a distinctive Grgich style.

The Critics

A great controversy brews in the wine industry. Are wine critics like Robert Parker telling us what we should like – what is good wine and bad, and influencing how wine is crafted? With Parker's 100-point scoring system as well as the highly influential *Wine Spectator's* 100 point rating, wines and winemakers achieve cult status when their wine is rated close to 100-points. The film Mondovino calls attention to the debate about 'manufacturing' wine according to the ratings. Numbers do help when we're looking for that special wine for an important occasion. I am the first to admit I look forward to tasting high scoring wines. But I don't always prefer them, nor do the experts agree. So what's a wine drinker to do? Experiment, explore, and discover which varietals are your favorites. Is there a particular winemaker's style you like?

When I traveled a lot across the country teaching, I knew I could count on Kendall-Jackson chardonnay for a pleasant wine experience. The other day I purchased an Australian Shiraz for $4.99 and was delighted with its complexity and rich layers of flavor, far better, to my palate than a Parker 99-point Shiraz I sipped recently.

The more we learn about wine and the senses, the more we can appreciate the vast molecular collaboration that goes into our personal experience, and the more we can trust our own opinions. We are the critics that count! And what about the glass and taste?

Glasses Shape Taste

Claus Riedel revolutionized wine tasting by proposing that the shape of the glass affected taste perception and drinking pleasure. "The correct choice of glass shape enhances the flavors of wine," is an apt slogan for one of the world's largest and finest glassware producers. According to Riedel, the glasses are designed to bring together the personality of the wine, smell, taste, and appearance. The size of a glass affects the quality and intensity of aromas. The breathing space is chosen according to the "personality" of the wine or spirit.

Red wines require large glasses, white wines, medium-sized, and spirits, small ones (to emphasize the fruit character and not the alcohol). Have you discovered this phenomenon for yourself? Glass shape and size certainly influence the aromas we are able to come into contact with. I prefer large red wine glasses for all wines though I haven't experimented to see how glass shape influences my tasting pleasure. I have discovered that coffee tastes different when I sip it from a large mug or a more delicate china cup.

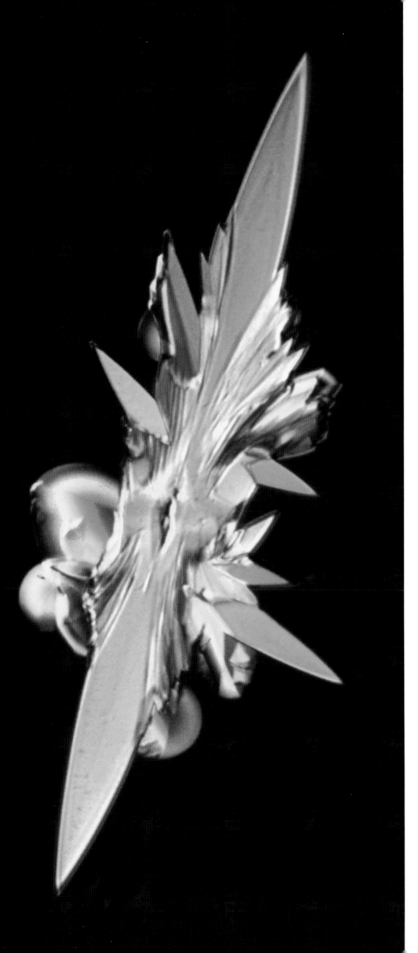

Shaping the Language of Taste

The very first wine I photographed made me question where the words come from that people use to describe wine. The merlot's microscopic portrait reflected something soft and inviting to the palate. But a big tannic cabernet sauvignon was a lot harder to drink, and its microscopic display reflected a pointed personality. One wine was soft and drinkable, the other sharp, needed time to soften. This originated the seed of an idea, that microscopic shapes reflect our experience; that there is a shape component to taste.

Describing wine in words, we compare it to what we are familiar with — tastes like cherry, smells like roses or tobacco. Wine critic Robert Parker relies most heavily on language of the aromatics and his olfactory sense, whereas *Wine Spectator* critics James Laube and Harvey Steinman focus more on gustatory words. Why such a discrepancy? Sensory experiences are subjective. Give judges the same wine to assess; their verbal descriptions and ratings of the wine will vary greatly. Now throw in what we're learning about hypersensitive palates; no doubt we will see that individual biology plays a part.

*In really delicious wines, you just
can't take your nose out of the glass.*

—Heidi Peterson Barrett

LEFT:
1977 BV Georges de Latour Private Reserve
Cabernet Sauvignon at 6 yrs

Pat Simon's Wine Shapes

Pat Simon, British wine writer and critic, former wine consultant to the World Bank, UN Food and Agriculture Agency, and Master of Wine for 40 years, wrote in *Wine Tasters' Logic* that he made mental images of a wine, formulating shapes as he learned. His lexicon of shapes was useful to follow how the wine's shape changed at each stage of development. At wine tastings he also noted that some people scribbled images, not words. He performed one published experiment with his series of images. Though *Harper's Wine and Spirit Gazette,* which published his study, poked fun at it, the tasters reported that the shapes chosen were useful to them. I include his seven shapes here to give you more imagery to consider as visual language or cues for your wine experience.

What is interesting about Simon's intuited shapes - some are similar to what we see in wine under the peering eye of the microscope.

BELOW:
Pat Simon's Shapes

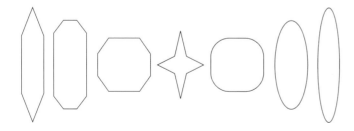

What we are doing with our tasting notes is using a "code" language that gives information about a number of aspects of the wine. We should take ourselves a little less seriously when we are attempting the difficult job of describing wine in words.

– Jamie Goode - *The Science of Wine*

Smell and Language

A recent article by Jaron Lanier, in the popular science magazine *Discover,* poses the theory that the sense of smell gave rise evolutionarily to our language. Consider how the brain processes the senses; sight and sound are processed by 'number' as both depend on measurable electromagnetic spectrum. Taste and smell are multi-dimensional molecular inputs that depend on space and shape of the molecules. Picture the smell or taste of an apple. Its flavor molecules land on a variety of receptors 'painting a picture' of that smell and taste, hence words come to mind, sharp or perfumey. Time and research will tell whether these chemical senses form one basis for the language of taste. In the meantime, pay attention to how you name and describe your experience.

Is your language centered on scent, taste or a combination?

In your wine adventures, see if you can describe one wine without comparisons. And though the experts and publications inform us of high rated wines as the "best," your palate knows what is best for you. Trust it and enjoy even if it's a Two Buck Chuck or white zinfandel.

How to Taste

This is one of my ongoing questions to winemakers and wine lovers alike. How do you taste, judge, and know wine? Heidi Barrett, the wine goddess, was very generous with her time and expertise. Here's how she approaches crafting a wine.

"I divide tasting into three parts. I feel a beginning initial palate, mid-palate and finish. I give each a two-stroke count – 1, 2 for the beginning, 3, 4 for the mid-palate, and 5, 6 for the finish. I basically made that up for that's how I see it. So when I'm putting a blend together I'd see the initial palate is good but maybe there's a hole around number 3. That needs to be lifted by another wine. What will fill in the missing parts? If it's short on the finish, 5,6, I ask what will add that missing component. Cab franc is mostly a 1, 2; it doesn't have the other stuff. For a cabernet sauvignon that's mostly 3, 4, 5, and 6, I can give it a little 1, 2 punch by adding cab franc. The six-part count helps me when I'm making a wine. I want every note hit so that the wine is complete and balanced. I always try to round out anything that sticks out."

Of course, you and I are not likely to be constructing wines, but Heidi's approach may help us "get inside" wine more deeply. She suggests looking at our overall impressions of the wine, the overall intensity, is it big or small? She thinks of light wine as small whereas a heavy wine is big.

Of course, it's not only about the taste, the aromas add to our pleasure of wine.

A 3 point approach to taste wine

1. The Front - your initial impressions when the wine hits your mouth and nose
2. Middle - what you feel after the first touch, wine is still in your mouth
3. The finishing touch - what's left after you swallow the wine

 You can easily make it a beginning, middle and end.

 Let's give it a try.

 Fill your glass. Sniff, Sip, and Taste. *Toast!*

Sensory Awakening

To enjoy wine we use all of our senses. Before wine gets near our mouth, we hear the sound of the popping cork, the music of wine flowing into the glass. We clink glasses and offer a toast. With our eyes we notice color and clarity. White wines, typically straw-colored in their youth turn golden with time. Red wines often begin at the purple end of the spectrum adding gold with their years as well. An old red wine may actually look brownish or rust-colored.

Next, our nose gets into the act, into the glass. We sniff, "sipping" in through our nose the layers of fragrance from the grape and its vinification. Once we remove our nose from the glass, our mouth finally tastes the wine, though nose impressions never leave us and are inextricably married to our sense of taste.

Rolling the alcoholic potion in our mouth the tongue picks up nuances of flavor and tingly tactile experiences. When we pull in more air as we slurp, oxygenation adds something new to our tongue tastes. Is the wine sharp and aggressive, or soft and inviting? Does it seem to dry the mouth in the first sip? Does it hold our attention long after we've swallowed, leaving a memory of something to be tried again or no, no, no? Can we pick up flavor, fruit, or country of origin? I am always amazed how people can possess such highly skilled palates that they taste vintage and vineyard. Do you ever wonder how that person trains their mouth and nose?

ABOVE:
Kunde Chardonnay Vines

Can we use verbal and visual vocabulary to describe and enjoy this sensual feast? With that next glass of wine, let an image come to mind as you slowly savor this wonderful gift of the gods. Does a picture or shape come to mind; does a song or poem? Here's an opportunity to further develop your taste vocabulary. Does your wine taste like one of these pictures?

Next time you swirl wine in your mouth notice what your tongue tells you. How does the taste of wine change after eating cheese, bread, meat, salad, or chocolate? Discover your preferred wine and food partnerships. *The most important aspect — enjoy.* ◊

OPPOSITE PAGE
Sonoma-Cutrer Chardonnay

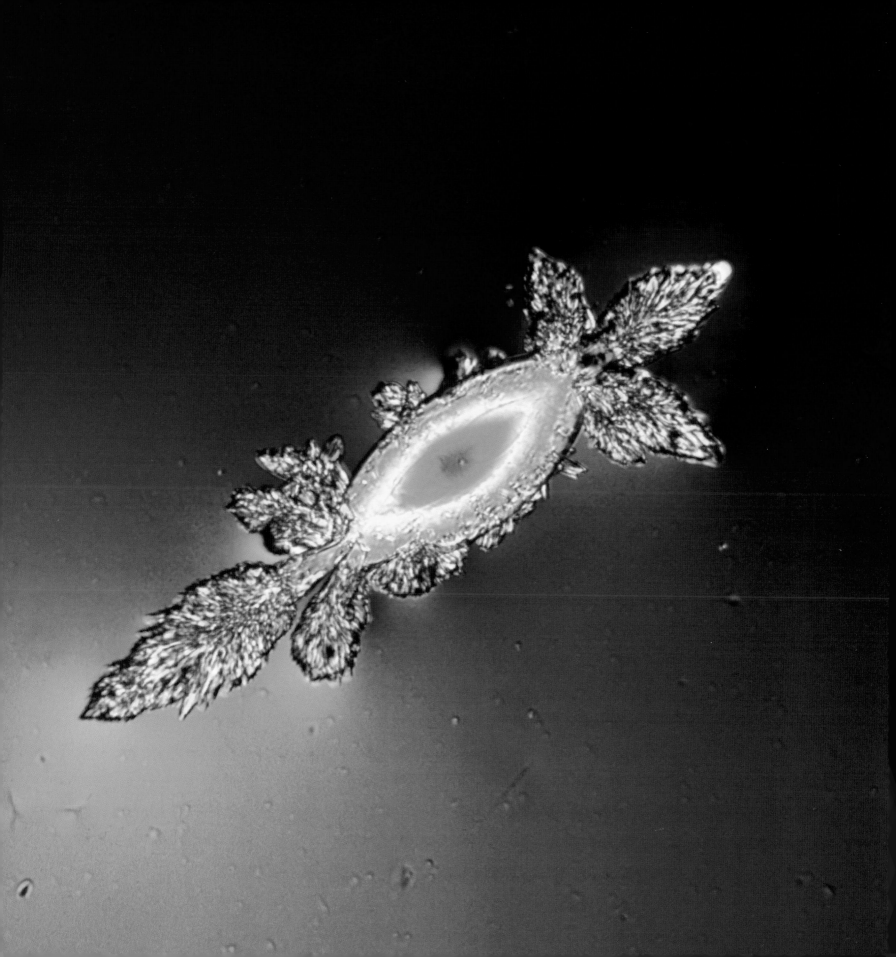

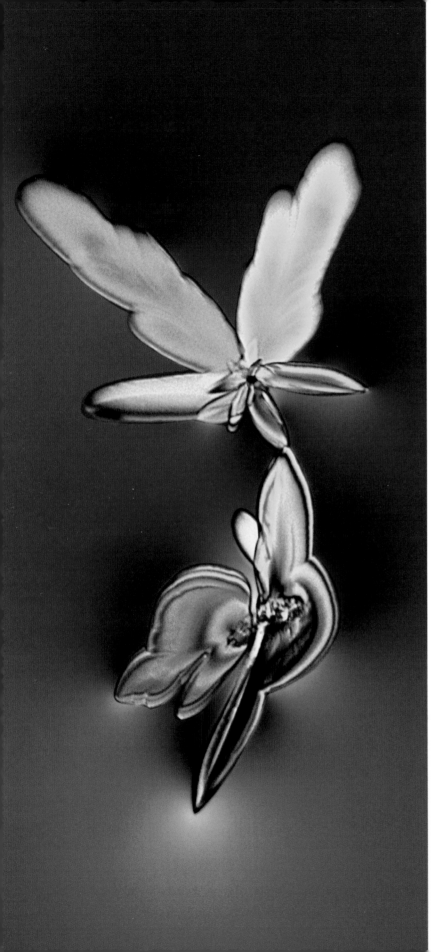

Chapter 4

WINE LEGENDS:
Art in the Bottle

The beautiful is a manifestation of the secret laws of nature. When nature begins to reveal her open secret to a person, she feels an irresistible longing for her most worthy interpretation, art.

— Goethe

I call this chapter Wine Legends, because of the famous wines I photographed, the extraordinary people who helped create this industry, and for the fabulous legendary myths that wine tells.

What makes something legendary so that it stands out far and above others? If it is a wine, what makes it so memorable that people talk about it for years and want another glass filled? In the past I never thought about wines being legendary. I tasted some, simply because I was a 'wine paparazzi' aiming to photograph their beauty secrets. To me, now, legendary wines are those that are incredibly beautiful or unusual like La Sirena Moscato Azul 2004 pictured here.

LEFT:
Moscato Azul

ABOVE:
1977 BV Georges de Latour
~ 6 years old

The first notable vintage, with a celebrated designation, that I encountered was Beaulieu Vineyards (BV) "Georges de Latour Private Reserve Cabernet Sauvignon," though I didn't know it was legendary at the time. The wine buyer at my local market recommended it; so I purchased it to share with friends. I didn't like this expensive cabernet; it was much too harsh for my taste. We all wondered what made it so famous. Even though a wine may be called "legendary," that doesn't guarantee you're going to like it. To the microscope it was beautiful. With that first famous cab, I experienced the pulling on my tongue, not knowing this was a reflection of potential ageability.

In a recent conversation with the WineSpirit Group, Jan Shrem, owner and founder of Clos Pegas Winery, recalled giving a legendary French Bordeaux to his vineyard manager who found the wine less enjoyable than the inexpensive red table wine he was used to drinking. "Tastes change," Jan said. Our experience influences what we call 'good' or 'bad.' Beginning wine drinkers often find the big reds less to their liking than a soft, slightly sweet wine or smooth merlot.

The bold tannic red wines may not be popular with new wine drinkers; nonetheless they are here to stay. In the beginning of American wine, big reds made

Napa Valley famous and it was Beaulieu's Georges de Latour and Inglenook that birthed Napa Valley as a producer of great cabernet sauvignon.

Beaulieu Vineyards, Georges de Latour and André T

In 1900 Georges de Latour, a native of Bordeaux, planted vineyards at Rutherford and near Oakville. The founder of Beaulieu Vineyards, he was responsible in 1938 for bringing over the brilliant young Russian-born André Tchelistcheff who helped craft the budding California wine industry. The 1936 cabernet sauvignon, started by Latour and finished under André's artistic expertise, won the Grand Sweepstakes at the 1939 Golden Gate International Exposition in San Francisco showing great promise for Napa Valley.

When Georges died in 1940 his wife Fernande kept his vision alive by naming BV's top cabernet "Georges de Latour Private Reserve Cabernet Sauvignon." André also mentored BV's current winemaker Joel Aiken who has been there since 1982. Here's a photograph of Aiken's 2002 Georges de Latour enjoyed at the 2006 "Oscar's" Governor's Ball.

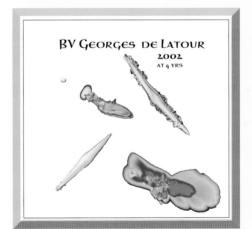

RIGHT:
2002 BV Georges de Latour
cabernet sauvignon ~ 4 years old

André's Legacies

André is a legend in his own right.

A White Russian soldier in World War I, at the age of 20, André was left for dead when seventy-five percent of his unit was machine-gunned down. Surviving that, he and his family safely migrated from Russia to Czechoslovakia, Yugoslavia, then France where he studied agriculture and food technology. In Paris he began his specialization in wines and vines joining the Pasteur Institute to learn wine microbiology. André was working as an assistant at the agronomy experimental station in Paris in 1938 when Georges de Latour arrived looking for a winemaker and viticulturist. The director recommended the Russian émigré since he thought his French candidates would always be homesick for France. After all, André had already lived in several different countries, spoke many languages, so what difference would it make for him to move again, this time to California. Called the "Maestro of California wine," André went on to become one of the most influential figures in the wine community guiding American winemakers from the 1930s to today. By the 1940s BV wines were served at the White House to Eleanor Roosevelt and Winston Churchill. Not only did André help make Beaulieu wine world class, he mentored most of the early winemakers of the Napa Valley including Robert Mondavi, Louis Martini, Joe Heitz, Mike Grgich, and Jill Davis.

Napa Valley Cabs

Bob Thompson writes that in the early days, Napa Valley Cab meant only BV Georges de Latour and Inglenook cask. The vineyards that produced these two wines sat side by side on what is called the Rutherford Bench. In those pure unblended cabs, seasoned tasters looked for the distinctive note they call 'Rutherford dust.' In 1952, there were four Rutherford dust producers. In 2006 this legendary land of 3,263 acres, is home to forty wineries that cultivate its distinct taste of terroir.

The Ages of Inglenook Cask Cabernets

The claim has been that 19th century Finnish sea captain and viticulturist Gustave Niebaum founded Inglenook in 1879. However, according to Andrew Jones in *The Stories Behind the Labels,* the first founder was a Scot named William Watson who bought the land in 1872. Watson wanted to develop a health and holiday resort so he looked for land secluded from the road. He found a peaceful sheltered location at Rutherford, built a home, planted a seventy-nine acre vineyard, and

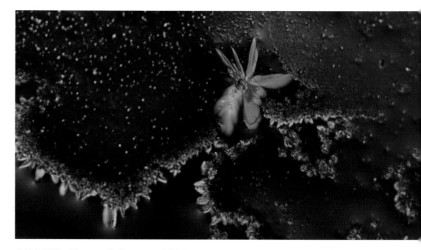

ABOVE: Young Cabernet, 1980 Inglenook

named his property "Inglenook," the Scottish word for "cozy corner." Unfortunately in those days, people didn't travel much to the cozy corner and the resort failed. In the seven years that Watson owned Inglenook, his vines fully matured attracting Captain Niebaum's attention who purchased the already established vineyard in peak production. Though Watson named and planted this piece of paradise, it was Niebaum and his descendants who turned it into the one of the first highly acclaimed wineries in California and the Americas.

After the repeal of prohibition, Niebaum's grandnephew John Daniel Jr. pioneered the rebirth of Inglenook as a winery through the early 1960s. He and winemaker George Deuer made wine without compromising time or money. Wines were fermented in open topped redwood tanks and aged in ancient oak ovals from Germany's Spessart forests. This Rutherford property helped establish Napa's cab credentials in the 30s and 40s with rich, dense, age worthy wines.

What John Daniel labeled as 'cask cabernet' was based on his palate and intuition. Though the wines came from the same vineyards and were made the same way, he selected one or two of his old oak oval casks as having slightly superior wine and bottled it that way. In 1985, sitting next to Andre, I was fortunate to taste and photograph ten Inglenook cask cabernets dating from 1941 to 1983. From this series and his comments I discovered some visual phenomena of wine aging.

The 1941 Inglenook Cask Cab remains one of the greatest California reds ever produced. It was the first California cabernet to be rated a perfect 100 points by *Wine Spectator* editor James Laube. On release it sold for $1.49; in 1999 still drinkable, it sold for $1399. In 2004 wine writer Alan Goldfarb told me he had recently enjoyed this wine when Robin Lail, John Daniel's daughter served it to him. It was still good.

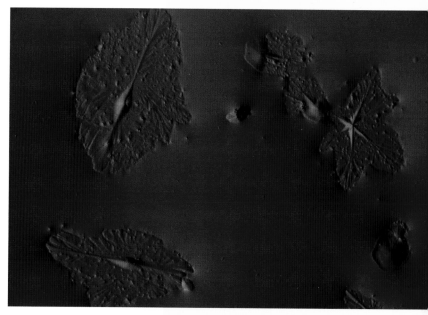

ABOVE:
Over the Hill; 1961 Inglenook ~ 24 years old

BELOW:
1941 Inglenook ~ 44 years young

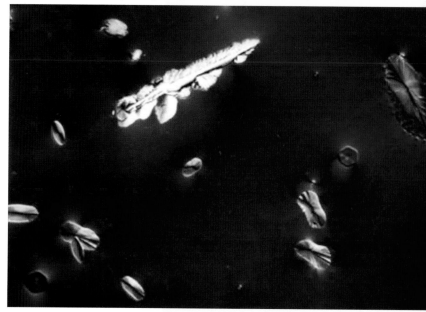

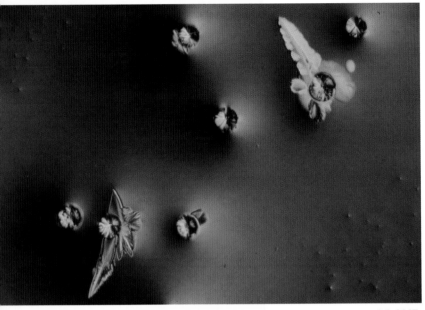

ABOVE:
1968 Inglenook ~ 17 years old

BELOW:
1978 Sterling Merlot Butterfly

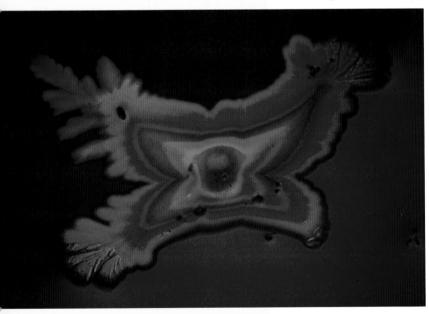

Before the Inglenook series, my portraits encompassed wines ranging from harvest to about ten years old; the microscope revealed wine's growing complexity and sometimes a loss of vitality with age. The older Inglenook wines added another piece of the puzzle, a new form giving hints at long term ageability, as seen in the 1968 Inglenook. Initially when I photographed wines, I was looking for beauty as well as the most representative forms. I ignored the form I call 'ageability' in young wines since if there were any, there were very few. Once I witnessed their abundance in old viable wines, I went back to reassess the younger ones. Lo and behold, the jewel existed in many young ageable cabs.

Over the years, unfortunately, the esteemed Inglenook winery changed hands many times and wine quality deteriorated. However, once the name "Inglenook" was sold, and famed movie producer Francis Ford Coppola separately purchased the vineyards and winery, outstanding wines are again coming from that legendary land.

The First Merlot

If we talk about creating a legend, Peter Newton and his partners built their dream of a castle in the sky where people could come to enjoy wine. What better name to give this winery than 'Sterling', since Newton had made his millions, in London and San Francisco, as a negociant in sterling silver. Perched high above the Napa Valley, the gleaming white Greek-inspired buildings of Sterling Vineyards became the first showplace for the fledgling California wine industry in the 1970s. To reach this lofty image of the Greek isles, visitors take a memorable tram ride rising high above the valley floor. Of all the wineries in Napa and Sonoma, this is the only one you can see from a distance.

Not only did the first owner and founder of Sterling Vineyards build a legendary destination site, Newton planted the first merlot vines in the Napa Valley. Merlot was to become the second famous red wine of the valley. Sterling merlot was the first American wine to grace the tables of the famed Hotel Ritz in Paris. Sterling also became the first winery to support this wine art by licensing images for postcards sold in their tasting room.

1976 Paris Tasting

In celebration of the American Bicentennial activities in Paris, English wine merchant Steven Spurrier, owner of a well known wine shop and wine school, set up the now famous 1976 Paris wine tasting. His American students brought California cabernets and chardonnays to Spurrier's attention and he was curious to see how these newcomers would compare to French wines made from the same kind of grapes. California chardonnays and cabernets were pitted against the best white Burgundies and red Bordeaux. The judges, prominent French wine and

food experts, were sure that the upstart California wines would be easy to pick out and be inferior to the French. The big surprise - two California wines took top honors! The 1973 Chateau Montelena chardonnay made by Mike Grgich bested the white Burgundies; the 1973 Stag's Leap Wine Cellars cabernet sauvignon by Warren Winiarski surpassed the Bordeaux.

Compared to the French, since California wine-making was in its infancy in the early 1970s, their winning was especially shocking. The Judgment of Paris put California winemaking on the map; Winiarski and Grgich entered a class of world-esteemed winemakers.

Shaping Chardonnay: Mike Grgich

Miljenko "Mike" Grgich is often considered the "King of Chardonnay." His initial claim to chardonnay fame was when the wine he made for Chateau Montelena was deemed the best white wine in the world. The "Judgment of Paris" gave Mike needed recognition; his hard work, dedication, and skill showed he was now ready to fulfill the dream - his own winery. When Austin Hills of the Hills Brothers coffee family approached him, his dream became a reality. Grgich Hills Cellars was born on July 4, 1977. The first chardonnay made at Grgich Hills (1977) was named "Best Chardonnay in the World" at the famous "Great Chicago Showdown" where 221 chardonnays were tasted.

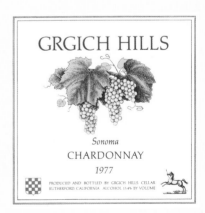

LEFT:
1977 Grgich Hills Chardonnay

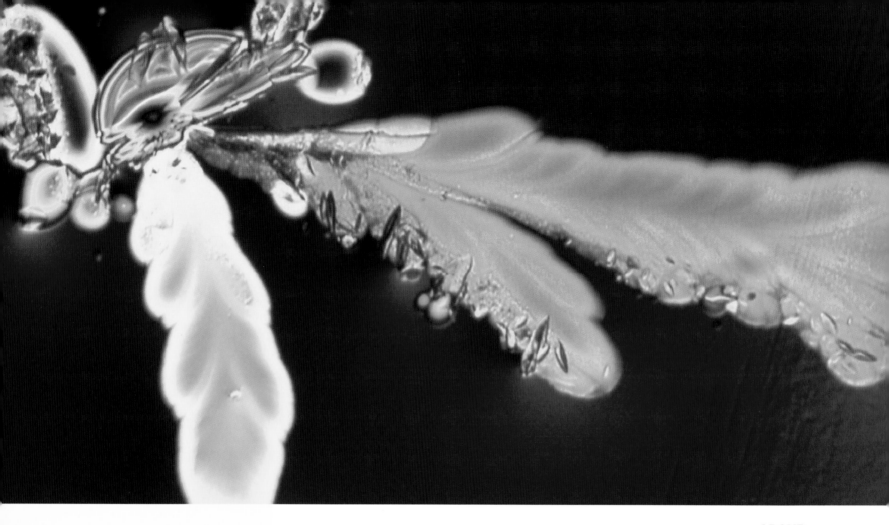

Almost 30 years later, I had the opportunity to taste and photograph that wine and it still had incredible beauty to show for all of its years. Though not as lively in flavor as younger Grgich Hills' chardonnays, it reveals the invisible hand of a great master of chardonnay.

It was through photography that I met Mike Grgich and his wines in 2005. I was commissioned to photograph a series of their tasting room chardonnays and cabernet. A year later I fell in love with his chardonnays. Not much of a white wine drinker, I typically buy or order pinot noir or syrah. A comment on my wine blog (Wine Sex, Beauty in the Bottle) enticed me to open a bottle of chardonnay.

The blogger's comment was made in relationship to pairing chardonnay with food. Those made without malolactic fermentation, like Grgich Hills, went much better with food than the fat buttery chardonnays resulting from 100% malolactic fermentation

So ever the explorer, the following afternoon while I was roasting rosemary chicken, I decided to open a 2003 Grgich Hills chardonnay. I was as surprised as those French judges must have been. This wine, even before food entered the picture, carried a distinct chardonnay nose, a smooth and balanced eloquence. I was delighted that this crisp yet soft chardonnay turned out to be a superb sipping wine, before dinner, and was even better with the rich buttery garlicky chicken.

Vines not Mines

Mike Grgich, not only pioneered great chardonnay, he is helping pioneer sustainable organic viticulture. All 366 acres of Grgich Hills vineyards now are biodynamically farmed making it the most acreage in the US dedicated to biodynamic grapes. What is even more exceptional about this well aged vintage winemaker is that he hasn't forgotten his Croatian roots. There he opened a new winery Grgich Vina to help young Croatians take up winemaking and learn modern winemaking techniques. He and his family play an active part in the Roots of Peace Mines for Vines program that plants grape vines to replace deadly land mines. What a wonderful way to give back.

This takes us back to a theme of this book - the holy mission of the grape to create inner and outer peace. Thank you Mike Grgich for reminding us to connect back to our roots and nurture the future generations of wine growers and wine lovers.

"Over the years I have learned to communicate with the wines and how to nurture them. I realized that you don't make wine only with your head and your senses. You make wine with your heart. You have to pour your heart and your love into the wine. To me, wines are like my children, and you have to transmit to them the richness of your spirit."

Jess Jackson: Making Chardonnay for the Consumer

The very first chardonnay that I fell in love with, a taste to remember was this bejeweled beauty, one of Jess Jackson's first chardonnays. This portrait of his 1983 Vintner's Reserve, showed a microscopic design seen only in chardonnay with 100% malolactic

fermentation. Throughout its microscopic terrain, this pattern was consistent. A consistency in quality was also born out in the Kendall-Jackson (KJ) chardonnays themselves. When traveling in the backwaters of the US of A, I could usually find a KJ chardonnay on the menu. I knew it would be pleasurable to drink and I could afford it.

Jess Jackson's first wine was released in 1983, the 1982 Kendall-Jackson Vintner's Reserve Chardonnay. His intent was to make the best chardonnay in the United States and to popularize the idea of varietal wines. His 1983 Chardonnay won the first platinum award ever presented by the American Wine Competition. And in 2009 we discover that the new American president Barack Obama is a fan of KJ chardonnay!

Jackson and Grgich were among the pioneers to use oak barrel fermentation for chardonnay. Whereas the KJ chardonnays undergo secondary malolactic fermentation Grgich's chardonnays do not. Chardonnay seems like a more "feminine" wine (in mouth and microscopic design) when it undergoes malolactic fermentation.

Noble Grapes

Legendary wines are typically crafted from what's called the noble varietals or classic grapes. According to Karen MacNeil in *The Wine Bible,* a classic varietal must manifest considerable quality over a long period of time and be grown in more than one place. The noble reds are cabernet sauvignon, merlot, pinot noir, and syrah; the noble white grapes are chardonnay, sauvignon blanc, chenin blanc, riesling and semillon.

Chardonnay, which MacNeil likens to Marilyn Monroe, can certainly be seen as a big, bold feminine wine when you take a peak at its hidden voluptuous form.

NEXT PAGE:
1983 Kendall-Jackson Chardonnay

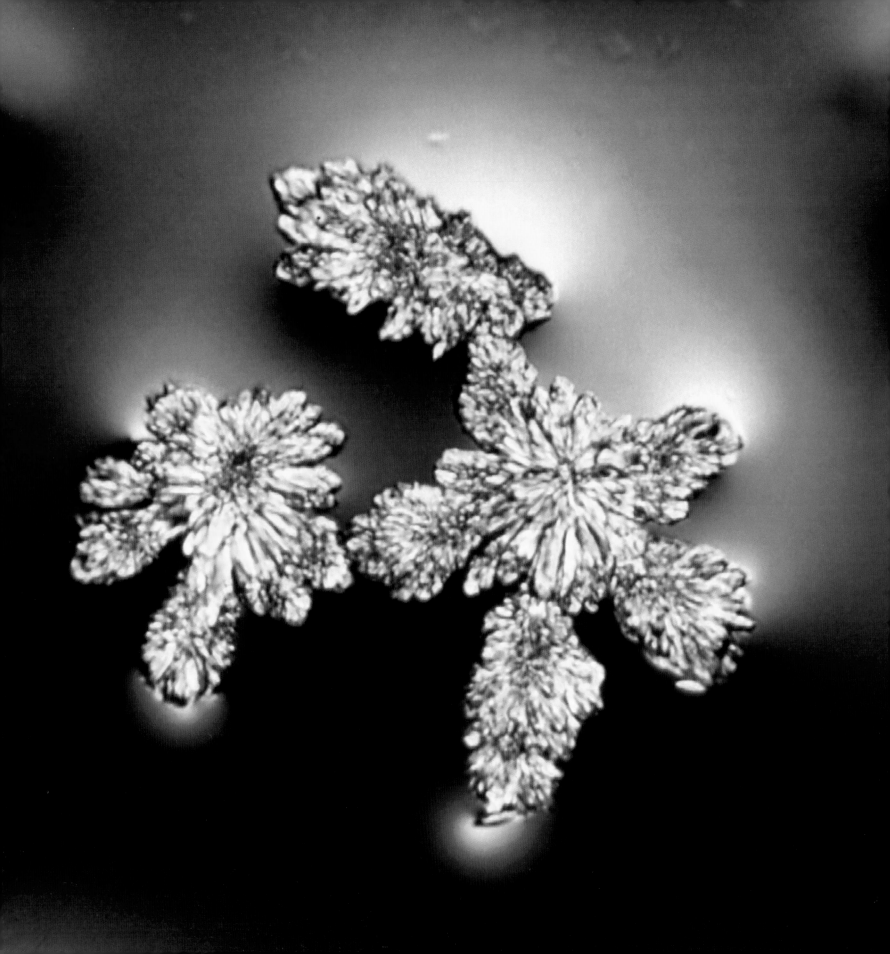

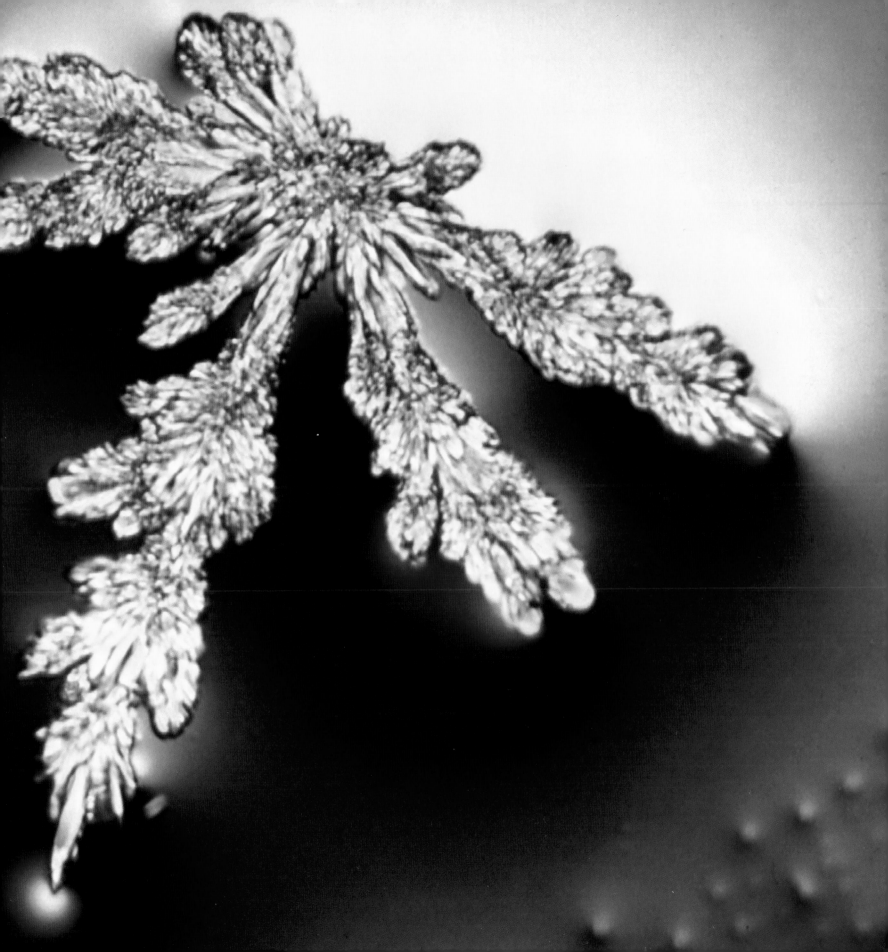

This grape creates full-bodied wines and its style ranges from crisp tropical fruit to rich, buttery, and bold. Chardonnay fermented and aged in oak barrels, if "cooked to perfection" will be creamy and complex. This grape loves cool temperatures and is grows well in California, New York, Washington, Australia, Champagne, Burgundy, and the Languedoc.

To quote MacNeil again – "Where chardonnay is all buttery roundness, sauvignon Blanc is taut, lithe, and herbal, with a keen stiletto of acidity that vibrates through the center of the wine. *If chardonnay is Marilyn Monroe, sauvignon Blanc is Jamie Lee Curtis."* Their styles are reflected in their signatures. Which is which?

ABOVE:
Chateau la Mondotte

BELOW:
Kenwood Chardonnay
Sterling Sauvignon blanc

 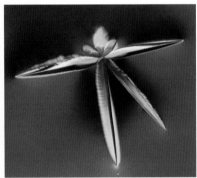

Noble Reds

The most prominent noble red grape is cabernet sauvignon, whose wines start off angular when young, transform into complex potions. Prized wines from Bordeaux (the first growths), Bordeaux blends and excellent cabs from California benefit from cabernet sauvignon's powerful fruit and linear structure. Bordeaux blends, wherever they are made, contain mostly cabernet sauvignon balanced with some merlot, cabernet franc, Petit Verdot, and Malbec.

Merlot, whose name in French means "little blackbird," is frequently blended to add softer structure to cabernet sauvignon. Softer and more rounded on the palate than cab, merlot often looks like that microscopically.

This stellar French wine, a 2000 Chateau la Mondotte from the St. Emilion region, is predominately merlot (80%) and was deemed by critics to be "a candidate for perfection." The *Wine Spectator* gave it 95 points; Robert Parker gave it 96-98 points. Do the words experts used to describe this luscious wine mirror its portrait?

Rich, opulent, intense, delicacy, finesse, depth, concentration, silky, sexy, layered texture, purity, full-bodied finish

Pinot POWER

Often considered the most sensual of the red wines, a fine pinot noir, my personal favorite, is often supple, silky and earthy, full of cherries and chocolate. It is also the first of the reds I could identify cherry with tongue and nose. Though it's lighter in color and body than

cabernet, merlot or syrah it's as rich in layers of flavor. The pinot noir grape, originating in Burgundy, provides some of the most legendary wines for this varietal.

In the new world, Oregon first gained fame for perfecting this grape, while the cool coastal climates of the Russian River, Sonoma and Central Coasts of California are quickly claiming aclaim for world class pinots. Of the noble grapes, it is considered the most difficult to grow, most sensitive to climatic change, soil, and winemaking practices. Pinot is as finicky on the vine as in the barrel. Its risky nature is probably what challenges and intrigues winemakers who are romancing this grape.

I fell in love with pinot noir during the Harvest of 2004, around the same time *Sideways* came out. It was nearly twenty years since I had done anything with wine and I had never worked the cellar at a winery. I was now going to be part of making wine from the very beginning. During my long lived flirtation with wine, I had photographed them at all stages of development and fame, walked vineyards, and gave multimedia tastings. Yet I had never been intimately involved in the whole process with my arms deep into the vats.

During the 2004 harvest I helped craft pinot noir and chardonnay for a small boutique winery in the Russian River. "Small" means the winemaker, two cellar rats, and me. The winemaker took me to all the different vineyards from which he was purchasing grapes; he showed me how to sample grapes for ripeness. From the vineyards I would bring back to the small lab, plastic Baggies filled with grapes to taste and measure sugar levels. I was so pleased when I began to know the Brix just by taste. I smile remembering that piece of learning. Another AHA moment was when I detected and tasted the fragrance of deep rich cherry in a still gurgling barrel. As I described this to the winemaker, he told me that was unique to Burgundy, not usually

ABOVE:
Pinot Noir Grapes

THREE WINES FROM PINOT GRAPES

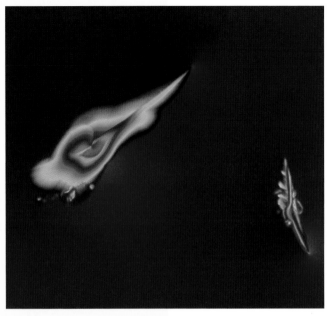

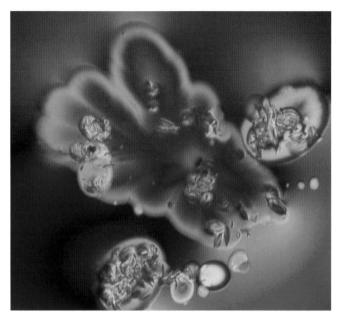

ABOVE: BURGUNDY 2002 Domaine G. Roumier, Bonnes-Mares
CALIFORNIA CENTRAL COAST 2003 Kosta-Browne Santa Lucia Highlands

BELOW:
OREGON 2003 Ponzi Reserve Willamette Valley

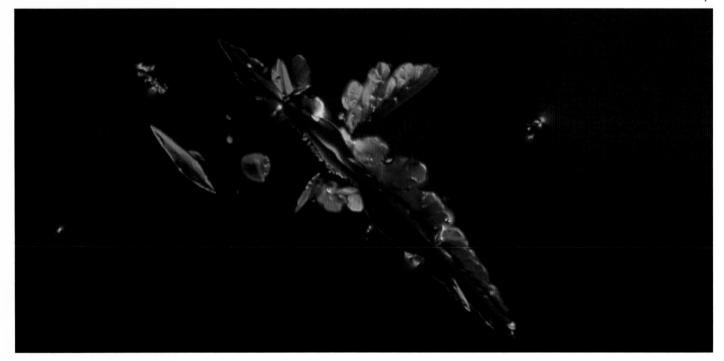

Russian River. Turns out that those barrels of pinot turned out to be a major winner two years later, Chasseur 2004 Joyce Vineyard. It also made me smile that perhaps I had the nose for making wine, a dream.

This seduction power of pinot engages me so fully I may never need another grape. With wines made from the pinot noir grape I began again to see hints that different regions or styles showed different characteristics.

This book has grown like a sprawling vineyard needing more space. It's impossible to do justice here to each grape varietal or legendary vintage. Look in the resource section of this book to discover many fine wine books. My three favorites are *The Wine Bible* by Karen MacNeil, Jans Priewe's *Wine from Grape to Glass*, and Jamie Goode's *The Science of Wine*.

The Legendary Robert Mondavi

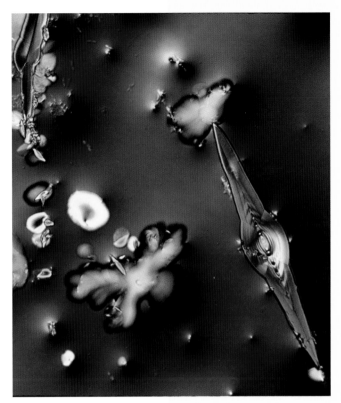

ABOVE:
1979 Robert Mondavi Reserve Cabernet Sauvignon

People, who write about wine and those who are fortunate enough to drink it, remember famous vintages most. Yet the people behind the vintages with their vision and persistence are the real story of wine. For Americans, the wine noble is Robert Mondavi.

His presence has been a great gift to wine lovers. He brought modern winemaking techniques to the sleepy Napa Valley, and engaged in extraordinary public relations taking his wine into restaurants to taste along with expensive French wines from the wine list. He built a showcase winery expanded by wine and food, art and music events. He was a showman first class. To Mondavi, wine was a sacred and civilized beverage, wine was life.

Not enough can be said about his contribution to wine, especially California wine. He certainly stands tallest among a number of might oaks responsible for building the California wine industry into what it is today. His vision and uncompromising energy will live forever.

Marvin R. Shanken – Editor and publisher of the *Wine Spectator*

The most visible legend of American wine, Robert Mondavi, more than any other individual, transformed a California farming community into a respected world wide billion dollar wine industry. He also changed our eating habits enjoying wine as food.

Mondavi, like Grgich, started early with wine, sipping it watered down as a young child, typical in Italian families. As an adult in 1943, Robert persuaded his father Cesare to buy the oldest vineyard and winery in the Napa Valley, Charles Krug. Robert became the salesman and his brother Peter, the winemaker. For the next twenty years they focused on producing jug wines. In 1962 Robert traveled to Europe for the first time; he was wined, dined, and educated in winemaking techniques by the great old families of France and Italy. He returned with visions that Napa Valley wine could achieve the same greatness as French and Italian wine. His family, unfortunately, did not share that vision. This ignited the famous family feud, which severed the relationship between Peter and Robert. Robert left Krug, and in 1966 started his own winery beginning his long climb to wine stardom making and promoting wines in ways never done before.

Mondavi adopted winemaking techniques and marketing programs that seemed outlandish at the time; yet which many now emulate. Technologically, Mondavi was always at the forefront, introducing temperature controlled fermentation tanks in the 1960s to the adoption of NASA mapping technology.

> *I want to make wines that harmonize with food – wines that almost hug your tongue with gentleness.*
>
> –Robert Mondavi

Many notable winemakers 'developed their chops' with Mondavi including Mike Grgich, Warren Winiarski, Charles Thomas, Selma Long, Paul Hobbs and even the great André T (Tchelistcheff) spent time working there. Robert's obsessive drive to make world-class wine, his risk-taking business style and lavish spending made him a force to be reckoned with.

After persistent proselytizing in the United States and abroad, Mondavi became recognized as the foremost visionary in one of California's major industries. In 1979, when California was still considered an enological wasteland, Mondavi shocked the world by partnering with Baron Philippe de Rothschild of Chateau Mouton-Rothschild, to make an expensive Bordeaux-style wine in California. Opus One continues today as a primo wine with cult status. His winery, founded in 1966, has been a cornerstone of the California wine industry. Now part of the Constellation Brands, Robert Mondavi Winery is being shepherded into not only remaining a first-class winery but perhaps to even exceed Robert's expectations. His legacy continues to be nurtured at the winery and in the art events still overseen by his wife Margrit Bievier Mondavi. He and Margrit gave us the bigger picture of wine by bringing together chefs, food and wine pairing events, and the serenades of summer concerts. Through their passion for life, we have learned how wine enhances and celebrates all of life.

What Makes Our Own Lives Legendary

It is 10 am. The winemaker has opened a huge two-foot wide black book and is readying to taste his first wine of the morning. It seems a bit too early to taste wine; to swirl and sip wine sounds a little extreme to me, nonetheless I sit with him swirling my own glass. The white wine is crisp, clean; my untrained nose notices nothing. The winemaker, with eyes closed, smiles and seems to be very pleased with his creation. A sauvignon blanc, his favorite varietal, becomes a legend among my wine photographs. The first real star of microscopic signatures, seen on pages viii. 7 and 53, it helped launch my photographic career. Sent along with two other wine portraits, it won a prize in the prestigious Nikon Small World competition; chosen from twenty other wine images, it landed on the cover of two wine magazines (*Wines and Vines, Alles Uber Wein*) and opens the chapter on taste in the *Scientific American* book "Molecules".

BELOW:
Rubicon Estate Rubicon 2000

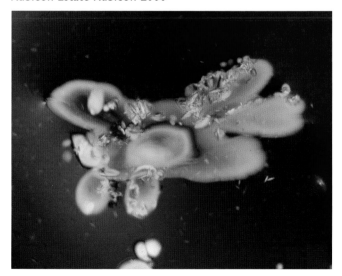

Here's where wine Rorschach steps in

People often say they see in the Sauvignon Blanc a dancer, a lotus, a fairy. I offer some more answers. It's the spirit and signature of the gleeful winemaker. Sometimes I call it Sir Blanc referring to its angular masculine nature. Other times it is Spirit Dancer. It also represents a basic structure in wine, a backbone. Now take a look at the Rubicon, what do you see?

This chapter emphasizes varietals and winery legends of the Napa Valley where my work with wine began. I apologize to the many legendary winemakers in Napa and worldwide who have not been included in this edition. The rest of my years could easily explore further creations. What I add -- the speculation that I could build my own legendary life while making a unique contribution to winegrowing and the experience of life itself, shared and dared!

Science can only take us so far in winemaking and then human artistry and nature step in. As a scientist, who has spent more than three decades in the laboratory, I yearn for answers to the practical meaning of these pictures. As someone touched by the camaraderie, social and sacred rites associated with wine, I can only add that the inner art of wine adds more to the legendary qualities of this amazingly complex beverage. And for some reason, in the legend of my own life I have been pulled time and again to dwell more deeply in this potion. To know wine more intimately, we may know ourselves and the magic of life. ◊

Wine is poetry in a bottle.
– Clifton Fadiman

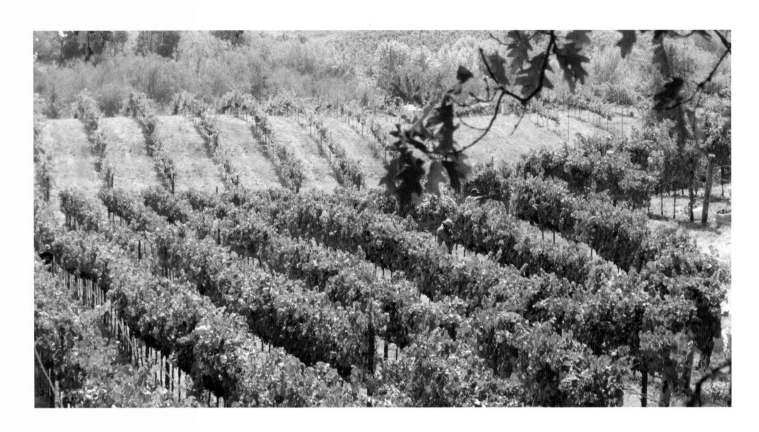

Chapter 5

CULTIVATING WELL-BEING

Wine is so special because it is mankind's one source of comfort and courage, his only medicine and antiseptic, his one resource to renew his tired spirits and lift him above his weary saddened self.

– Hugh Johnson ~ *The Story of Wine*

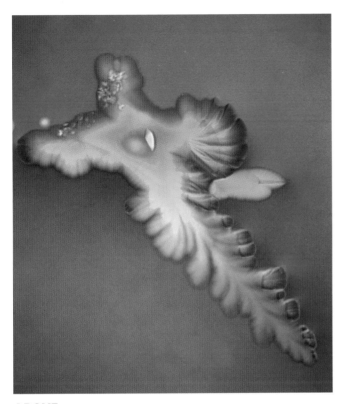

ABOVE:
1978 Merlot, Sterling

Hospitality Not Hospital

My journey into the life of wine began in a hospital where I "lived" at my lab studying deadly diseases. I was more intimate with cells than with people, my everyday relationships being with grieving families and children who faced death. Burned out, emotionally exhausted, I was spent from the search for the elusive "magic bullet." My leukemia research and slide shows for children with cancer ultimately brought me to the hidden world of wine. I created photomicrographic art from vitamins, minerals, and other substances of life and witnessed the power of the images to initiate a pleasurable or peaceful moment, connection or inspiration.

Before my interview for artist-in-residence at Sterling Vineyards, I peered into, tasted, and photographed one of their wines. That first photograph of merlot secured the prestigious opportunity. I had two years to prepare for the show and "apprentice" to the winery. In addition to discovering the inner beauty of wine, I experienced the welcoming friendship from the people behind the scenes– the winemakers and grape growers, cellar workers, and tasting room staff. Soon I learned that hospitality was a lot better than hospital. I fell in love: with the whole process, the smell of the cellar, vines dancing on the hillside, the people, and of course, the spirited elixir in the wine glass.

This chapter embraces three perspectives: medical science that explores data, mindbody and molecular factors for health; lifestyle factors of human choices, connection and spiritual comfort; and the heart of romance. Wine for generations has been associated with living the good life. Now we will learn that the good life is a healthy one. Life-saving antioxidants and

ABOVE:
Cabernet franc grapes

ABOVE:
Food in market

relaxation-inducing molecules in wine, the sustainable cultivation of the vineyard, savoring moments together with friends, family, and community all add to creating well-being. We can cultivate lifestyle choices, just as we cultivate a vineyard for the most flavorful vitality.

When I stopped doing laboratory research to search for what contributed to health and healing, I began teaching health professionals and patients what I was learning – lifestyle factors that enhance and support our daily quality of life. I taught the growing body of scientific evidence underlying lifestyle medicine along with practical skills for reducing stress – relaxation techniques, meditation, and imagery.

What is Well-being?

The World Health Organization (WHO), the health agency of the United Nations, defines health as a state of complete physical, mental and social well-being, not merely the absence of disease. WHO's

goal is the attainment of the highest possible level of health for all people. I prefer the word *well-being* to health. A state of well-being integrates body, mind, and spirit; someone may be ill, yet enjoy a state of well-being. Wine can contribute to every level of being well with the exception of those who are yeast sensitive or alcohol intolerant.

Wine helps lower our risks for many illnesses. It relaxes us, makes us friendlier, more social, jovial, and more likely to have a good time. We laugh more and talk more. When we drink in moderation, we feel a whole lot better about life and ourselves.

Beyond the French Paradox

The better cardiovascular health among the French people compared to Americans has been a puzzle. Even though the French eat a lot more saturated fat (meat, cheese, butter), smoke more, and exercise less, the French have forty percent fewer heart attacks. Initially, drinking red wine was seen as the principal difference. Though a daily glass of wine is an indispensable part of French and Mediterranean life, it is not the only factor that can promote healthier hearts in that area of the world. Their lifestyle also includes other health promoting factors such as eating more fresh food than processed, more fruits and vegetables, spending leisure time with family and friends, sharing relaxing camaraderie. We would do well to emulate such health enhancing practices.

Since I came to wine from medical research and patient care, I have been aware that current investigations show that not only molecules, wine, and food contribute to our health. Our relationships are important. Studies show that people with more social interactions are likely to have better and more years of health. My explanation for the French Paradox is that

the social aspects of sharing wine contribute to well-being, not simply the molecules in wine. One prescription for a 'sick' or broken heart might be, Take two friends out for a glass of wine, some music and call me in the morning.

The simple act of sharing a glass of wine can promote a sense of well-being. A small amount of wine eases tension in our minds and hearts. Alcohol can lift our spirits. Friends can, too.

When do you enjoy wine? Are you typically by yourself or are you with other people before you sip a glass of vino? I rarely drink alone, what about you?

The Heart of Community

Heart disease, the number one killer in the United States, may not only be the result of bad diet, the wrong genes, stress, or little exercise; research shows that emotions, attitudes, and relationships also influence our heart's health.

Dr. Dean Ornish's pioneering research demonstrated that blockages of the coronary arteries could be reversed when people make major lifestyle changes including stress reduction, diet, and participation in support groups. Ornish and others learned that reducing stress and being part of a supportive group might be the most important healing factors. In groups, people often learn to "open their hearts" and explore their strengths and vulnerabilities. Just think how wine facilitates that process.

I was fortunate to be part of a medical team developing this new lifestyle approach for people with heart disease. It required an eight week commitment, prescribed exercise, meditation, ten percent fat intake, shared meals, and a support group.

ABOVE:
Sharing wine with friends in Italy

We met twice a week for four hours. Many wanted no part of the group yet the cardiologist in charge, Dr. Mark Wexman, insisted that group participation was a requisite part of the plan. What I found most profound was how quickly close relationships built through this approach. The reluctant forty year old bank president was soon sharing his fears with the retired engineer of eighty. Within a few weeks, the men who wanted no part of the group welcomed that portion of our evenings together. From a scientific perspective, physical risk factors for heart disease improved, as did levels of anxiety and hostility.

Like all good foods, wine, beer and spirits nourish and satisfy the body. What sets them apart is the very direct way in which they touch the mind.

Harold McGee – *On Food and Cooking*

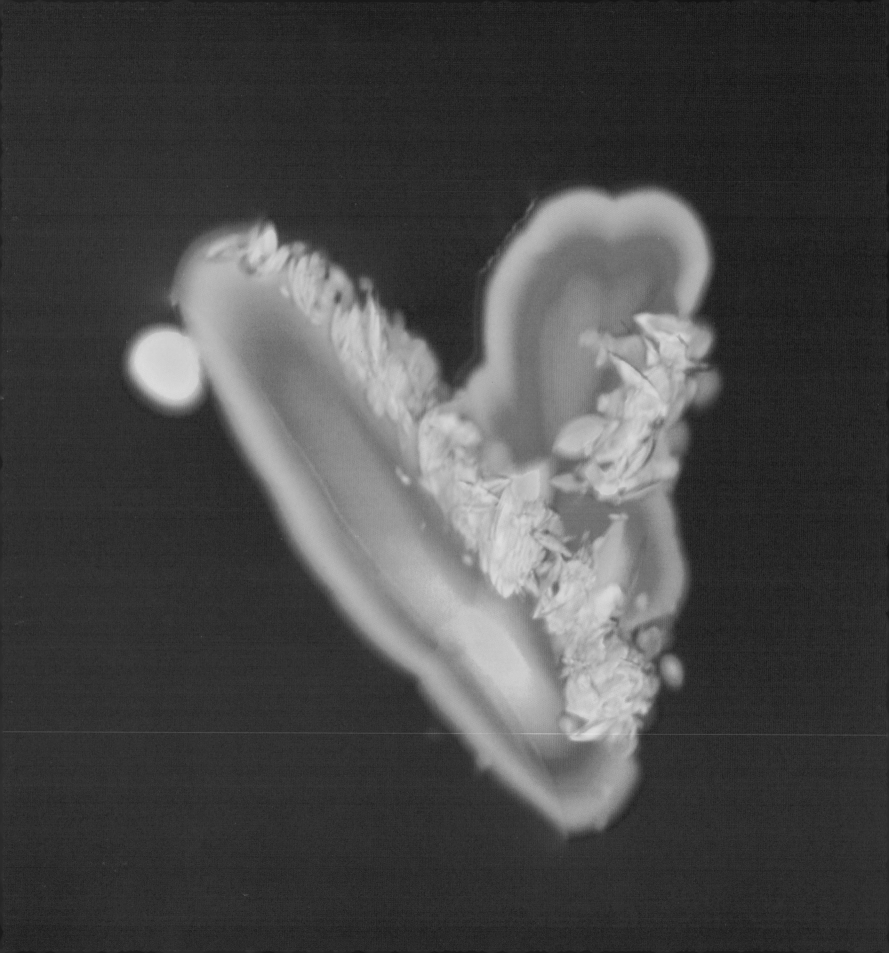

This is the first heart I discovered hidden in wine. Is it a symbol of how the land, vine, and wine were loved? For this wine grapes were grown biodynamically.

Health Benefits of Moderate Wine Consumption

- **Lowers the risk of heart disease and stroke**

- **Lowers the risk of diabetes and ovarian cancer**

- **Lessens the possibility of dementia and Alzheimer's disease**

- **Improves memory and cognitive functions in the elderly**

- **Enhances bone density**

- **Stimulates sensuality**

All the studies of health benefits of wine refer to moderate consumption, which is about one half to two glasses of wine a day, the lower amount for women.

OPPOSITE PAGE:
2001 Quintessa, "Bordeaux blend"

The most publicized chemicals considered as protective factors in red wine are the antioxidants and polyphenols. To understand what they do to help our hearts, let's take a look at what's the latest theory of what causes heart disease. The initiating factor for is inflammation of the blood vessels. In other words, it's not simply the fat in our diets it's the internal environment of our arteries. When we lessen the inflammation of our tissues, damage to our blood vessels diminishes and our risk for other diseases is lowered. Anything that curbs inflammation reduces our risk for a heart attack. Now here's where wine antioxidants and polyphenols come to the rescue.

The skin of the red grape contains antioxidants that hinder inflammation. These same chemicals protect wine from oxidative damage and ensure longer life for red wines. The molecules that protect red wine protect the human heart. No wonder the ancients believed they were pursuing longevity by drinking wine, which they were taking the gods inside. Why else would their spirits lift?

Red wine, tea, chocolate (cacao bean) and highly colored fruit all contain heart-protecting tannins and antioxidants. They lessen inflammation and prevent the oxidation of LDL-cholesterol ("bad" cholesterol). A combination of inflammation and accumulation of oxidized LDL initiates the blocking of blood vessels. For people who don't drink alcohol, red grape juice, blueberries, prunes, dark chocolate, or resveratrol may fill the bill.

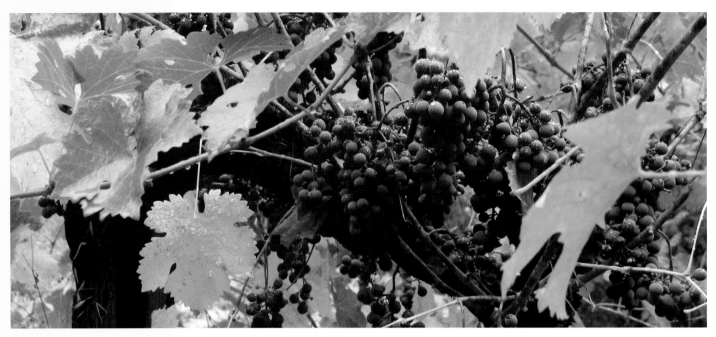

Wine and the Heart, A Molecular Perspective

A glass or two of red wine benefits most of us. In fact, abstinence from wine may actually increase the risk for coronary artery disease (CAD) as shown in dozens of large investigations. One nine-year study of more than 500,000 people reported the risk of dying from any cause was greatest among abstainers and people consuming six or more drinks a day.

One of the virtues of wine is the alcohol itself. When we consume wine, our bodies produce more heart-protecting HDL-cholesterol, the "good cholesterol." HDL latches onto fat in the bloodstream and takes it to the liver to be metabolized. High levels of HDL in our blood help keep the fats away from the vessels. Alcohol also relaxes us, lubricates conversation and human interactions.

Getting on the bandwagon to learn which of the many constituents in red wine could be the "heart medicine," scientists isolated resveratrol from red grapes and wine. The grapevine produces resveratrol to protect against fungal infection. Under experimental conditions, purified resveratrol an antioxidant, inhibits inflammation, reduces blood clot formation, and prolongs the lifespan of obese mice. "There are some fascinating effects of resveratrol in animal systems," notes plant biochemist Alan Crozier of the University of Glasgow. "To get similar doses into humans through red wine, you would have to consume more than 1,000 liters of red wine a day." Hardly health inducing.

Resveratrol, other antioxidants and grape pigments all contribute to wine's health promoting qualities. So does its alcoholic content. Ethyl alcohol, a central nervous system depressant, lowers inhibitions. With our first sips, we feel stimulated, more animated, and excited. It frees our tongue to say words we might not have spoken had our inhibitions not been lowered. Alcohol may relax us by elevating our alpha brain waves. Excessive consumption impairs memory, thinking, concentration, muscle coordination, speech, and vision. Alcohol is also an aphrodisiac and provokes desire. However, too much diminishes a man's ability to act on that desire; though he may be aroused, he can't perform due to diminished penile blood flow.

The degree of intoxication and what is "too much" depends on our body weight, genetics, gender, and the amount of alcohol in our cells. In general, the body can metabolize about ten to fifteen grams of alcohol each hour, which is equivalent to one standard drink every 60-90 minutes. A standard drink contains about 1/2 ounce of ethanol or 200 quintillion molecules.

Researchers are finding many different molecules in wine to be the panacea. Science moves ahead deconstructing wine looking for the one magic ingredient. If you look only for the molecular causes to health you may never examine the human or social benefits.

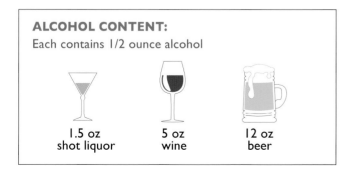

ALCOHOL CONTENT:
Each contains 1/2 ounce alcohol

| 1.5 oz shot liquor | 5 oz wine | 12 oz beer |

Wine and Romance

Whether you are cooking up a romantic meal or dining out, the timeless combination of food and wine provides the perfect modern day spark for an evening of love.

— Andrea Immer Robinson

Though there is no question that wine, in moderation, can be good for our health; it may also be good for our love life. Beyond the scientific perspective of wine's gifts, I was challenged by my editor (BA) to look at the role wine plays in romance. Not being in a romantic relationship at the time I had to reflect back and draw upon other people's insights to enrich this sexy topic.

An insightful discussion with Paul Wagner, wine historian and public relations wiz, president of Balzac Communications, made me reconsider what romance is and what role wine plays.

The supporting role for wine in seduction, sex, and romance begins even before the two people are together. In the hunt for a perfect bottle for the occasion, Paul recommends that the most romantic and wonderful wine is one that will make you both happier, one with which the two of you are comfortable and enjoy. That statement made me cringe when I remembered that my last love always brought wine to share that he'd enjoy. I found little pleasure in the sauvignon blanc he loved. I likely failed to celebrate our time together when I chose a gentle red to educate his palate, a no-no for a romantic gesture.

For a truly romantic gesture, choose wine that is immediately pleasurable to both of you, not one you have to think about, discuss, or convince the other of how good it is. Here's something to consider when you are kindling a new romance. Do you share the same tastes in wine most of the time? Do you bring wine to share that you know only you will enjoy or that the other person will find pleasure in? What does the other person bring to share with you? I speculate that how we choose wine for a romantic interlude may be indicative about the quality of relationship we are nurturing. Part of romance is giving of yourself. What you pour for the other person should reflect your caring and consideration. It is a gift you're giving someone else.

When I asked Paul if there was a perfect romantic wine, he replied, "of course not." He did warn people to stay away from big heavy red wines on a first date.

Your teeth might be blackened, which would be attractive only to Count Dracula. What you want is a sensual wine that is fun to drink.

A romantic evening usually includes a candlelit dinner where the candlelight illuminates the two of you and the rest of the world disappears for a while. You are both in a circle of light focusing on each other. Some of Paul's most romantic meals have been simple picnics on the beach with wine, cheese and sourdough bread, some olives and chocolate.

A romantic occasion is a shared experience, a mutual adventure of pleasure, time to stop and enjoy life together. You are dedicating yourself to the other person. According to Rabbi David White, Executive Director of WineSpirit, when we share a glass of wine, we are brought into the moment, right now. The world stops and we can experience the treasure and pleasure of the gift of the present.

Wine can be a love potion. Love potions have to do with slowing down, relaxing and fully enjoying our senses. And of course, enjoying our senses enhances lovemaking.

In fact, studies in the British journal *Nature*, report that alcoholic beverages enhance libido and sexual desire by raising testosterone levels in both men and women. Moderation is key. More wine won't give you more desire; it will only bring you sleep and you'll miss out on the romantic interlude.

Wine is a shared experience, an opportunity to share a new adventure, to create a sense of intimacy.

— Paul Wagner

Here in the United States, we enjoy wine for seduction, romance, and celebration. However that's not true elsewhere. In Italy and France, where they drink wine regularly, it is not so much an expression of romance or a special occasion; sharing wine is part of everyday life. In the United States, wine is the beverage for special occasions. It takes any meal out of the ordinary, whether a romantic seduction or big family Thanksgiving dinner

Wine is the only beverage made according to the cycles of nature. It represents the Harvest, a time for feasting and celebrating all that nature brings forth. Including love and romance, family, and fun.

The Sensuality of Wine

As we savor the sensuality of wine, our senses are stimulated. Michele Ostrove, editor-in-chief of *Wine Adventure* magazine, says that wine adds flavor to a relationship. We feast our eyes on each other, we stroke the glass, and can't wait to taste — the wine and each other. We breathe and take in the scents of our lover. We are transported with the other to another dimension of life.

Not only can wine enhance romance and our senses, one wine, Pinot Noir, has been considered by some, to be the sexiest wine of all. What sets it apart from all other red wines is its fluid, voluptuous textural "feel" described as succulent, velvety, silky, juicy, sumptuous, and luxurious. Sounds like a beautiful woman or a sexy wine. Oded Shakked, winemaker at

Russian River Valley's J Winery, compares Pinot Noir's juicy texture to "liquid foreplay."

Now it's your turn. What do you consider a romantic moment, how does wine add to the experience? Are some wines sexier than others? Can you remember your most sensual encounter with wine?

The Bigger Romance, Sustainability

Now that we've enjoyed the pleasure of a glass or two of wine with another, how does our love of wine enhance the health of the vineyard and the planet?

Without getting lost in the myriad details of organics or biodynamics, I see that wineries are paying greater attention to their relationship with the land and the people who work it. The need to heal the soil, so damaged from years of chemicals and pesticides, has pushed winemakers to look for better ways to ensure that the soil stay fertile and productive for

years, not just the coming season. Paul Dolan, president of the Wine Institute and former president of Fetzer Vineyards, when guiding Fetzer to become organic, believed he was helping, not only the bottom line of the winery, but also the health of those who worked in the vineyards.

Grapes and wine are going organic because of the growing concern that the continued use of dangerous pesticides depletes the soil as well as damages the health of both the workers and creatures that help to balance life in the vineyards. Cynics say it's only because "organic" has become a financially attractive label. Yet more vineyards, at great financial costs, are becoming sustainable and avoiding pesticides and chemical fertilizers costly to the environment. However you may see no indication of viticulture changes on the bottle of wine. Some winemakers don't acknowledge their organic practices in print because of past bad reputation of wines made unconventionally. Those that do will show on a wine label – either that the wine is 'organic wine' or 'made with organic grapes.' Both require organically grown grapes.

Organic Wines are Rare

To qualify for organic certification, a vineyard must be free of all chemical pesticides, fungicides, and fertilizers for at least three years. Since the certification process is time consuming and expensive, many organic growers change viticulture strategies but don't get certified.

In California, organic certified grape growers are allowed to use some botanicals to control insect infestation, powdered sulfur and copper sulfate to prevent mildew, and organic green manures, organic composts, rock mineral soil enhancements and seaweed extracts. To be certified by the largest organization, California Certified Organic Farmers (CCOF), ground cover crops must be planted between rows of vines, the seeds for which must be certified organic. As of 2006, more than 8000 vineyard acres in California had been certified organic. In 1989 the US had only 200 acres. The label on the bottle can say, "made with organically grown grapes." A list of wineries using organic grapes is in the Resource section. Many European wines are made from certified organic grapes, but the USDA doesn't recognize European certification. European wineries certify only the vine growing practices for organic wines, not the subsequent winemaking practices. Organic viticulture, in the long term, heals the soil, environment, and creates a better future for all involved with the wine industry, as well as those living near or in the vineyards. World-wide, organic acreage continues to grow.

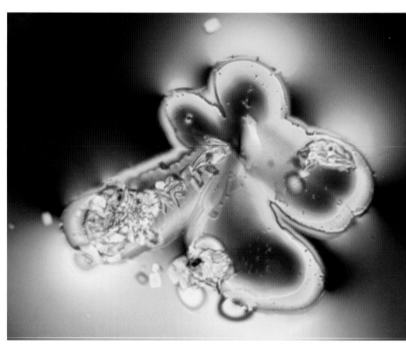

ABOVE:
1997 F.E Trimbach Riesling (made from organically grown biodynamic grapes

Organically grown grapes do not mean organic wine. For a wine to be certified organic,: a slew of additional standards must be met. All the cleaning procedures in the cellar and the gondolas carrying the grapes to the winery must comply with organic standards. If grapes are brought to the winery in gondolas, the trucking company must produce affidavits as to how the gondolas were cleaned between loads. How every pump and hose in the winery is cleansed must be documented. If egg whites are used for fining the wine, the eggs must be certified organic. You can see why labels may just say made with organic grapes rather than organic wine. The biggest difference between organic wines and wines made with organic grapes - SULFITES.

Sulfites & Organic Wine

Many wineries comply with all requirements for organic certification except one – the addition of a small amount of sulfite to the wine just before it is bottled. Sulfites, in the form of sulfur dioxide, prevent spoilage by thwarting the growth of mold and bacteria.

As early as 100 BC, Roman winemakers discovered that burning sulfur wicks inside their barrels helped prevent wine from spoiling. In the sixteenth century, Dutch traders learned that only the wine treated with sulfur could survive long sea voyages without turning to vinegar. Hence, sulfite additions became a universal tool in winemaking. Modern winemakers, except those making certified organic wine, may add sulfites (in the form of potassium metabisulfite or sulfur dioxide gas) immediately after crushing the grapes, when wine is put into barrels for aging, and just before bottling. Adding sulfite right before bottling is a not allowed for organic wine; if sulfite is added, the label can declare only that the wine is made from organic grapes. "Wines without sulfites are on a fast track," says Bob

Blue, winemaker at Bonterra Vineyards in Hopland. "They taste old quickly."

There is no such thing as a 'sulfite-free' wine since yeasts naturally produce some sulfites during fermentation. The FDA allows a winery to put on its label "no sulfites wine" if the wine contains less than 10 ppm (parts per million). Although the legal limit in wine is 350 ppm, most wines with added sulfites generally contain only 25-150 ppm. Wines made without added sulfites are very perishable and need to be stored in the refrigerator, even the reds. Katrina Frey of Frey Vineyards, one of the few wineries making certified organic wine, recommends that people drink their white wines within one year after bottling and finish an open bottle of white wine within a day. Their red wines last only five to eight years. Winemakers admit the fragility of wines made without added sulfites and state that they are an acquired taste.

The Politics of Sulfites

Zealous anti-alcohol activists convinced the FDA and the wary consumer that sulfites in wine were dangerous. This pressured the FDA to begin enforcing the labeling 'contains sulfites' on every bottle of wine made or imported in the US after 1986. Ironically, foods such as raisins, soy sauce, pickles, and fruit juices contain ten times more sulfites than wine and don't require such a label. The anti-alcohol lobby only sees the problems with alcohol consumption, not the benefits.

If you thought sulfites in wine gave you headaches, yet can eat dried fruit without a problem, it's not the sulfites in wine causing the headache. With all the attention given to supposed sulfite sensitivity, it is estimated that only 0.25% people living in North America have serious sulfite allergies. People who claim they get headaches from sulfites in red wine, but not white, are likely getting headaches from alcohol,

histamine, or other substances in the wine, not sulfites. In fact, white wines contain substantially greater sulfite concentration than red, since they lack the pigments and antioxidants that protect from deterioration. Dr. Curtis Ellison recommends people who get headaches from wine drink less and take 400 mg ibuprofen thirty minutes before imbibing.

Cosmic Grapes?
Biodynamics

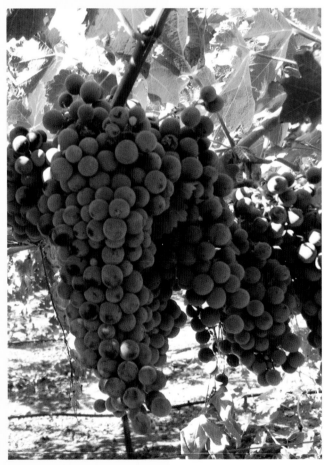

Some viticulturists and winemakers are taking organics a step further, to biodynamics. A biodynamic vineyard or farm is **organic plus.** Biodynamic agriculture, conceived in the 1920s by Austrian philosopher and scientist Rudolf Steiner (founder of Waldorf Schools), focuses on the "living soil," environmental influences, etheric and cosmic forces. Steiner, like ancient and modern Taoists and indigenous peoples, believed that all life on earth is connected to, and influenced by, the cosmos. Some biodynamic practices are similar to recommendations for planting and harvest in the *Farmers Almanac.* Cultivation and harvest are done according to phases of the moon. With biodynamics, growers attune to nature, the elements, cosmos, and the land. A diversity of life in the farm or vineyard is essential. Plants are grown to attract bees and butterflies. Animals graze the weeds and supply organic manure for compost. Biodynamic farming has flourished in Europe for decades where farmers had nothing to do with the chemical approach to agriculture used here in the United States.

Critics of biodynamics focus on the unusual practices, especially cow horns filled with manure buried at the spring equinox from which is made a very dilute potion to be sprayed on the leaves of the grapevines at the autumn equinox. Ivo Jermanez, vice president of winemaking at Grgich Hills, told me that once he saw the difference in the vineyards sprayed with these "weird concoctions," there was no turning back.

In the world of wine, a growing number of respected viticulturists who've converted to biodynamic vineyards claim their vines are healthier and more resistant to disease, the soil is more alive, and that their wines show more character. By building up the soil in the vineyard with biodynamic practices they are making wines considered to be more flavorful and better expressions of terroir.

Jim Fetzer's Vision

Not yet convinced that better wines were made with biodynamic grapes, I headed out to Jim Fetzer's incredibly beautiful "winery on a lake" for another glimpse of what makes a biodynamic winery special. Was I in for a treat. First of all, key to biodynamic principles is diversity of life – animals in the vineyard, cover crops, and a variety of plants growing nearby. Until I visited Jim's Ceago Vinegarden in Lake County, most biodynamic vineyards I had visited previously appeared more monoculture.

Jim Fetzer, Owner and President of Ceago Vinegarden, and former President of Fetzer Vineyards, grew up with his ten brothers and sisters in the vineyards of Mendocino county. Together the family developed Fetzer Vineyards into an internationally recognized and respected winery leading the United States wine industry in organic farming and ecological business practices. The Fetzers were, and are a farming family. They have always been on the forefront of environmental efforts, beginning in the mid-1980s with their demonstration organic garden at Hopland in Mendocino County and continuing through the development of the McNab Ranch dedicated to biodynamic and sustainable farming.

In 1992, the eleven Fetzer siblings sold the Fetzer Vineyards brand to Brown-Forman for a reported $80 million. As part of the agreement, they were prohibited from making any kind of beverage for sale -- from wine to apple juice -- for eight years. Plus they could never use their own name. In the meantime, as they waited until the year 2000 to make wine again, they worked on perfecting grape growing.

Soon after the non-competition agreement expired, four of the Fetzer siblings launched their own wineries. The largest is Jim's Ceago Vinegarden.

ABOVE:
Jim Fetzer

Patti Fetzer Burke owns Patianna Organic Vineyards in Mendocino County; John owns Saracina winery, while Dan, the youngest, produces wine under the name Jeriko Estates. Patti's sauvignon blanc is a classic and Jeriko's sangiovese is a wine to look for. Jeriko made our nation's first sparkling wine from certified organic grapes.

After meeting many of the Fetzer clan who were supporting the Mendocino Film Festival I truly fell in love with biodynamic wines. Later I went to Lake County to interview Jim to learn what inspired him towards biodynamic growing. For him, it began with Alan Chadwick, the 'father' of French intensive biodynamic farming in the United States. Jim saw the incredible gardens at Covelo, California developed by Chadwick, and decided to go organic and then biodynamic. Interestingly, three decades ago I apprenticed with one of Alan Chadwick's students because I had been enchanted by his biodynamic garden. That was long before my wine days, and at the time my idea of a garden was a potted plant that lived.

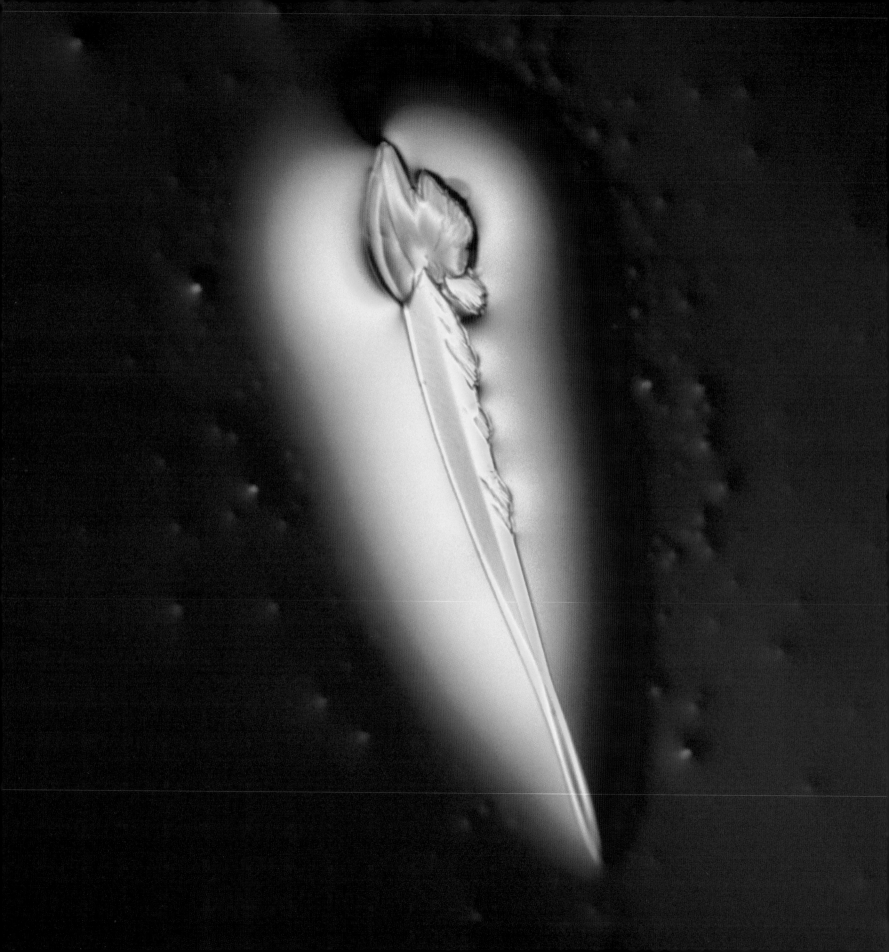

Jim related the changing growing practices of their vineyards. "In the beginning we were pretty natural at Fetzer (launched in 1968). I remember growing up in a vineyard filled with meadowlarks and spiders. Occasionally you'd find a snake wrapped around the vines; there was mustard and cover crops. It was so vibrant with life. We had horses and cows, pears, grapes, alfalfa fields, and sheep. My mom made butter, cheese, bread and all that. This was a full-on farm, which was basically biodynamic. When we began developing the ranch, we started tearing out the alfalfa and got rid of the sheep. We became more monoculture, planting only vineyards and began using chemicals. Soon we saw problems in the soil and vines. The birds and other life in the vineyard were gone.

"That's when we started paying attention to Chadwick's principles of farming, which led us back to organic gardening. When Michael Maltis became involved, he told us that grapes were the easiest crop to grow organically. Soon all of our vineyards were converted to organic farming. By the time we sold the Fetzer Vineyards, we had 2000 acres organically certified by CCOF. That's when Bob and I started working more closely with Michael in our vineyard."

Jim and his brother Bob experimented comparing organic vs. biodynamic growing. After one year, all of McNab Ranch was converted to biodynamics because they saw huge differences in qualities and aromas of the soil, as well as how the plants responded.

Is organic or biodynamics a marketing gimmick? According to Jim Fetzer, at that time there were a lot of wines labeled organic by default because they didn't do anything. The wines were pretty poor so they decided to position themselves out of the organic segment, and go up a notch to biodynamic, which seemed like more serious farming. So, it was both a marketing ploy and a continued commitment to a high-level green and sustainable winery.

It is more labor intensive and more costly. Additional equipment is needed - like stirring machines and machines for application of the biodynamic preparations. Compost piles have to be built. However, another benefit of biodynamics, it helps you better understand the plants. Jim believes a grape grower's job becomes more efficient when utilizing the forces of nature, working with them, instead of fighting them.

Jim's commitment to sustainability goes beyond grapes, and includes family. All three of his children work at Ceago. Instead of resting on his laurels, and whatever millions he received after selling Fetzer Vineyards, he's building a whole new destination winery because his children wanted the winegrowing and hospitality life to share in. And they love working together.

What brought Jim Fetzer to Lake County was the fact that it was far from the crowds of Napa and Sonoma; it was a fun spot without fog in the summer. At 1400 feet, they're perched on a high mountain lake with the cleanest air of any county in California.

When the interview was over, Jim generously gave me an insider's tour of the entire Vinegarden - the lavender fields, the recycled palm trees and 100 year-old olive trees, the chickens and the sheep, the bat box. He walked me out to the pier and showed me bass jumping in the lake. They are the only winery in the country with boat, kayak, and floatplane access. He showed me the biodynamic room, a tower kept cold that held all the biodynamic preparations. It felt like a mysterious alchemist's chamber of secrets. He has another one where they distill essential oils. They press olive oil, sheer sheep, and gather chicken eggs, an amazing operation. Talk about sustainable and organic.

OPPOSITE PAGE:
Patianna Organic Vineyards certified biodynamic Sauvignon Blanc

Ceago Vinegarden is a most sensual experience. The sun glistens on the lake lighting up the Mediterranean villa-like structures that comprise the Vinegarden. It is not called a winery since there is no winery there! Though most of the vineyards, farm, tasting room, lavender fields, and all the animals that make biodynamics so abundant are at Ceago, the wine is made in nearby Redwood Valley. The environmentally approved plans for Ceago Vinegarden include a green resort, spa, restaurant and housing. If you visit in May or June, fragrant lavender fields teeming with bees and butterflies dancing above the blossoms will delight you.

Not only is the place a glorious way to spend the day, you can support high level organic farming. You may purchase olive oil from their 100 year old olive trees, essential oils and hydrosols distilled from their lavender, enjoy seasonal products in their café and of course, imbibe some of the finest biodynamic wines around. Be sure to check out their Rosé, not just another pink wine. To sum it up, this is doing life without aggravation, says Jim Fetzer.

ABOVE:
Mike Benziger

Mike Benziger– the Spirit of the Land

Mike Benziger is another gracious biodynamic winemaker, whose love for the spirit of the land is strikingly evident in how he cares for, and talks about it. Our meeting at the Benziger Family Winery imbued me with an even greater appreciation for people who embrace biodynamic viticulture.

We start with the vineyards driving to the top of the estate. The vineyards growing in a 360 degree bowl create an encircling sanctuary of vines. Long before grapes graced this property, the Wappo Indians performed sacred rituals here. From this vantage point we look on one of the many wildlife sanctuaries planted to attract beneficial insects and birds.

Mike spoke about why biodynamics was his choice. At first, like others, he started growing vines conventionally with chemical fertilizers and toxic

ABOVE:
Ceago lavender field

pesticides. His observations were much like Jim Fetzer's, in that he saw that life in the vineyard was disappearing, no insects, few birds. Something had to be done to remedy this loss of life and vitality.

Enter Alan York, a student of Alan Chadwick's. York, a well-respected biodynamic horticulturist, grew a variety of plants before venturing into growing grapevines biodynamically for his first client, Jim Fetzer. York convinced Mike that biodynamics was the best way to heal and replenish the earth. He also considered biodynamics the best way to bring out a sense of place in the grapes. At this visit I learn why.

A biodynamic vineyard is a biodiverse organism; it is a farm that celebrates Gaia and honors the living Earth.

A closed, self-sustaining system of nutrients, it fosters a profound sense of place. No wonder terroir can emerge from wines made from biodynamically grown grapes. Cows eat the grasses on the land; their 'leavings' are composted with other plant waste from the area, and fed back to the earth as compost tea. Sheep, the vineyard's mowers, eliminate weeds between the vines, and doing their prancey dance, loosen and aerate the soil. Their droppings add to the soil's rich nutrients. All nourishment - from the soil, compost, insects and animals - is cultivated on the same land. Nothing comes from outside this terrain to sustain the vines, so that the essence of place is strengthened each season. Just consider how different this is from other ways of growing wine.

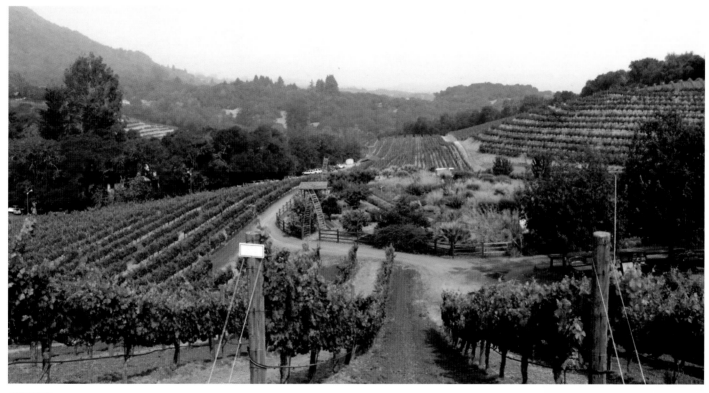

ABOVE:
Benziger Family Estate

All water is recycled through beautifully constructed wetlands. The used water flows by gravity and is aerated before it flows into the adjoining clean pool. The clean pool is covered with a beneficial organism to protect the water below. Mike considers this the kidneys of the land.

Biodynamics focuses on connections and life force. Is life force the same as soul, I ask Mike. To him, life force seems larger, more inclusive; it is the evolutionary, organizing integrative force. It is potential. Our human mission is to manifest the potential of our neighbors, the planet, and ourselves. Sounds like my definition of our soul's mission, to manifest purpose.

Mike's perspective is that on this Earth we share such potential and intelligence with plants and other animals. I became acutely aware of plant intelligence when he reminds me, that the day after the summer solstice, plants "know" there is less light than the day before; now they need to put their energy into ripening the berries rather than creating leaves. Plants, our teachers, carry the wisdom of life and cosmic forces.

Plants, and our cosmic connections, always astound me. They, along with some microscopic algae, are the only self-sufficient organisms on this planet. Just think, plants can't move or go shopping. They depend on the nutrients and water in the soil, the carbon dioxide in the air, and the energy of the sun to manufacture everything they need to sustain their life, and ours. They depend upon Place. We depend on them for survival. Mike's underlying sense of the sacred offers a compelling view of a vineyard, one that cares for us. In wines made from biodynamic grapes, he is bottling the incredible environment that surrounds, and is included in their grapes. The elements of nature — earth, fire, air and water — are revealed in the spirit of the wines. Ancient symbols

for these elements are displayed on the fence that encloses the Scottish Highlander cows, another essential life force at the estate.

We next visit the 'medicine house' where the biodynamic preparations are made. The cow horns filled with manure gets the most attention from the press, yet what was once cow poop turns into a rich, granular nutritive medium after being buried in these cow horns for six months. A special ritual is done at the equinoxes to honor this practice of generating life force for the vines.

Mike Benziger senses his world as sacred. He speaks passionately about intentionality, of elemental design, and connectedness in nature. "Biodynamic vine-growing fosters connections. It connects you to the land through the vines, the cosmos through the sunshine, to people through the creation and enjoyment of the wine. It connects us to the spirit that lives in our vines and wines."

BELOW:
Benziger medicine house - cow horns

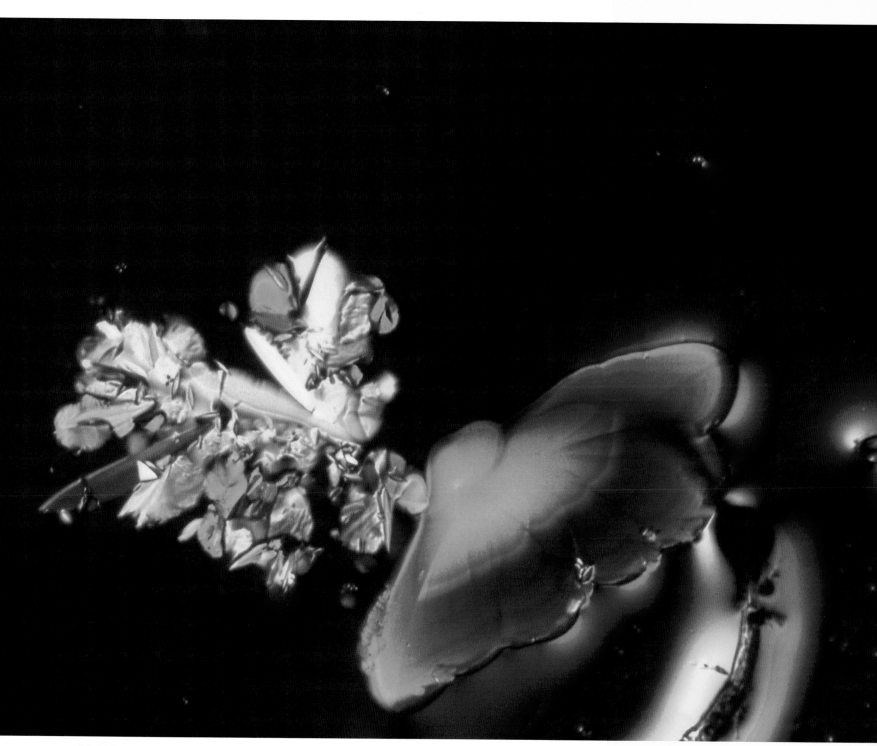

ABOVE:
2000 Chateau La Mondotte

In California, Ceago, Patianna, Sinskey, Benziger, Grgich Hills, Quintessa, Phelps and Araujo are just a few of the growing number of American wineries making outstanding biodynamic wines. As of 2006 Grgich Hills had the largest acreage in California devoted to biodynamic grapes. There are now more than 300 wineries worldwide that are using biodynamic practices. In Europe they've been doing it a lot longer.

In France, biodynamics is practiced on small estates, and by a number of large prestigious wine companies. The largest biodynamic wine-producing firm is Chapoutier, based in the Northern Rhone village of Tain-L'Hermitage. The Chapoutier brothers, Michel and Marc, chose the biodynamic route in 1988. Not only does organic and biodynamic growing improve the soil, many converts are convinced that biodynamics wines are more evocative of the place they're grown. They express terroir, or the soul of the place. Not a passing fad, consider that wineries that have switched to biodynamics include some of the most significant European wine producers such as Clos de la Coulée de Serrant, Domaines Leroy, Leflaive and Comtes Lafon in Burgundy, Chateau La Mondotte in Bordeaux, Dominio de Pingus in Spain, and Alsace's F.E. Trimbach and Zind-Humbrecht. An impressive list of organic and biodynamic wineries is in the Resources.

To return to our theme of the soul and heart of wine, I was surprised to discover when the World of Fine Wine Magazine chose images for an article I was writing for them, three of the pictures were of biodynamic wines, a fact I had not known until after the article was published. I knew Quintessa was biodynamic, but not the European wines since their bottles typically are not labeled as biodynamic. Is it a coincidence that those three biodynamic wines, "grown with intentional connection" all revealed a hidden heart?

Cultivating Health

Cultivating grapes and wine fulfills an important model for agriculture and human health. When we pay attention to the consequences of our actions, in the vineyard and in ourselves, we make profound contributions to the future of our planet.

Caring for the soil, protecting those whose daily labor secures a healthy crop, working with nature, we open our hearts to the greater purpose of the grape, to ensure survival of life. The health of the Earth is in question. Global warming has already had an impact on wine growing regions. Dr. Gregory Jones at Southern Oregon University tracked weather changes over the last fifty years, noting an increase of two degrees Fahrenheit. Doesn't sound like much, but it's already influenced vintages and climate variability. He and his colleagues are predicting that if the trend continues in the next 50 years, cool climates will be the best wine growing regions. Think English cabernet, Alaskan chardonnay. The present warm growing wine regions may no longer exist.

Another topical environmental issue is how to stopper the wine bottles. The only sustainable closure is natural cork. Trees are not cut down to harvest cork; only the outer bark is stripped off. The lifespan of a cork oak tree is about 200 years, which provides twenty harvests and a biodiverse environment for critters and plants. The main issues around using cork are its expense and risk of "cork taint." If you've ever had a corked bottle you know what I'm talking about – a musty barnyard smell coming from a moldy cork. Yet consumers prefer cork to alternative stoppers even though unscrewing a cap is a lot easier than popping a cork. Who cares?

OPPOSITE:
Ceago Vinegarden Cabernet Franc
(Demeter certified biodynamic)

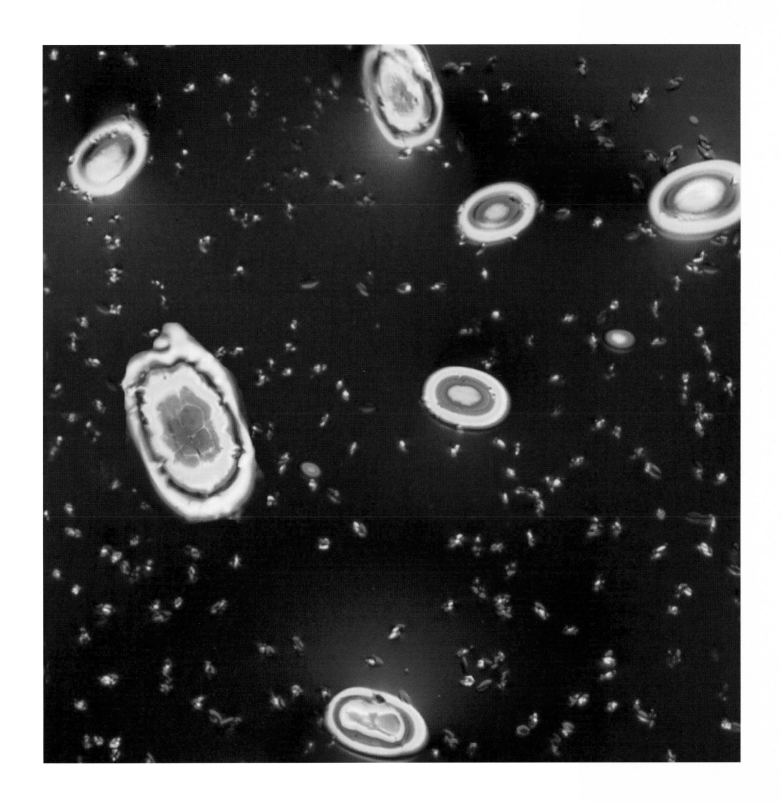

It's part of the mystique of wine. So concerned about losing its cork forests if the wine industry moves to screw caps, the Spanish government has outlawed the use of alternative stoppers in its top wine growing areas. The cork debate could fill a book, and has. Sure, there's money and mold to think about when a winery makes the closure decision. We, as consumers, can talk with our pocket books and buy wines that support the health of the environment. And so far, from all the surveys taken, we prefer cork. How wine is packaged is the next frontier – will it be synthetics, screw caps, those squeezable tetra-packs, or edible containers? *Time will tell.*

Survival: Our Own and the Earth's

And so we end as we began this chapter, to recognize that one of the functions of wine is to create healthy relationships. Those who are part of growing and making wine recognize that relationships make it all happen. A healthier way of cultivating the vines and nurturing the land provides better health for the creatures living there and enjoying the riches of the vineyard. Even how wine is bottled and closed influences survival. The choice is ours how we contribute to the planet of the grapes. ◊

RIGHT:
Cork tree

Chapter 6

THE SPIRIT OF THE GRAPE

I learned that Dionysus was the god originally responsible for the marriage of people and plants . . .Wine itself is a peculiarly liminal substance poised on the edge of nature and culture as well as civility and abandon. It is truly an extraordinary thing, this artful transformation of raw nature – a fruit! into a substance with the power to alter human perception.

– Michael Pollan –*The Botany of Desire*

Have you ever wondered why the grape is the only fruit that gives us elixirs so heavenly they are called divine? Why not kiwi or pineapple, apple or date wines? What is so unique about the grape that it has had a cult like following since ancient times?

The grape and wine share a history with civilization

that may seem coincidental, but is it? Wine has had a place in our history almost as long as humans. As we began to cultivate the grapevine, economies developed and wine quality improved. Now wines are given numerical scores as to their greatness. Yet is it a numerical score that tells us the true greatness of the wine experience?

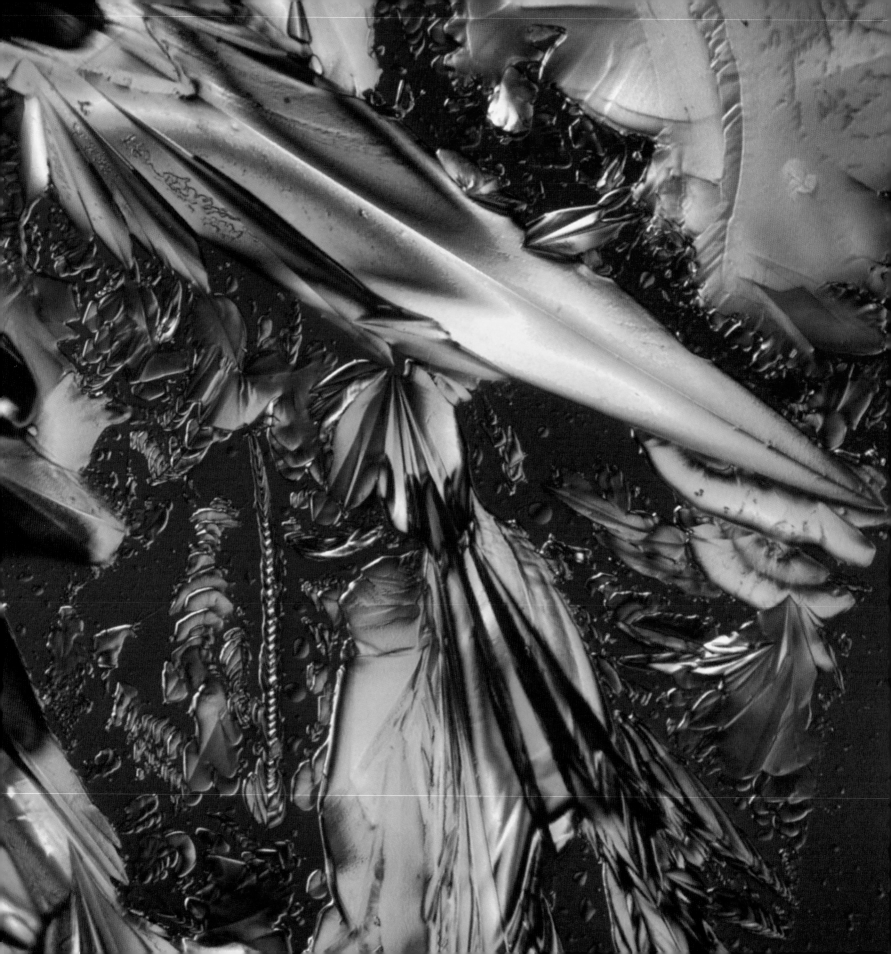

Why the Grape?
Molecular Legacies

What is so unique about the grape that it is the only fruit used to craft vintage wines called 'bottled poetry?' One of the answers relates to its chemistry, another to its elemental nature and spiritual purpose.

First a grape's uniqueness depends on its tangible chemical properties:

Only the grape
contains tartaric acid.

Unlike all other fruit, grapes
do not contain starch.

Grapes' molecular repertoire is ideal for becoming wine. It has lots of sugar and water to make a potent alcoholic libation. When the skins marinate in this libation, layers of luscious pigment and tingly tannins leak out. Skins and seeds supply molecules that provide for greater structure, complexity, color and the ability to age. The spirit of the land, people, winds and sun, its ease or struggle to grow shapes the grape's chemistry, as do its inherited tendencies for flavor, intensity and personality. It is not simply molecules that make wine divine.

Grapes have a spiritual
purpose to fulfill.

OPPOSITE PAGE:

Tartaric Acid

Spiritual Purpose
of the Grape

In the best-selling book *The Botany of Desire,* Michael Pollan lyrically describes relationships between humans and plants, from a plant's point of view. Pollan posits that plants have a purpose; that the purpose of the apple, tulip, potato and marijuana is to fulfill human desires that would, of course, encourage human intervention. The 'collaboration' between the needs of plant and human moved forward the destiny of both.

The grapevine, one of Earth's earliest fruit-bearing plants, took root where human civilization began, more than 8000 years ago. To ensure the survival of her offspring, Grape had to offer the nearby population of creatures something they couldn't do without. Grape made itself so tantalizing it ensured continued cultivation by the humans that followed her arrival on the planet. "Plant me," she insists, and witness the vast acreage around the world of about 20 million acres saved for the sole cultivation of her roots.

Let's suppose that the grape's purpose is to make humans happy and, by keeping these creatures happy, the planet Earth is protected, a bit. Think about it. Starting as wee kidlets we love sucking on a sweet juicy grape, licking grape jam on our toast or grape popsicles that make our tongues purple. Next we graduate to hand held snacks - raisins, those yummy sweet dried old grape remains, chock full of iron and other mineral goodies. When we discover the kick of champagne or being made giddy from a glass of wine, the divine vine comes into the picture. Our desire to feel this way begins our deal-making with the grape.

If the purpose of the grape is to ensure the health and happiness of the human creatures they share the planet with, what can the grape do to guarantee that happens?

The Mythic Grape: How the Grape Grew Her Powers

Once upon a time, all the plants had a talk about which would be the fairest in the land and which one would become the Green Ruler of the planet. Grape won, hands or roots down. She made the best promises. "I will bring sweet juices. I will be the source of spirited liquid that will ease pain and suffering of others living on the planet with us. I will spread joy by spreading my vines all over the Earth to ensure the survival of a growing kingdom."

Look around at the power of the grape. What other plant has captivated attention of most cultures around the world? We don't have too many romantic tales about potatoes, yet grapes have starred in many films: The Grapes of Wrath, Under the Tuscan Sun, Ten Commandments. In Sideways, the pinot noir grape seduces the hero; can you imagine being seduced by the popular pea, the lentil or Brussels sprouts? Has any special grape captivated your attention?

The grape is the smartest plant of all.

Put me in the place where I must struggle to get my hold on life. Once I am rooted into the heart of the Earth I will bring back the spirit and love you put into me.

- Grape Translations

LEFT:

Grapes as Raisins, featured in Films and made into jams

The grape helps us to enjoy life provided we help her take over vast acreages worldwide. No wonder every culture finds blessings in her offerings from grape to vine, to wine, to seeds and oil.

Was the grape sanctified to help impart a spiritual connection between plants and the human kingdom? From the time of our earliest ancestors, wine has served as a glorious celebration of the riches of harvest, a symbol that life is good. The gods love us.

Like the sacred buffalo for Native Americans, every part of the grape and vine can be enjoyed. No part wasted. We fill her green leaves with tantalizing tidbits; her vines warm us when they are no longer able to produce grapes. And oh, her grapes, sweet and succulent for the table, shriveled as raisins, or transformed into the vinous libation with which we celebrate life. A toast to the mighty grape!

The Grape Escape

In the early days of wine, our ancestors discovered this mysterious liquid eased their troubled minds and lightened their hearts and spirits. The alcoholic potion blurred boundaries from everyday reality to something more. Wine, with its ability to intoxicate and engender a sense of "other-worldliness," provided opportunities for people to come into contact with their gods. When we share a bottle of wine or a clink of the glass, we may engender a sacred moment. To give gratitude, enjoy, share and reach into another's soul, 'tis the spiritual purpose of wine. In the cultural history of almost every society, wine has played an important part in family and religious gatherings, celebrations of victory, the harvest, life and death, and changing consciousness.

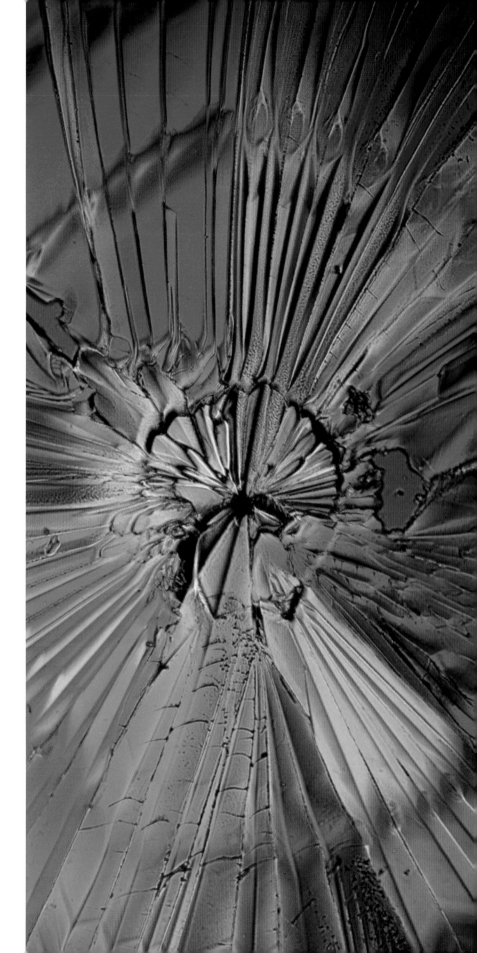

RIGHT:
Frangelico Liqueur

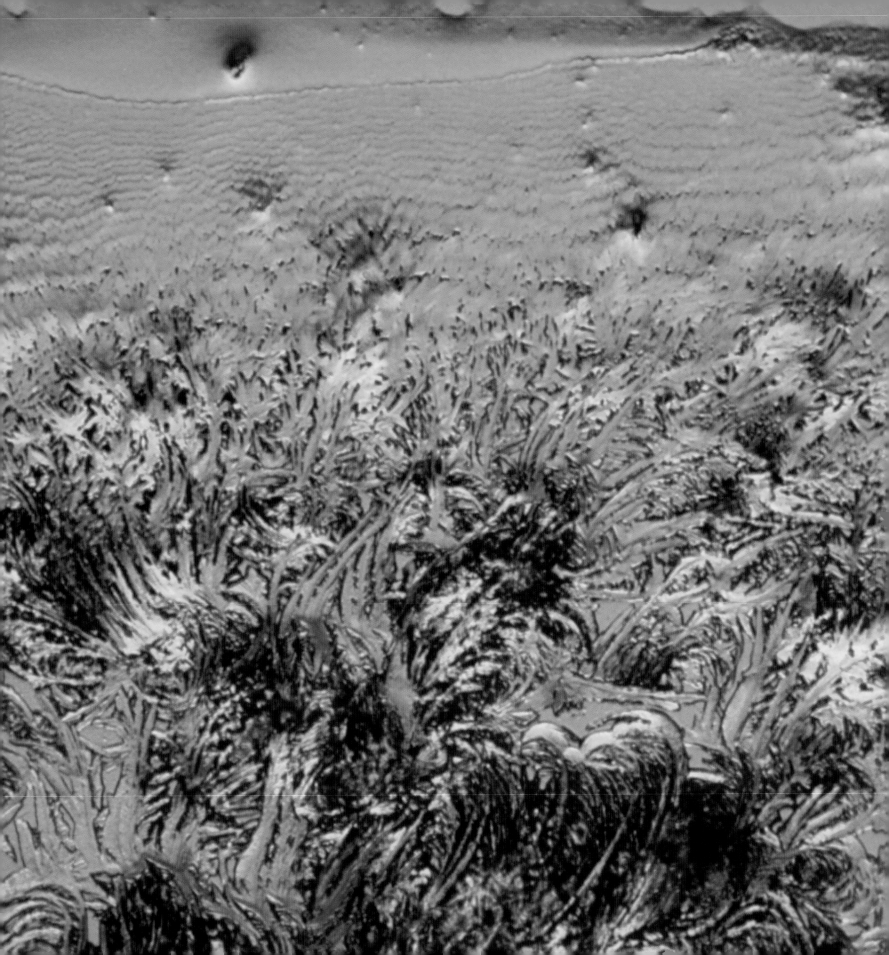

Intoxication

Humans have always used plants and their brews to lessen pain or alter their mood. Through trial and error, they discovered plants that could kill or heal. One plant could calm, another stimulate, and others alter every day reality. Every human society, with the exception of the Eskimos, has explored indigenous psychoactive plants. Eskimos have their psychoactive experience with mushrooms or fungus. More than 4000 plants from nutmeg, cannabis, peyote to coffee and tobacco contain psychoactive substances that can alter mind, mood, and energy. Some are so powerful in their consciousness bending and mind altering effects that they are taken only as part of a special sacred ritual. In the 1960s, people began experimenting with the hallucinogenic drug LSD. They did it, in part, to "get high" yet also to discover other realities. For many, LSD opened people to spirituality.

Early on, alcohol from fermented fruit was the most widely enjoyed mind changing substance. Sweet ripe fruit sitting in a warm place ferments, changing sugar into alcohol. This alcoholic by-product is an aromatic calling card. Animals detect the alcoholic scent of fermenting fruit and know there's sweet ripe fruit for the taking. Humans must have learned about grapes and wine in the same way. In moderation, alcohol makes us feel better, relaxes and stimulates, lessens stress and criticism, and makes us more sociable. Wine, unlike other alcoholic beverages, is the primary drink consumed for religious and ceremonial adulation.

What cultivates our continued love affair with the fruit of vine?

Is it only its ability to intoxicate?

OPPOSITE PAGE
LSD: Hallucinogen

Intoxicants: Sacred Spirits

Alcohol, accompanied by a bevy of beautiful molecules in wine, creates nectar so divine. No wonder that the early folks, who 'didn't know better,' thought there were spirits, gods or some magical hidden energy that changed the way they felt. They got happier and nicer, more playful and loving, when they sipped in moderation.

How can such a small simple molecule, ethanol, C_2H_5OH alter consciousness and the mind? The physical attributes of grape alcohol, known as ethanol or ethyl alcohol, play a role in what happens to us. Ethyl alcohol, soluble in both water and fat, can penetrate the cell and change its physical tension. It makes the membrane surrounding the cell more fluid and flexible. In fact, ethanol can release tension throughout the body and mind. As a powerful central nervous system depressant, it lowers the inhibition bar; we are easier on others and ourselves. We may get drowsy soon after a glass or two of wine. You may also notice that your sleep is disturbed if you drink too close to bedtime.

ETHANOL
ETHYL ALCOHOL

$$H-C-C-O-H$$

Formula C_2H_5OH

"ALCOHOL"

Wine, one of the most ancient of medicines on this planet, has been both praised and damned ever since. It was even associated with the supernatural and religion. Early in our history, people believed wine was a gift from the Gods; perhaps it contained the gods. No other alcoholic beverage has enjoyed the notion of being god-like. According to the Hindu tradition, when we bring wine to our lips we're sipping the "God beverage." The Persian mystic Rumi likened intoxication with wine to his ecstatic love of God.

Centuries before the birth of western religions, wine had a mythical personification in Dionysus, the ancient Greek wine god. Dionysus was said to come to Greece from 'overseas,' probably Turkey or Anatolia, bringing with him viticulture, winemaking and his wine cult. When Romans adopted Dionysus he became known as Bacchus. Devotion to Bacchus became so extreme that the Roman senate outlawed the drunken orgies and festivals celebrating Bacchanalia.

Throughout time, harvest gods and goddesses arose linking wine, the vine, and the divine. Almost every culture had their royal deities that ruled wine and the harvest. Yet none was as strong as Bacchus that lives still in many hearts.

Wine Gods and Goddesses

Pagan gods and goddesses of the harvest and fertility were often the same deities associated with wine. Bacchus and Dionysus are the best-known, here are a few more.

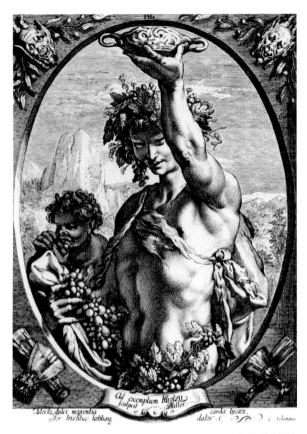

ABOVE:

Bacchus

Romans cultivated vines over the hills of Italy and France carrying the message of Bacchus throughout. After the Roman Empire collapsed, the Catholic Church took over growing vines and making wine. Once formal religions gave wine a permanent role in their rituals, the perpetual life of the grape was ensured.

Wine Gods and Goddesses		
Tezcatzoncatl	God of wine & native inebriating liquor, the pulque	Ancient Mexico
Yi-Di	God of wine and alcohol	China
Tara	Earth goddess, Goddess of spiritual transformation Wine is sacred to her.	India - Tibet
Spenta Armaiti	Goddess of the vineyards	Persian
Renenutet	Goddess of the harvest & wine	Egyptian
Osiris	God of wine, fertility god	Egyptian
Hathor	Goddess of wine & intoxication	Egyptian
Aca	God of wine & intoxicating beverages	Mayan
Geschtinanna	Goddess of vine & wine "Lady of the Vine"	Sumerian
Siduri	Goddess of Wine, Wisdom & Merrymaking "Lady of Happiness"	Sumerian/Babylonian

Sacred Rituals.
Wine Saved!

Even during Prohibition in the United States when alcohol use was forbidden, wine was permitted, PROVIDED it was used only for sacred church/synagogue rituals. The holy elixir of the grape was spared. Why not vodka or schnapps? A stout Guinness? Sacramental altar wine kept the vineyards in the United States alive for the fourteen years of Prohibition. Religions saved the sacred grape, or was it the grape that saved us? Many religious practitioners become intoxicated with the Holy Spirit and both Jewish and Christian rituals required wine.

**Hebrew
Wine Glass**

The Jews had the ecclesiastical foundation for the incorporation of wine into religious ritual; and the Jews who established the Christian faith made certain that the wine ritual was not lost in the new doctrine they preached.

- Richard Lamb and Ernest Mittelberger
In Celebration of Wine and Life

The Jews embraced wine in their religious ceremonies yet did not worship it like the early Greeks or Romans. Even now, wine is blessed first in the Jewish Kiddush ritual for beginning a meal or prayer. God is thanked for creating the fruit of the vine. Wine is the only beverage that has its own Jewish blessing. Another fruit first! Before every holy moment in the Jewish tradition - Sabbath, birth, weddings- a blessing over wine is shared. In the Talmud, a sacred Jewish text, it is written that "wine is good medicine; moderation in drinking is better than total abstinence."

Wine, so important to the religious ceremonies of the Jewish people, not surprisingly it followed Jesus into Christianity. During the Last Supper, the night before Jesus was crucified, Jesus urged his companions to drink the wine that it would become like the blood he would shed. This raised wine to greater spiritual heights. This symbolism is repeated in every Christian mass during the consecration of the Eucharist. To Christians, wine symbolizes the blood and spirit of Christ. No wonder it was saved during prohibition! It is one of the holiest symbols of the rich Catholic Church. Wine is more than just a drink; it is part of the fabric of Christian and Jewish religious traditions.

Though seemingly unrelated, scholars remind us that Jesus and Dionysus/Bacchus share similar stories. Both Jesus and Bacchus came from the mating of a mortal Mother and a divine Father. Bacchus' mother was the mortal Semele; his father was Zeus, the supreme God of the Greeks. Both Jesus and Bacchus performed miracles. Jesus' first public miracle was turning water into wine. Both are linked to resurrection; Jesus was resurrected twice, Bacchus three times. By drinking wine, adherents to either Bacchus or Christianity are "consuming" or "internalizing" their God.

Drunk in the Bible: A Look at Noah

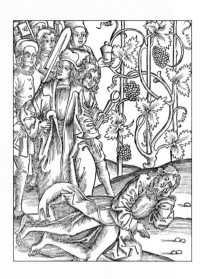

In the Bible, wine is cited for pleasure, as a symbol of life and God, and a dangerous intoxicant. In the Old Testament, Noah was named a drunkard for his celebratory binge after the first harvest of his grapes. But let's have a realistic look at Noah. Can you imagine how you'd feel if you'd been stuck on the ark for 40 days and nights with a lot of smelly animals. It has finally stopped raining. As the floodwaters subside, your ark is hung up on some mountaintop. Noah the farmer steps out of the ark and plants himself a vineyard. It took at least three years before he'd have enough grapes to harvest for wine. Finally, years after landing, Noah, in a happy stupor, offers blessings of thanks for the vine. Needing to caution against excess, the authors of the Bible made Noah a drunk rather than a patient man. Our continuing puritanical views in the United States still put wine into the 'dangerous' category.

> In the Hebrew tradition, **'kosher wine'** cannot be made until grapes are in their fourth season. In the wisdom of viticulture, it's not until the third year of a vine's life that grapes are considered vital and mature enough for wine.

Wine in the Next Life

Some civilizations were so afraid of the powerful spirits within alcoholic beverages, it was forbidden. In the Islamic tradition, alcohol and wine are forbidden in this life, allowed only in the afterlife when you are dead and in heaven, if you get to heaven. Whether cultures love or hate wine, it is still held in great esteem saved for the most sacred times. Even in Islam, the power of wine as a celebrated doorway to pleasure and goodness is acknowledged.

Mystical Wine

By embodying their Gods, humans engage in a mystical experience.

A mystical experience may come through nature, art, music, flying, war, falling in love, loss, death, anything that breaks through the daily routine can carry the message to the soul. A veil is lifted and we can see beyond the façade. We know there is another dimension to existence. We are no longer isolated. An authentic mystical opening brings us a sense of wonder, and a growing revelation of a far larger more marvelous universe.

– Bede Griffiths~ Christian mystic

Definitions of "Mystical"

- A spiritual meaning not apparent to the senses or the intellect

- An individual's direct communion with God or ultimate reality

- The word *mystic* comes from the Greek for *mystiko/mystos*.

- Relates to mysteries, the occult

- Having magical properties

- Inducing a feeling of awe or wonder

- The numinous, impenetrable, a direct knowing of God or sacred wisdom

Spirits of the Vine Captured in Molecular Remains

The spirit of the grape through its inner life captivated me. I peered into the remains of wine with a microscope, and thought that what I saw looked like "spirits" or "angels." Decades of exploration, seeking meaning in these images, brought me to an understanding that wine is life. Wine has a soul and heart from which we can drink in and find meaning. Enjoy this book as a journey of discovery into messengers hidden in the grape, wine, vine and soil, messengers for the heart.

Through these wine photographs we enter invisible dimensions of life. We cannot see the alcohol that transforms our mind and mood, yet we experience its effects. We can see the "spirit's images" captured through the microscope. How do they make us feel? When we travel into the invisible we explore a dimension of divinity.

Intoxication with D'Vine

Back to the beginning. Why the mystic grape? It comes down to definitions and experience. My definition of a mystic is someone who seeks to know God, however "God" is defined. Doorways to a mystical experience are as simple as walking in the forest, taking communion, lighting candles, blessing the wine, or sipping and sniffing.

The grape as mystic moves our mind, molecules and heart towards God, opening us to a sense of connectedness. And of course, the grape fulfills its purpose as it opens us to ours. To Rumi, the great mystic poet 'wine' and 'drunk' were metaphors for God-intoxication, not alcohol consumption. Rumi was so in love with God, he was intoxicated! His poetry reads like erotic ecstatic love.

The grape fulfills her promise to help us humans' open to happiness and a deeper connection with all living things. Her spirited life engages ours. The spirit of the grape shows life in microcosm and macrocosm. When we peek into the inner life of this spirited potion we see the story of life. Remember she is here to make us happy. ◊

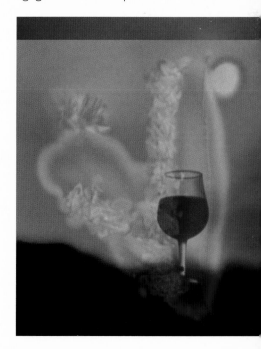

RIGHT
Quintessa heart
and wine glass

Chapter 7

THE SOUL OF WINE

Now whatever is this red water, boss, just tell me! An old stock grows branches, and at first there's nothing but a sour bunch of beads hanging down. Time passes, the sun ripens them, they become sweet as honey, and then they're called grapes. We trample on them; we extract the juice and put it into casks; it ferments on its own, we open it on the feast day of St. John the Drinker, it's become wine! It's a miracle! You drink the red juice and lo and behold, your soul grows big . . .

Nikos Kasantzakis – *Zorba the Greek*

When we reach the bottom of that once full glass, bottle, or barrel, we touch our humanity and connect with each other when we stop to sip and toast. A five or fifty dollar wine doesn't matter; it's the sentiment we share through drinking this simple beverage of soul.

What is Soul?

The idea of a soul compels us to look at the meanings given to the word since it embraces one of the most ancient concepts of a culture, a religion, and an individual. When we explore soul we delve into the mysteries of life. Neither visible nor measurable, soul is as elusive and controversial as spiritual beliefs and God. Native Americans hold that all things - animals, plants and even rocks - have soul. Other groups believe only humans possess soul. In Christian Science, Soul is the name for God. In Jewish mysticism, the soul is a spiritual magnetic field with no boundaries and connects us to the source of creation.

Defining SOUL

How do you define soul?

What, or who, has it?

Where does it come from?

Words & Concepts used to define SOUL

Animating force

Consciousness

Character

Essence

Our Truest deepest and highest nature

Spiritual part that exists before, during, after the body dies

Another view of soul refers to the spirit of a people. There's soul music and soul food that characterize the flavor of African-American culture, rhythms, and origins. If we're lucky, we may have a soul mate.

To many, soul is ethereal consciousness, an invisible conscience and enlivening energy that inhabit the physical body. It is an energetic essence that drives our material plane. To some, as soon as the human egg is fertilized, it has a soul; others believe we have no soul until the day we are born. In my opinion, the soul persists long after the vessel is empty.

Soul is invisible, like mind and God; it is the container for our spirit, intent, and life. The Soul writes in the script of molecules, music, emotions, energy, and the senses. Seeing inside the grape and wine we encounter soul in a story of sustaining life and love.

Soul leads us to the highest expression of our life's purpose

In The Spirit of the Grape Chapter, I speculate that Grape's purpose is human survival, happiness, and revival of the planet. The "Grape" encourages us to take better care of the Earth, the workers, and each other. My purpose is to tell the story of the sacred inner life of the grape, and us.

Soul Work – Renewing the Spirit

I believe that soul is linked to our individual purpose. Since I was a little girl, I believed that each of us was here for a purpose, that once we find and complete that purpose, we die. Therefore I never wanted to complete mine. Then one of my guides on the spiritual path, Tomas Pinkson, reminded me, "You're going to die for sure. It's guaranteed. Do you want to

leave without finishing your mission?" My mission is to show the sacredness in our molecules and cells, help decipher their meaning and mysterious magic.

Though I love a fine syrah, a buttery chardonnay, or a big red, I don't have to sip wine to experience 'grape' pleasure. I feel profound joy just from being in the vineyard or plunging my arms into a fermentor of pinot noir grapes. When I began writing this book, I had no intention of completing it without a publisher's advance and approval. Then I realized I was writing it anyway and recognized it was bigger than my conscious mind and my bank account. However the money flowed in enough to complete it.

ABOVE: Merlot Vineyard

This book, and my wine experience, must be my soul's choice. For why else did I take on the 2004 winery harvest internship since it was very physical for this young woman in her early sixties. I survived months of purple fingers and the bees hovering in the vineyard surrounding the sweet grapes. Stepping into a vineyard, my soul, that voice inside me, claimed it knew how the vineyard was taken care of and loved.

A well loved vineyard gave off "happy vibes." I took in all aspects of a vineyard; it has become for me, a place of coming home, sanctuary, and renewal. Not long ago, after months of not being able to walk, due to a fractured foot. Finally free from the cast, the first place I went to stretch my legs was in a nearby vineyard.

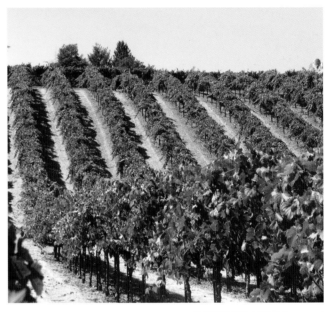

ABOVE: Hilly Vineyard

Called by the Grape

Those who hear the voice of the grape calling, often hear it as something deep in the soul. Many people working with the grape in some capacity feel the same way; it's no accident. A message summons one to pursue the spirit of the vine. Perhaps it arrived in a bottle of Bordeaux or a waving grapevine surrounded by acres of happy vines. Perhaps it was harvest time with its showy silver streamers flapping around vineyards to keep ravenous birds away. It looks like the vineyard's having a party; a happy time makes me smile.

'Soul work' is what we are 'called to do,' like ministering to the sick, caring for the earth, creating art, becoming a priest, or winemaker. I propose that the soul work of the grape is sustainability and human happiness, celebrating connection, community, and nature. Since the grape has a purpose, wine must has a soul.

Does Wine Have a Soul?

According to wine writer Matt Kramer of *The Wine Spectator,* only fine wines have soul, "everyday wine is pretty soulless. The source of wine's soul is "the voice of the earth." Jim Fetzer says that wine loses its soul when it is over manipulated rather than a natural product of the soil. Winemaker Heidi Peterson Barrett believes all wines have a soul, as does Dr. Liz Thach, wine business professor at Sonoma State University and hobby winemaker.

Thach proposes three levels to the soul of wine:

- The grapevine itself

- Fermentation, in which yeast, by changing sugar to alcohol, sacrifice themselves to birth wine. Yeast shares its life, biochemical machinery, and soul to create wine.

- The person drinking wine connects his or her soul with the soul of wine, and wine becomes a catalyst for opening our souls.

Heidi Barrett also sees the soul of wine from several angles. One point of view is that wine is a time capsule of what happened with the weather and winemaking. Time is captured in wine like no other agricultural product. From another perspective, wine is a living, changing entity, constantly moving. "Wine definitely has the living element whether you call it soul or not."

Powerful stuff, wine, that it can open and connect our souls while capturing time. Like Jim Croce's song, *"Time in a Bottle."* David Freed, grape grower, chairman of UCC Vineyards Group and co-founder of WineSpirit, puts it this way. "As a grower, I think the soul of wine reflects the combination of nature, man, and the divine in partnership. When, where, and with whom we drink adds to wine's soul." Freed further clarifies his view of the soul of wine -

- **Nature** includes terroir, land, weather, and growing conditions

- **Man** represents human engagement in vineyard and winemaking

- **Divine** is the magic of fermentation and aging

- **Each** bottle ends up with its own persona, just like we do.

From the perspectives of growers, winemakers, and business people, the soul of wine is living nature, inclusive of time and terroir, the mysterious molecular changes during fermentation and aging, as well as the human touch caring for the vineyards, making, and drinking wine. The soul of wine includes us, how we engage with the wine and share it with others. According to many, the land holds the soul of the wine and "terroir" expresses it. I consider the microscopic terrain as inner terroir, the extracted essence of wine. No wonder we enjoy it to celebrate life, from birth, death and the afterlife.

The Soul of the Winemaker

It amazes me that three winemakers can start off with the same juicy grape, from the same vineyard and harvest date, yet produce three different wines. How is that possible? Does the winemaker's energy impart some hidden character? I knew a "grumpy" winemaker who was angry a lot of the time; his wines were delicious but their microscopic forms all showed sharp edges. I thought they perfectly reflected his personality. The Japanese researcher Emoto, photographing microscopic expressions of ice crystals, claims that positive or negative thoughts and emotion affect the forms made by frozen water. Might we see the same thing with wine?

Upon meeting Heidi Peterson Barrett, my fantasy (because of her great wines) that she would be sweet-natured was confirmed. She is a beautiful, joyful, generous spirit whose strong gentleness shows in her award-winning wines. One of the highlights for me was getting to know Heidi and some of her wines. I asked whether she thought the winemaker's personality (consciousness) influenced the wine. "Sure, your personality goes in. I think if you are an upbeat, optimistic person and have a balanced life you're going to make pretty upbeat balanced wines. They're delicious. And I think if you are a person who struggles and has a lot of angst, your wines are going to be a little more angular. It's just how your life is. It comes out in everything."

LEFT: Chardonnay

RIGHT: Heidi Barrett
in the vineyard

Molecular Soul

The soul of wine, as an idea, came to me first, through the pictures of the beautiful molecular collaborations. Microscopic remains offered clues to character. Soul was in the molecules. A dear physician friend, Beverley Kane, reminded me that some people believe that molecules and atoms have consciousness, therefore, a soul. But like music and food, some wines and molecules may have more soul than others. Molecules express wine's physical essence imprinted by its spirited environment. Microscopic portraits reveal the product of human collaboration with nature. Because there is a change in the features of an image when a wine is alive, or 'losing' it, wine is a perfect reflection of life with soul. One of my first glimpses into the soul of wine was seeing it "lose its light and substance" when

its vitality diminished. A microscopic story of birth, life and death made evident.

When I first met Heidi, I shared with her the proposed cover for this book. She thought this was a perfect picture. Pointing to the heart of the center, she said, "the soul's right here. The heart in the center of the cross. That's the soul." I had never seen that before she pointed out 'the soul' in the picture.

My friend and book mentor Bethany and I have had an ongoing discussion about this image - which is right side up? What do you think? Is picture A with the arrow right side up, is picture B upside down? Do you see different things in A and B?

A: Merlot with arrow to the soul

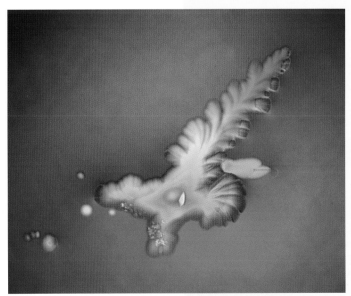

B: Merlot flipped up

Language of the Soul

The language of the soul is not cerebral, does not speak in words...
To attune ourselves to the language of the soul we need to broaden our
range and let go of preconceived notions...it lives at the edges of thought
and is symbolic, metaphoric, and poetic. It doesn't matter that we cannot
grasp it with our minds, another part is touched...Via the soul we get
information from other realities.

Rabbi David Cooper – *God is a Verb*

Noted psychologist and author Marion Woodman reiterates that the soul understands the language of poetry and metaphor, integrating image with feeling, mind, and imagination. An image becomes a metaphor or symbol when it speaks to the whole person. Images of the inner wine can act as symbols and speak about the essence of the wine.

Some of the language used to describe wine is based on form – full bodied, prickly, long; or familiar foods – blueberries, peaches; or an aromatic treatise – a tar road, leathery, floral. The words are a product of our experience, they are not the experience. Words are part of the tapestry creating colorful imagery, to evoke a knowing or understanding in the listener. Only if you've experienced blueberry can you recognize it in wine.

When I ask myself what I mean by the "soul of wine," a couple of things come to mind. The photographs of the inner world express part of the soul of wine, the 'spirits' of the vine hiding on the microscope slide. The magical forms seem to dance on the glass. Austrian scientist-philosopher Rudolf Steiner claimed

to see the 'inner life of plants,' what he called devas or elementals. Derived from Sanskrit *"deva"* means "to shine." According to Steiner and the philosophy of theosophy, Devas are the "shining ones." In Hindu Scriptures, devas refer to life that is invisible. Are the forms seen through the microscope, devas? They certainly are invisible shining reminders of the mysterious invisible qualities that make up life.

People found meaning in the wine images long before I did. Celia Lenson, at the WineSpirit "Art and Soul of Wine" presentation, reported after seeing the wine's inside story, "Now I know why wine is so spiritual."

Decades ago, on seeing the first merlot's portrait, owners of a new winery wanted a portrait of their first sparkling wine. When they saw its photograph pictured here, the French owners said, "Oh, no, we can't use that picture for our wine, no one would drink something that looks like that." They had preconceived ideas of what their wine should look like and it wasn't this. Yet many who see this think it's perfect for a bubbly sparkler.

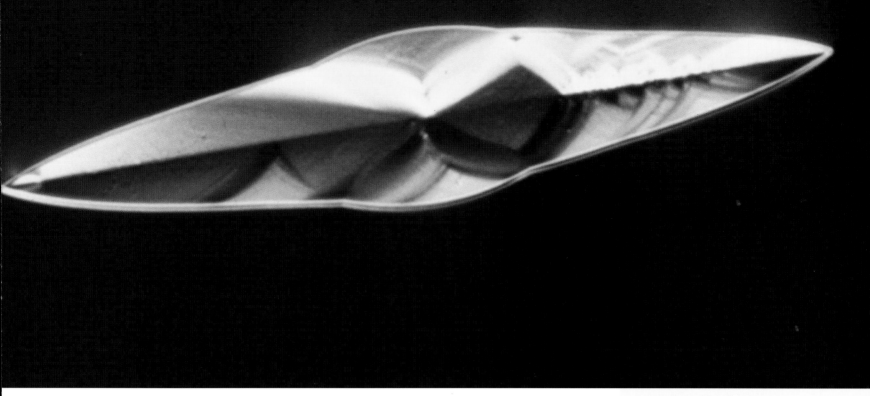

A Feminine Soul of Wine?

The core soul of all wine is the fecund feminine grape, a fruit of the woody plant vitis vinus. Yet during transformation, can the blood of the grape be coaxed into more aggressive or subdued nature? Are there feminine or masculine wines? Does the spirit, or soul of wine, have a gender?

Heidi Barrett, at first said she typically didn't think of wines as being either masculine or feminine. Then she thought a while and described her Moscato Azul, the only white wine she makes, as a feminine wine. "Why feminine," I asked her. "Because it was perfumey and delicate," she replied. Then she said, "Most red wines are masculine." I always see the Moscato as wine angels.

The soul in wine is the light it carries, the spirit, the perfume it emits, and the joy it permits. The soul of wine shows in the magical devas that populate the nectar, the elements that contribute to the beauty of a fine wine.

How we grow our grapes influences its nutrients, taste, vitality, and spirit. Growing sustainably, without pesticides or artificial fertilizers, we make an investment in the soul of our planet and the life of wine.

One evening, wine sang out
with all its soul:

"I send you, Man, dear disinherited,

From my glass prison with
its scarlet seals,

A song of sunshine
and of brotherhood!"

– Charles Baudelaire - *The Soul of Wine*

Wine Toasts

Wine is one time capsule in its creation and another when we drink it to toast a special moment. Clinking the glass with a friend, we may offer an elaborate gesture, a simple "salud" or "cheers", yet the sentiment of raising our glass brings much opportunity to celebrate and remember a special moment. Where did the idea of "toast" with a glass of wine come from?

The custom of toasting has been around for almost as long as wine. Some claim that a primitive form of toasting dates back thousands of years to nomadic tribes who sprinkled a few drops of drink on sacrificial altars to appease the hunting gods.

Twenty-five hundred years ago, the Greeks toasted the health of their friends for a highly practical reason — to assure that the wine they were about to drink wasn't poisoned. It was a symbol of friendship for the host to pour wine from a common pitcher, drink it before his guests, and satisfied that it wasn't going to kill them, then raise his glass to his friends to do likewise.

Toasting continued with the Romans. In fact, the Roman practice of dropping a piece of burnt bread into wine to temper it gave birth to the term toast from the Latin *tostu*. The charcoal of burnt toast actually reduces acidity of slightly off wines making them more palatable. Of course, we no longer pop a piece of toast in our glass. Today the 'toast' in our glass is symbolic, though our wishes for the good health of those gathered with us are not.

By the 1700's, toasting was the thing to do. Partygoers would often toast to the health of people not present, especially celebrities and beautiful women. A woman, who was the focus of many toasts, became known as the "toast of the town." Almost every language has a toast to the health of the guests.

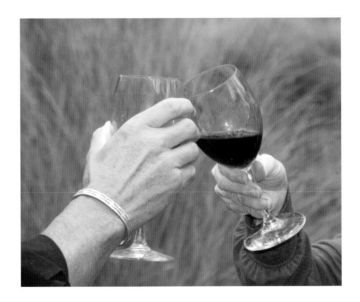

Fill to him, to the brim!
Round the table let it roll.
The divine says that wine
Cheers the body and the soul.

A Toast to the Great Grape

The world of the grape is monumental – grape growing and winemaking, soil and the seasons' symphonic hand touching each grape's potential, tastes and flavors that merge or purge, people drawn to create fine wine, those who look to the bottom line, and those whose goal is the top of the line. ◊

Wine has been a part of civilized life for some seven thousand years. It is the only beverage that feeds the body, soul and spirit of man and at the same time stimulates the mind.

– Robert Mondavi –*Harvests of Joy*

Blessings and Drinking Toasts

May the road rise to meet you.
May the wind be always at your back.
May the sun shine warm
upon your face.
And rains fall soft upon your fields.
And until we meet again,
May God hold you in the hollow
of His hand.

May you live as long as you want,
And never want as long as you live.

May you never lie, cheat or drink
But if you must lie, lie in
each other's arms
And if you must cheat, cheat death
But if you must drink, drink with all of us,
because we love you!

———

Always remember to forget
The things that made you sad.
But never forget to remember
The things that made you glad.

Clink! Clink! A Toast in Many Languages			
Arabic	Fi sahitak	Indian	Apki Lami Umar Ke Liye
Bengali	Joy	Irish Gaelic	Slainte!
British	Cheers!	Italian	Alla Salute! Salute / Cin cin
Chinese	Wen Lie! Kong chien	Japanese	Kanpai!
Croatian	Zivjeli / U zdravlje	Latin	Sanitas bona / Bene tibi
Czech	Na zdraví	Mandarin	Gan bei
Dutch	Proost	Pakistani	Sada bashi
Egyptian	Fee sihetak	Polish	Na Zdrowie!
Farsi	Ba'sal'a'ma'ti	Portuguese	Saúde
French	À votre santé / Santé	Russian	Za vashe zdorovye!
German	Prosit!	Spanish	Salud!
Greek	Yasas!	Swahili	Afya / Vifijo
Hebrew	L'Chaim!	Scandanavian	Skal!
Hungarian	Ege'sze'ge're!	Welsh	Iechyd da

Chapter 8

SAVORING LIFE

What is the aim of a vineyard? I imagine it is there to finish the soul-work of the vigneron, a projective screen that might enable him to better understand why he is here. Perhaps ultimately, it is there to provide him with . . . pure delight.

—Randall Grahm, *The World of Fine Wine*

Seasons of Life

In cold wet January, vineyards along the Russian River are often flooded to the top of their stakes. How do these vines survive, I wonder. I learn it's because the vines are dormant and resting for the winter that they make it through. The water slowly recedes and the warming sun invites bud break. In late spring, the leaves begin their showy dance and soon the valley is filled with the pregnant breath of the vine. Toward the end of August, a fearful excitement fills us; what will this season bring? Will the grapes mature before the rains come? There is a rush to pick the succulent berries and another harvest begins.

I've lived these seasonal rhythms for many years and continue to be inspired by the seeming death of the vines and their reemergence into blossoming and fruitful plants. Year after year. For some vines, their lifespan exceeds human life. How few of us humans make it with such productive vigor. In the vineyard, age is an advantage. Old vineyards imbue the grape with greater complexity from their years of experience

BELOW:
115 year old zinfandel vineyard at Ridge Lytton Springs

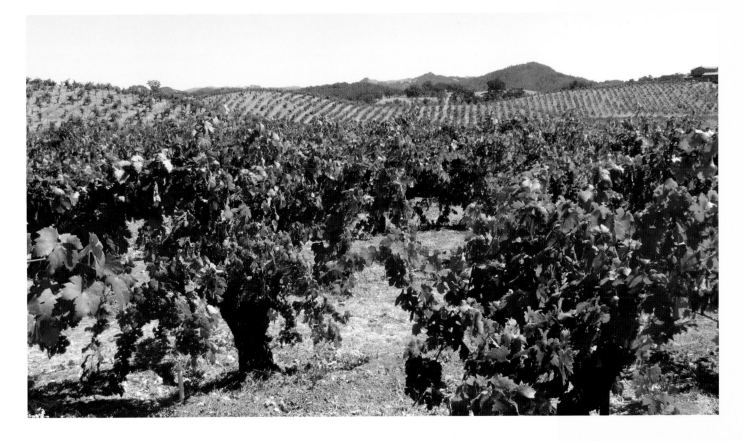

Reflections in a Vineyard

Old vines dance, waving their arms full of fruit. What an amazing vision, spectacular in their fall colors, these vines are much larger and more gnarled than the last time I was here several years ago. It was spring long before the first budding.

I headed up to Ridge Lytton Springs because I wanted some new pictures of old vines.

Besides capturing a photo or two, I capture a moment to savor life here in the vineyard, a reminder of the seasons of life. It is a joyful place to be; I marvel at the vine's tenacity. Always renewed by being in a vineyard, I ask, what can I learn, what can we learn from these old vines?

- *Patience*
- *Allow time to mature*
- *Permit a field of work to survive even when less than perfect*
- *Hold fast to your vision for wisdom and complexity to develop*

As we age like these old vines, how may we contribute to the continuity of nature, what gifts do we have to offer? We go through dormant phases, creative and transformative stages, to reach abundance and renewal gathering nourishment for a push towards another vintage.

Dormancy

My work with the spirits of the vine remained dormant from about 1990 to 2003. What triggered me to work again with wine was an art show plus a drastic change in employment. We faculty members at the University of Creation Spirituality (now known as Wisdom University) were invited to display our artwork for the new incoming students. I offered a few of my "old wine photographs" for the show. One student told her friend, Carol Emert, a wine writer for the *San Francisco Chronicle*. Carole wanted to interview me even though I hadn't photographed a wine in more than a decade.

I was living in a tiny studio I had taken as a writer's retreat while traveling around the country teaching bodymind medicine. Almost everything I owned was in storage. However, my microscope was stashed safely under a table somewhere in the house. Carol insisted on seeing where "Sondra, the artist-scientist" worked. Reluctantly I agreed. Carol's interview resulted in a wonderful article illustrated with my wine portraits - "Scientist looks at the inner life of wine." It brought many calls, emails, and renewed my interest in the inner life of wine

Another motivation to revive my relationship with wine was that my well-paid job as an educator to health professionals came to a halt. The company I consulted for went belly-up, and though I had been praying for more local work, I hadn't meant it to happen quite so abruptly. However, unexpected changes and challenges are the nature of life – for humans and grapes. These two events occurring simultaneously - the article and change in employment - convinced me to reinvent myself, to bring out my dormant wine explorer, one more time. Being around wine and the vineyards always inspired me.

The studio I lived in occupied the lower floor of my media mentor-book editor Bethany Argisle's house. When I wasn't traipsing around the country teaching, she was helping me complete a book about science and the sacred. Wine was not in the picture.

It was with Bethany that I had enjoyed the first bottle of merlot that launched the original wine explorations. She also instigated my first interview in the *San Francisco Chronicle Magazine* 1984. Now many years later, I began working with her bitten once more by the wine bug.

{PICTURE SHOW}

WINE DESIGNS

Floating galaxies? Jewels in space? The latest manifestations of modern art? Not quite. What you're looking at here are photographs taken through a microscope of wines and a liqueur.

Sondra Barrett, a San Francisco biochemist, was studying slides of wine in her laboratory one day when it suddenly struck her, looking at the molecules, how uncommonly beautiful they were. Was there, she wondered, a connection between the molecules' shape and the wine itself? Could it be that perhaps straight-edged molecules produce Cabernets, while round molecules create Pinot Blancs? What if each wine has its own distinctive design, visible only under the microscope?

Dr. Barrett still hasn't found answers to these questions, but some patterns are beginning to emerge. "For instance, you start with grape juice," she says, "and as the wine gets older the molecules get bigger. So when they talk about 'a big wine,' that's exactly what happens microscopically. And the sharp edges of the molecules smooth out, too, with age."

A sampling of Sondra Barrett's "photomicrographs," as she calls them, will be on display at Sterling Vineyards in Calistoga from March 5 through May 5. □

Photography by
Sondra Barrett

A molecule of a Sterling Vineyards Merlot, 1978.

(Above) *A close look at Concannon Johannisberg Riesling, 1981;* (right) *a molecule of Frangelico, an Italian liqueur.*

February 5, 1984/San Francisco Sunday Examiner & Chronicle 6

ABOVE:
1984 *San Francisco Chronicle*

Ideas Don't Evolve in a Vacuum

Until that second *Chronicle* interview (2003) I had called the images "spirits of the vine" or "wine spirits," angels, devas, and elementals. Since I was considering revisiting the world of wine, I googled 'wine and spirit' and discovered "WineSpirit," a Napa Valley-based organization that was meeting in two days; I went, of course. Founded by two Davids, (White and Freed, a rabbi and lawyer-grape grower), WineSpirit offers a place for conversation and community to explore the deeper meanings of wine and life. Many stimulating discussions and connecting with people with wine wisdom expanded my view of wine. It also provided plentiful new wine samples. With my microscope out of hiding, I began photographing wine again. For one year, none of the wine pictures excited me.

Then, a "sign." WineSpirit launched its first seminar series with my offering "The Art and Soul of Wine." Leslie Rudd, owner of the Rudd Estate Winery in Oakville and Dean & DeLuca Gourmet Foods, co-sponsored the event. The plan was to show the inner wine story I had developed decades earlier. We would also taste wine the usual way and a new way, with our eyes. Ahead of time I photographed the wines we would have at the event. The Rudd wines were exquisite. They excited me to once again pursue beauty in the bottle tracking the "footprints" of delicious wines.

My tasting partner, "Antonia Zabione," with her very poetic language, said that Rudd's old vine chardonnay embraced her mouth like a lover; it wrapped itself around her. Take a look at that wine's portrait with its flowing wraparound nature that my friend articulated.

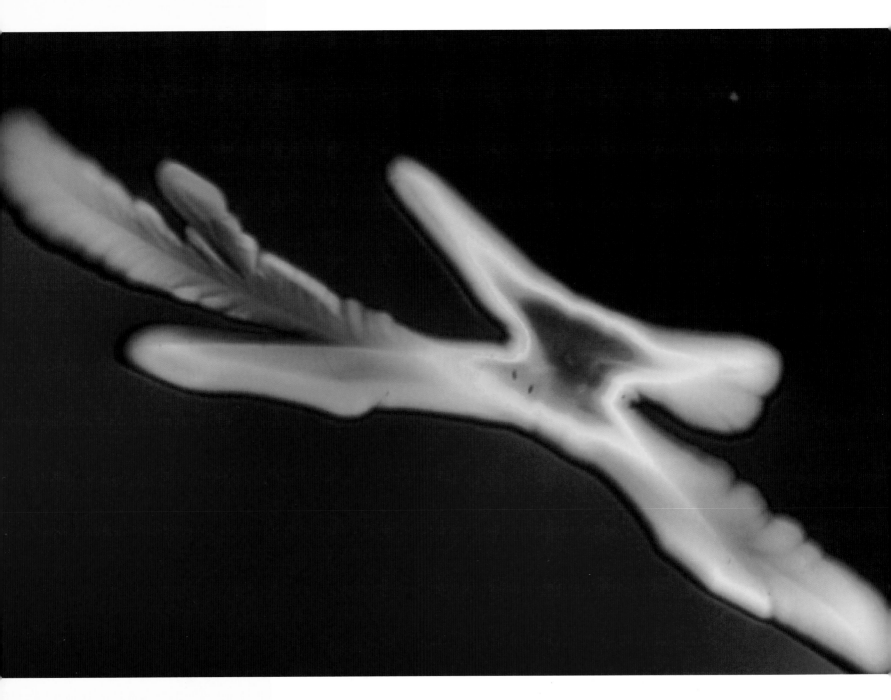

ABOVE:
2002 Rudd Old vine chardonnay
Russian River Valley Bacigalupi Vineyard

This luscious old vine chardonnay came from the same vines that gave birth to the legendary California chardonnay that won the 1976 Paris Tasting - 1973 Chateau Montelena made by Mike Grgich.

Rudd's wines revitalized me. Until then, I was disheartened every time I shot another roll of film. I assumed that the beauty and patterns I had seen in wine decades earlier must have been a fluke. Now, at long last, the story reemerged.

Here are two "time capsules" of a 2002 Rudd Cabernet Sauvignon, the first was photographed in 2004, the other in 2005. I call the older version of the 2002 cab "Opening Up." It has grown larger and softer in form compared to the younger tight cab. Shapes change with age (just like us). The older bottle also now revealed what I call "Jewels of ageability" (at arrow), a form sometimes seen in wines that lived long and well.

Once again I uncovered spirited images that tell of hidden secrets within the wine. These few wines inspired me to continue on. Since then, talking to winemakers and wine lovers over the years, I discovered that more than a few saw how the images reflected their own impressions of the wine. Others said, it was only beautiful abstract art.

Blended Senses

Yet I persisted in the exploration. Twenty-five years ago I began with a hunch that molecules not only shape our experience of wine, they also shape our language. How do molecular forms play a role in our sensory experience? Can we taste round? Do we drink or avoid angles? What role does molecular shape play in taste? Scientists tell us that "tasting shapes" is an abnormal mental condition called synesthesia. Winemaker Randall Grahm says we all need to be synesthetes to fully enjoy wine.

BELOW: 2002 Rudd Oakville Estate Cabernet Sauvignon
(Photographed in 2004)

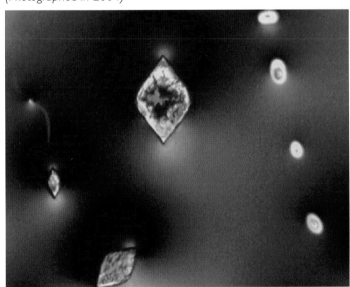

BELOW: 2002 Rudd Oakville Estate Cabernet Sauvignon
(Photographed in 2005)

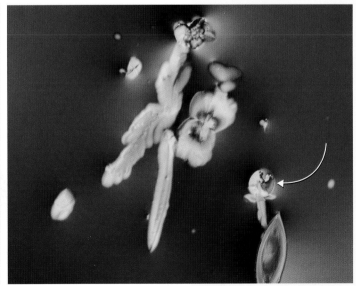

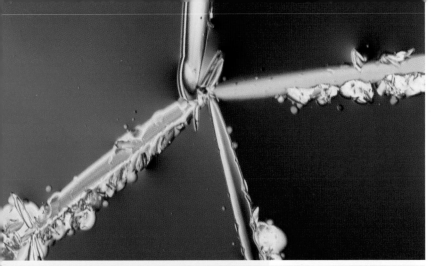

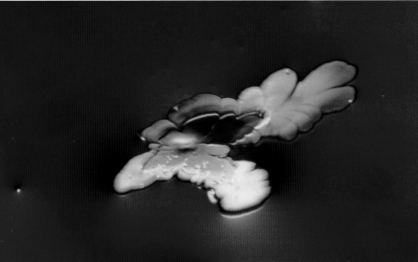

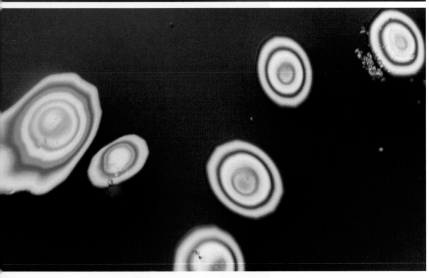

ABOVE:
A chardonnay, meritage, and pinot noir from the Frank Family

Synesthesia is a state in which sensory experiences are cross-wired in the brain. For instance, a person who is a synesthete may see the number **3 as red,** or hear the color blue (like Jimmy Hendrix did), or taste an angular chicken. A *Scientific American* review reported that sensory mixing is more common among women and creative people. It's also reported that such inter-connected sensory pathways strengthen memory. Each sense activates different regions of the brain creating a network of the total experience. The more senses engaged, more neural links and stronger memory. It is said that the great André T, who could recall any wine he tasted, remembered wines as personalities and shapes.

Sipping wine is a sensory experience yet we use words and our intellect to describe this sensual body experience. We can share with others our verbal impressions of wine. Why not add visual imagery – wine portraiture - to the mix?

At a recent presentation for the Institute of Noetic Sciences, a wine distributor said that the images confirmed what he had felt all along about the essential qualities of wine. For example, there **are** angular wines. After presentations to hundreds of people I witness that most can distinguish the molecular designs of wine from other food and tastes.

Savoring

In a commitment to savoring life, I offer this work as a doorway into the mystical, magical, and molecular world of wine. The beauty within wine is not questioned, though my interpretations may be. When you get to be well-aged in the cellar as I have been, you know when it's time to release the creation to let others have their chance to savor, discuss, and explore the inner spirit of wine. Here is an opportunity for you to get inside wine at home.

How to Get Inside Wine

Invite friends over to enjoy a lovely meal or savory nibbles, and of course, wine. Make sure there are designated drivers. Have a few wine images available. You can make color copies from this book, purchase prints or simply bookmark pages. Ultimately we will have a deck of cards with the images.

Introductory warm-up and for non-imbibers

- Choose a wine portrait and discuss "Rorschach style" what it could symbolize in terms of taste, texture, or personality of a wine. In other words, what does the picture say to you?

- Explore how the image and your language represent an experience of wine.

- Taste a wine to see if it fits the image or 'style.'

Play Taste a Shape, "Wine Rorschach"

- Just like the introduction, have a few wines to share and some pictures.

- As you savor each wine, do any words, images, or feelings come to mind?

- Choose from among the wine portraits (in this book or wine deck) the ones that best reflect your experience.

- Is there a consensus among your fellow tasters? Do you pick the same or different images for that wine?

- Will you remember the essence or spirit of the wine better because of the discussion and your connection to an image?

Play with the images and have fun. Remember our experience of wine is subjective and personal, so is what we may call art and beauty.

Words follow lumberingly after the clear, precise, yet indefinable impressions of the tongue.

—Hugh Johnson

From the Beverage in a Bottle to our Inner Life

As part of my digging deep into the roots of this work, I have had an ongoing inner conflict about the pictures. Are they only art? Do they have scientific or practical value? What's their relevance to enjoying and tasting wine? On and on, the conversation goes inside my head. I doubted myself and this unseemly passion I had with the vine and wine. So, what do I conclude about all of this?

Scientists tell us there are at least 400 different compounds in any wine. How these parts mingle and blend give us our ultimate experience. As does our mood and environment. We participate in the alchemy, translating a sip of wine into pleasure, or not. Drinking wine is a holistic experience – one that brings together the chemistry in the bottle, the art within the glass, our mood, the environment, who we're with and our sensual perceptions. We are part of the equation of taste.

As a scientist I also fought with other demons of my mind, which continually said, "you can't talk about spirit in molecules, soul in wine or divine design. Yet I never hesitate to wonder and rejoice in the beauty of the hidden universe, the spectacular patterns of nature." There's something there, beyond the chemical information," my students tell me.

Renewal

In this gesture of renewal for my own life I offer you a result of this "mission impossible," the incredible spirit that forms wine. As I read this manuscript one final time I realize this book is perhaps more about me than wine. The compelling beauty and potential meaning pushed me to make visible this unlikely world. This I know for sure, hidden patterns of molecular collaborations form inside wine. They offer an eyeful of delight and awesome expressions of life. When I take on my "cellular anthropologist" persona (aka Alexandra the Grape, Cellular Sleuth) I call the patterns a "wine code." Only you will be able to decipher its meaning.

The shape of living things is a difficult language to interpret ... Nature uses the same language of form for all living things ... using the same physical laws. For those of us whose life's work has been to study nature, a beautiful picture can illuminate us in an instant. We may not be able to give words to what we see, or explain the phenomenon, yet intuitively from the image, we know something new.

—Dr. Marcel Bessis (1917-1994), French scientist who pioneered microcinematography

The next time you sip and imbibe that delicious nectar, imagine the soul, spirit, and people who brought it to life. Peruse the hidden characters dancing in wine, and discover for yourself how they speak to you of beauty, wonder, science, God, or spirit.

In this book I have attempted to bring together human life and the life of the vine. And like those old vines I offer you beauty and moments that may renew your spirit. We have reminders to make each vintage of our life one that bestows gifts from our seasoned experience. The grape and vine have given us clues to living well - stay rooted, be patient, pay attention to the weather, enjoy change, and be fruitful. And so we end where we began, looking for beauty and meaning in the universe and seeing it in wine and ourselves. ◊

Wine is a promise
made by patient people
willing to invest what they have,
into making something great
for someone else

Wine brings individuals together...to savor something of exquisite beauty that has no utilitarian purpose other than the grace it sheds upon our appreciation of life.

–Robert C. Fuller – *Religion and Wine*

ACKNOWLEDGEMENTS AND GRATITUDE

There are so many people I am indebted to for helping me along the way to this book. Thank you all for your support. If I've forgotten anyone, my mind may have forgotten, my heart hasn't.

First of all, to Marcia Starck, who saw my need to complete this book, who lovingly read the manuscript, and contributed the funds towards its production.

To Bethany Argisle, who championed my work, who tweaked every word, who shared many of the seminal wines included here, who was a mid-wife of this tome.

To Catherine Greco, the wonderful designer, who had no idea how much would be entailed to get this baby done, who lifted my sometimes flagging spirits along the way. Thank you for making this much more beautiful than I would have imagined.

To my parents, Natalie and Perk, though now heaven-bound, whose love grew me well. To my dad who said I could do anything I set out to do, I am sure he would be surprised and delighted with this.

To my son Ted, who helped wordsmith my ideas along the way, who asked questions to make me focus and be profitable. To my daughter Heather who shares her joy in life with me, always nurturing my spirit. To both of you, your encouragement made a difference as did sharing time, laughter and recipes that fed us all. And to my grandchildren Ethan, Benny, Harper and Micah, it is for you I leave this legacy of the marriage of art, science and spirit - for all that is possible.

To my dear friends at WineSpirit - David White, David Freed, Steve Russon, Charlie Johnston, Liz Thach, David Mendelssohn, Burke Owens, Paul Wagner, Tim Hanni, and Ron Scharman - who gave this work a place to grow deeper and in community. To David White, whose mystical intuition reminded me of the bigger picture.

To the winemakers who shared their wines, their stories and their loving spirit with me - Heidi Barrett, Mike Grgich, Mike Benziger, Jim Fetzer, Ivo Jermanez, Theo Rosenbrand, Bill Dyer, Jay Corley, John Thoreen, and Andre Tchelistcheff. And to the many unseen wine growers throughout the generations who made this story possible.

To Leslie Rudd and winemaker Charles Thomas for making such rich wines that helped me recapture the romance and beauty in wine. To Bill Hunter at Chasseur who let me intern a harvest season which enabled me to really get inside wine.

To Michael Pollan, whose *Botany of Desire*, changed how I viewed the grape, to seeing its purpose in human life.

To Kristi Moya, whose taste of love and love of food and the land, fed me when it was most needed.

To Carol Emert who forced me to take this work out of hiding when she interviewed me

To Valerie Presten and the folks at Sterling Vineyards for having the vision and patience to invite me to be part of their 'family' as artist which started all of this.

To Marshall Kadin who taught me how to use the microscope, to Max Rafelson, who helped me become a scientist, and to the California Academy of Sciences whose photographic show opened my eyes to the art in science.

To all the children and adults who allowed my pictures through the microscope to inspire them and teach me we were more than abstract forms.

To Tom Pinkson, my spiritual guide, who nurtured my heart, imagination and sacred intelligence, my most resistant parts.

And to my new Organic Wine Company friends Veronique, Joe, Laurie and Ron who by sharing wine together, teach and support me about the many gifts of wine.

And to God who gave me this mission and vision to share with you.

ORGANIC/BIODYNAMIC WINERIES IN U.S.

Wineries in the United States that grow grapes organically and/or use some or all **biodynamic*** practices. Depending on the practices, their wines may be labeled: made with organically grown grapes; organic wine; made with certified organic and biodynamic grapes; certified biodynamic. Some of these wineries use organic practices but are not certified.

CA	Adastra Vineyards	CA	Carmody McKnight*	AZ	Granite Creek Vineyards
CA	Alger Vineyards	WA	Cayuse Vineyards*	CA	Grgich Hills Estate*
CA	Alma Rosa Winery	CA	Ceàgo Vinegarden*	CA	Handley Cellars Vineyards
CA	Amapola Creek	CA	Ceritas *	CA	Hartley-Ostini Hitching Post
OR	Ambyth Estate*	OR	Chateau Lorane	CA	Hartford Court
OR	Amity Vineyards	VA	Chateau O'Brien*	CA	Hawley Vineyards
CA	Ampelos Cellars*	WA	China Bends Vineyards	WA	Hedges Family Estate*
OR	Antica Terra*	CA	Clos Saron*	CA	Heller Estate
CA	Araujo*	CA	Cooper Mountain Vineyards*	CA	Hidden Cellars Winery
CA	Arcadian*	CA	Corison 'Kronos' Vineyard	CA	Hobo*
CA	Arrowood Vineyards & Winery	CA	Coturri Winery*	CA	Honeyrun Winery
CA	Ashland Vineyards	OR	Cowhorn *	CA	Imagery
CA	B Vineyards & Habitat *	CA	Davis Bynum	CO	Jack Rabbit Hill*
CA	B.R. Cohn Winery	OR	de Lancellotti*	CA	Jeriko Estates & Vineyards*
WA	Badger Mountain	CA	De Loach*	CA	Joseph Phelps*
CA	Baker Lane*	CA	Demetria *	CA	JPV Freestone*
CA	Barnwood Vineyards	CA	Domaine Carneros	CA	Kamen*
CA	Barra of Mendocino	CA	Dover Canyon*	CA	Kenneth-Crawford *
OR	Beaux Freres*	CA	DuMOL *	OR	King Estate
CA	Beckman Vineyards*	OR	Durney Vineyards	CA	La Clarine*
OR	Belle Pente *	CA	EcoVin	CA	LaRocca Vineyards
CA	Benziger Family Winery*	CA	Ehlers Estate*	OR	Lemelson (Resonance Vyd*)
OR	Bergström*	CA	Ethan Lindquest*	CA	Littorai (biodynamic except for
CA	Bjornstad (Porter-Bass Vyd)*	CA	Everett Ridge Vineyards		Hirsch*)
CA	Black Sears*	CA	Evesham Wood* Winery	CA	Lolonis Vineyards
CA	Blair Fox (Purisima Mtn vyd)*	IL	Famous Fossil Winery*	CA	Long Meadow Ranch
WA	Blue Mountain (experimenting)*	CA	Favi Estate Winery	CA	Lutea Wine Cellars *
CA	Bonny Doon Ca' del Solo vineyard *	CA	Fetzer Vineyards	NY	Macari
CA	Bonterra Vineyards *	CA	FitzPatrick Winery	CA	Madonna Estate
OR	Brick House*	NY	Four Chimneys Farm Winery	CA	Margerum *
CA	Bucklin *	CA	Frey* Vineyards* no sulfites	CA	Marimar Estate*
CA	Calera Wine Co. Mt. Harlan Vyd	CA	Frog's Leap*	CA	Martella Wines*
CA	Caplaux 'Wilson' Vineyard	CA	Golden Vineyards*	CA	Masút*

OR Maysara Winery' Momtazi Vyd'*
CA McFadden Vineyards
CA Michel-Schlumberger
CA Mendocino Farms*
CA Morgan 'Double L Vineyard'
CA Montemaggiore*
CA Montinore Estate*
CA Nevada County Wine Guild
CA Opus One *
CA Organic Wine Works
CA Orleans Hill Winery
WA Pacific Rim (Wallula Vyd)*
CA Parducci Wine Company
CA Parr Selections*
CA Patianna*
CA Paul Dolan Vineyards*
CA Pax *
CA Pedroncelli
CA Porter Creek*
CA Porter-Bass*
WA Powers Winery
CA Presidio*
CA Preston (experimenting)*
CA Quintessa*
CA Quivira*
CA Qupé (Purisima Mtn vyd)*
CA Kent Rasmussen
CA Renaissance (converting)*
OR Resonance Vineyard*
OR Rex Hill (converting)*
CA Rhys (estate wines)*
CA Ridge (some vineyards)
CA Robert Sinskey*
CA Samsara (Purisima Mtn vyd)*
CA Sanford Estate
ME Shalom Orchard
NY Silver Thread Vineyard*

CA Sineann (Resonance Vyd)*
CA Sky Saddle *
CA Small Vines*
OR Sokol Blosser *
CA Spotteswood Estate
CA Staglin Family Vineyards
CA Sunny Oak Vineyard
CA Tablas Creek
CA Tandem *
CA Topel *
CA Tres Sabores
CA True Earth (Three Thieves)
CA Truett Hurst*
CA Turley
CA Unti *
CA Verge*
CA Viader*
NY Herman J. Weimer *
CA Wild Hog*
CA Yorkville Cellars

Some online resources:

Appellation Wines
http://appellationnyc.com/

Biodynamic Certification in US
http://www.demeter.net/

CCOF – organic certification
http://ccof.org/

CCOF Wineries
http://ccof.org/cgi-bin/organicdirectory_
search.cgi

The Daily Green
http://www.thedailygreen.com/going-

green/tips/organic-wines-biodynamic-wine

Organic Wine Company
http://www.theorganicwinecompany.com

Organic Wine Journal
http://www.organicwinejournal.com/

Organic wineries in Dry Creek Valley
http://www.winecountrygetaways.com/
dry-creek.html

Organic wines around the world
http://www.organicvintners.com/

Organic Trade Association
http://www.drinksmediawire.com/
afficher_cdp.asp?id=5387&lng=2

Organic Wine Sales
http://www.skurnikwines.com/msw/
OrganicWineries.html

BIBLIOGRAPHY

These reference materials were invaluable to my wine education and writing this book.

Ackerman, Diane. *A Natural History of the Senses*. New York: Random House, 1990.

Allen, H. Warner. *The Romance of Wine*. New York: Dover Publications, 1971.

Babor, Thomas. *Alcohol: Customs and Rituals*. New York: Chelsea House Publishers, 1986.

Balzer, Robert Lawrence. *Pleasures of Wine*. New York: Bobs-Merrill Co. Inc, 1964.

Beckett, Fiona. *Wine by Style. A Practical Guide to Choosing Wine by Flavour, Weight and Colour*. London: Mitchell Beazley, 1998.

Bespaloff, Alexis. *The Fireside Book of Wine*. New York: Simon and Schuster, 1977.

Braun, Stephen. *Buzz. The Science and Lore of Alcohol and Caffeine*. Oxford: Oxford University Press, 1996.

Chiarello, Michael. *Napa Stories*. New York: Stewart, Tabori & Chang, 2001.

Dolan, Paul. *True to our Roots*. Princeton: Bloomberg Press, 2003.

Ellison, Curtis. "Balancing the Risks and Benefits of Moderate Drinking." Annals New York Academy of Sciences 957:1, 2002.

Ellison, R. Curtis. "Wine and a Healthy Lifestyle." Wine Spectator, Oct 15, 2004

Ford, Gene. *Ford's ABC's of Wines, Brews and Spirits*. 4th edition. San Francisco: Gene Ford Publications and Wine Appreciation Guild, Inc. 1996

Forest, Louis. *Wine Album adapted from Monseigneur le VIN*. Paris: Metropolitan Museum of Art, 1927.

Goode, Jamie. *The Science of Wine*. Berkeley, CA University of California Press, 2005.

Harpur, Tom. *The Spirituality of Wine*. Kelowna, BC Canda: Northstone Publishing, 2004.

Harvey, Andrew, editor. *The Essential Mystics*. Edison, NJ: Castle Books, 1996.

Jackson, Ron S. *Wine Science: Principles, Practice, Perception*. New York: Academic Press, 2000.

Johnson, Hugh, Dora Jane Janson, David Mcfadden. *Wine, Celebration and Ceremony*. New York: Cooper-Hewitt Museum, 1985.

Jones, Andrew. *The Stories Behind the Labels: the History, ,Romance & Characters of the World of Wine and Drink*. Bathurst, Australia: Crawford House Publishing, 1994.

Kohlechner, Manfred. *Healing Wines: Celebrating Their Curative Power*. Brookline, MA: Autumn Press 1978.

Lamb, Richard and Ernest Mittelberger. *In Celebration of Wine and Life*. San Francisco: Wine Appreciation Guild, 1980.

Lissarrague, F. *The Aesthetics of the Greek Banquet: Images of Wine and Ritual*. Princeton, NJ: Princeton University Press, 1990.

Lucia, Salvatore Pablo, MD. *Wine and Health*. Menlo Park, CA: Pacific Coast Publishers, 1969

Lukacs, Paul. *The Great Wines of America*. New York: W.W. Norton & Co., 2005.

MacNeil, Karen. *The Wine Bible*. New York: Workman Publishing, 2001.

McGee, Harold. *On Food and Cooking*. The Science and Lore of the Kitchen, revised updated edition. New York: Scribner, 2004.

McGovern, Patrick E. *Ancient Wine: the Search for Origins of Viticulture*. Princeton, NJ: Princeton University Press, 2003.

Michaels, Marjorie. *Staying Healthy with Wine*. New York: Dial Press, 1981.

Mondavi, Robert. *Harvests of Joy: My Passion for Excellence*. New York: Harcourt Brace & Company, 1999.

Naisbitt, John. *High Tech, High Touch: Technology and Our Search for Meaning*. New York: Broadway, 1999.

Otto, Walter, F. *Dionysus: Myth and Cult*. Dallas, TX: Spring Publications, 1965.

Ough, Cornelius. *Winemaking Basics*. Binghamton, NY: Haworth Press, 1992.

Parks DA, Booyse FM. "Cardiovascular protection by alcohol and polyphenols." *Annals New York Academy of Sciences* 957:115, 2002.

Peynaud, Emile. *Knowing and Making Wine*. New York: John Wiley & Sons, 1984.

Pollan, Michael. *The Botany of Desire*. New York: Random House, 2001.

Priewe, Jens *Wine: From Grape to Glass*. New York: Abbeville Press, 1999.

Riedel's glass shape and taste http://www.riedel.com/website/english/frameset/homeenglish/information/shape_pleasure/shape_pleasure.html

Robinson Jancis. *How to Taste:. A Guide to Enjoying Wine*. New York: Simon & Schuster, 2000.

Robinson, Jancis. *On the Demon Drink*. London: Mitchell Beazley, 1988.

Robotti, Peter and Frances. *Key to Gracious Living*. Wine and Spirits. Englewood Cliffs, NJ: Prentice-Hall, Inc., 1972.

Seltman, Charles. *Wine in the Ancient World*. London: Routledge & Kegan Ltd, 1957.

Seward, Desmond. *Monks and Wine*. London: Mitchell Beazley. 1979.

Sharp, Andrew. *Winetaster's Secrets*. Toronto: Warwick Publishing Group, 1995.

Simon, Joanna. *Wine with Food*. New York: Simon and Schuster, 1996.

Simon, Joanna. *Discovering Wine*. New York: Simon and Schuster, 1994.

Simon, Pat. *Wine-tasters' Logic: Thinking about Wine and Enjoying It*. London: Faber and Faber Ltd, 2000.

Spiller, Gene, ed. *The Mediterranean Diets in Health and Disease*. New York: Van Nostrand Reinhold 1991.

Stuttaford, Thomas. *To Your Good Health! The Wise Drinker's Guide*. London: Faber and Faber, 1997.

Swinchatt, Jonathan and David G. Howell. *The Winemaker's Dance. Exploring Terroir in the Napa Valley*. Berkeley, CA: University of California Press, 2004.

Unwin, Tim. *Wine and the Vine: An Historical Geography of Viticulture and the Wine Trade*. London: Routledge, 1991

Vandyke-Price, Pamela. *The Taste of Wine*. New York: Random House, 1975.

Younger, William. *Gods, Men, and Wine*. London: The Wine and Food Society Ltd, 1966.

INDEX

A

acidity 21, 23, 26-28, 53, 101
acids 3, 12, 13, 20, 21, 25-28
 lactic 30
 malic 25, 26, 30
 tannic 3, 20, 23, 33, 34, 38, 44
 tartaric 3, 20, 23, 33, 34, 38, 44
aging xi, 28, 33, 34, 46, 70, 96
 microscopic clues of 5, 16, 17, 34, 47
 potential 44
Aiken, Joel 44
alchemy ix, 23, 28, 34, 111
alcohol
 See also consciousness, intoxication
 biological effects 65, 66, 70, 88
 consumption 88
 contents of beer, wine and spirits 66
Allen, H. Warner 10
antioxidants and polyphenols in wine 60, 64, 66,
 71
Apoptosis 17
Araujo 79
Argisle, Bethany iv, 1, 3, 98, 106
art or science xi, 6, 111
astringency 33, 34
Axel, Dr. Richard 24

B

Bacchus 89, 90
 See also Dionysus; gods in wine
Balyeat, Rachel xi, 7
Balzer, Robert 18
Barrett, Heidi Peterson x, 36, 38, 40, 96, 97, 100
Baudelaire, Charles 101
Beaulieu Vineyards x, 3, 4, 44
 de Latour, Georges x, 38, 44, 45
 Georges de Latour Private Reserve 38, 44
Benziger 75, 76
 Family Estate Winery 75-77, 79, 115
 Mike x, 10, 75, 77
Bessis, Dr. Marcel 111
Bible 91
biodynamic
 Demeter and BioVyn certification 79
 preparations 71, 74, 77
 viticulture 71, 72, 74-79
 wines 79
Birth Life and Death 15, 96, 98
bitter
 molecules 21
 taste 20-24, 33

blessings 86, 90-92, 102
 See also toasts
body in wine 28, 34, 53
Bordeaux blends 53
bottle closures 79, 81
bouquet 4, 25, 27
Brenner, Leslie 19
brix 13, 27, 28, 54
 See also sugar measurements 13, 27, 28, 54
Brown-Forman 72
Buck, Dr. Linda 24
Burgundy 35, 53, 54, 79
 G. Roumier, Bonne Mares 2002 55

C

Cabernet Franc 53, 60
 Ceago Vinegarden 80
 Helena View 65
Cabernet Sauvignon 24, 38, 40, 44, 50, 53
 Beaulieu Vineyards 38, 44
 images 6, 9, 16, 33, 38, 44-47, 56, 108
 Inglenook Cask 5, 6, 16, 45
 Napa Valley 44, 45
Caffeine 21
Called by the grape x, 95, 96
CCOF 69, 74
 See also organic wines
Ceago Vinegarden 72-75, 79, 80
cell receptors 19, 23, 24, 39
cells ix-x, 1-3, 11, 15, 17, 20
Chadwick, Alan 72, 74, 76
Chapautier 79, 111
Chardonnay 5, 12, 18, 30, 37, 48, 108
 See also Mike Grgich; Karen MacNeil
 Chateau Montelena 37, 48
 Grgich 30, 37, 48-52, 111
 images 11-13, 18, 31, 32, 38, 41, 48, 49, 51,
 107-109
 Kendall-Jackson 37, 50-52,
 Kenwood 30
 malolactic fermentation 30, 32, 49, 50
Chasseur 56
Chateau Lafite Rothschild 17
Chateau La Mondotte 53, 78, 79
Chateau Montelena 37, 48, 108
Chateau St. Jean 5
chemical senses 20, 39
 smell 24, 25, 28, 37, 39-41,
 taste 20, 27, 39-41,
Chiarello, Michael 36
chocolate 25, 41, 53, 64, 67
cholesterol 64, 65

Christianity and wine 90
community and health x, xi, 60-62, 96
complexity 4, 11, 17, 27, 30, 33, 37, 47, 84, 104, 105
Condrieu 25
consciousness 86, 88, 94, 97, 98
 See also alcohol, intoxication
 LSD 87, 88
Constellation Brands 57
Cooper, Rabbi David 99
Coppola, Francis Ford 47
cork closures 79, 81
cork taint 79
coronary artery disease (CAD) 65
Crozier, Alan 65

D

Daniel Jr., John 46
 See also Inglenook Cask Cabernet
David, Narsai 4
Davis, Jill 46
death in wine ix, 5, 11, 17
de Latour, Georges x, 44, 45
 See also Beaulieu
Deuer, George 46
 See also Inglenook Cask Cabernet
Devas 8, 99, 100, 106
 See also Steiner, Rudolf
Dionysus 82, 89, 90
 See also Bacchus; Jesus
Dolan, Paul 69
dormant vines X, 104, 105
Drinking in the gods 64, 86, 88, 91
Dyer, Bill 3
 See also Sterling Vineyards

E

elements 71, 77, 84, 96, 99, 106
 See also Benziger, Mike
Ellison MD, Curt 71
Emert, Carol 105
Emoto's water crystals 97
environmental sustainability 72, 75, 79
ethanol 26, 27, 66, 88
 See also alcohol; intoxicants
Eucharist 90
 See also Christianity and wine

F

Fadiman, Clifton 58
feminine wines x, xi, 50, 100
fermentation ix, 3, 7, 10, 13, 50, 57, 70, 88, 96
 primary 12, 13, 26-29
 secondary malolactic 30, 32, 49, 50

Fetzer family 72-75
Fetzer, Jim x, 69, 72-76, 91
 See also Ceago Vinegarden
five tastes, the 20
flavor x, xi, 12, 16, 20-22, 24, 25, 28, 37, 39, 41
flavor development 22, 28, 34, 36, 84
food and wine pairing 23, 49
form and function 3, 15
Franciscan Cabernet Sauvignon 33
Frangelico 86
Frank Family wines 109
Freed, David 96, 106
 See also WineSpirit
free run 13-15
French Paradox x, 61
Frey Vineyards 69, 70
 See also organic wine

G

Gaia 76
global warming 79
glucose 26
 See also sweetness
God-intoxication 88, 90, 92
 See also consciousness; Rumi
gods and goddesses of wine x, 18, 88, 89
 See also Bacchus; Dionysus
Goethe 43
Goldfarb, Alan 46
Goode, Jamie 35, 39, 56
Grahm, Randall 103, 108
grape
 growing regions, worldwide 34
 molecular qualities 84, 92
 origins 18, 53, 82, 84, 85
 purpose x, 79, 84, 85, 94, 96
 ripeness 25, 27, 28
 uniqueness 84, 85
Grgich Hills Estate 48, 50
 See Grgich, Mike; Jermanez, Ivo
 biodynamic 50, 71, 79
 Chardonnay 11, 30, 31, 48, 49
Grgich, Mike x, 36, 45, 48-50, 57, 108
Grgich Vina 50
Griffiths, Bede 91

H

hallucinogens 88
 See also LSD
hang time 28
Hanni, Tim 21-24
 See also umami

harvest 12, 13, 23, 26-28, 68, 86, 89, 91, 104
headaches 70, 71
health definitions 61
heart health 61, 62, 64, 65
 See also Ornish MD, Dean
 community 61, 62
 inflammation 64, 65
 wine molecules 64, 65
Hebrew traditions 90, 91, 102
Heitz, Joe 45
Hiaring, Phil 7
Hills, Austin 48
 See also Grgich Hills
Hindu traditions 88, 99
hospitality x, 60, 74
how to get inside wine 40, 110
how to taste wines x, 23, 24, 40

I

images and healing 11
imagination 99
Inglenook Cask Cabernet 5, 6, 16, 44-47
 See also aging; Daniel, John; Deuer, George
Inglenook Winery 3, 5, 45-47
inner life
 human 15, 58, 92, 94, 111
 wine 11, 15, 58, 92, 94, 105, 111
Institute of Noetic Sciences 109
intelligence, plants and cosmos 77
interference microscopy xi, 1
intoxicants 86, 88, 91
intoxication 66, 86, 88, 89, 92
 See also alcohol; LSD; hallucinogens
Islam and wine 91

J

Jackson, Jess 50
 See also Kendall-Jackson
Japan 22, 97, 102
 See also umami
Jeriko Estate 72
Jermanez, Ivo 71
 See also biodynamics; Grgich Hills
Jesus 90
 See also Christianity and wine; Dionysus
Jewish Kiddush ritual 90, 94
Johnson, Hugh 59, 110
Jones, Andrew 45
Jones, Dr. Gregory 79

K

Kane MD, Beverley 98

Kasantzakis, Nikos 93
Kendall-Jackson chardonnay 37, 50-52
Kenwood chardonnay 30, 31
Kombu 22
 See also umami
Kosher wine 91
Kosta-Browne Pinot Noir 55
See also Pinot Noir
Kramer, Matt 96

L

lactic acid 30
 See also acidity; malolactic fermentation
Lail, Robin 46
 See also Inglenook
Language.
 See also synesthesia
 micorscopic shapes 4, 11, 20, 99, 108-110
 shaping 20, 38, 39, 41, 108
 soul 99
 symbolic x, xi, 39, 99, 110
 taste and smell x, xi, 24, 25, 38, 39
 wine x, xi, 4, 11, 38, 41, 99, 108, 110
Lanier, Jaron 24, 39
La Sirena.
 See also Barrett, Heidi Peterson
 Moscato Azul cover 43
 Syrah 36
Laube, James 38, 46
LDL-cholesterol 64
 See also heart health
legacies of the grape x, 83, 84
legendary lives 43, 58
Lenson, Celia 99
leukemia x, 2, 60
libido 67
life force 77
lifestyle medicine 60-62
Long, Zelma 45
losing vitality 17
love potions 67
 See also aging
LSD 87, 88
 See also hallucinogens; intoxicants

M

MacNeil, Karen 50, 53, 56
malbec 53
malic acid 25, 26, 30
 See also acidity; malolactic fermentation
malolactic fermentation 30, 32, 49, 50
 See also secondary fermentation; malic acid

Maltis, Michael 74
Martini, Louis 45
masculine wines 50, 58, 100
maturity 15, 16, 18, 27
McGee, Harold 62
McNab Ranch 72, 74
memory of wines 3, 24, 41, 64, 66, 109
Merlot 1-3, 8, 24, 28, 38, 44, 47, 48, 50, 53, 60
 aging 4
 images 2, 4, 12, 47, 60, 98
microscopy x
 inages and healing ix, 2, 11
 markings of wine aging 4, 7, 98
 signature portraits of wine 3, 4, 11, 50, 58, 96, 98
 techniques xi, 1
molecular
 embrace 19, 111
 geometry 20, 25
 shape 19, 20, 24, 25, 108
 soul 98
Mondavi, Robert x, 45, 56, 57, 102, 109
Mondavi, Tim 5
Mondovino 37
monosodium glutamate, MSG 22, 23
 See also umami
Moscato Azul 43, 100
mystic attributes ix, xi, 18, 91, 92, 94

N

Naisbitt, John ix
Napa Valley xi, 3, 36, 44, 57
 See also Beaulieu; Grgich; Inglenook; Sterling
 1976 Paris Tasting 36, 48, 108
 Cabernet Savignon 44, 45, 48, 106, 108
 Native Americans 86, 94
Native American 86, 94
Newton, Peter 47, 48
 See also Merlot; Sterling Vineyards
Niebaum, Gustave 45, 46
 See also Inglenook
Noah in the Old Testament 91
 See also intoxication
noble grapes 50, 54

O

oak barrels 33, 34, 50
Obama, Barack 50
old vines 11, 104, 105, 112
olfactory receptors 21
 See also molecular shape
Olympus microscope 1
Opus 57

 See also Mondavi, Robert
organic.
 See also biodynamic; CCOF
 organically grown grapes 50, 69-74
 wine 69, 70
Ornish MD, Dean 62
 See also heart health; community
Oscars, the 44
Ostrove, Michele 68

P

painful sensations 20
Parker, Robert 36-38, 53
Pasteur, Louis 10
Patianna Organic Vineyards 72, 73, 79
 See also Sauvignon Blanc
patterns in nature xi, 11, 111
petit verdot 53
pH 21
Phelps 79
Pinkson, Tomas 94-95
Pinot Noir 1, 50, 53, 54, 68, 85
 See also Chasseur; Frank Family; Kosta-Browne; Ponzi
 Central Coast, California 55
 fermenting 13
 grapes 50, 53, 56, 85, 95
 images 55, 109
 Oregon, Willamette Valley 54, 55
 Russian River 54
plant spirits 9, 10
pleasurable tastes 20, 21, 23, 50, 67
Pollan, Michael ix, x, 82, 84
Ponzi 55
Presten, Valerie 2
 See also Sterling Vineyards
prohibition 46, 90
Proust, Marcel 1

Q

Quintessa 63, 79, 92
 See also biodynamic

R

raising the glass 101
reading wine labels 13, 69
refractometer 27
 See also sugar measurements
religious views and wine 9, 18, 88-90
 See also Christianity; Hebrew; Islam; Jewish
renewal 95, 105, 111
residual sugar 28
resveratrol 64-66

 See also heart health
Ridge Lytton Springs 35, 104, 105
Riedel wine glasses 37
Riesling 50, 69
 See also Trimbach
ripeness 13, 21, 25-28, 33, 34, 54, 77, 88
Robinson, Andrea Immer 66
romance and wine 66-68
 See also Wagner, Paul
Romans 70, 89, 90, 101
Roots for Peace 50
Rosenbrand, Theo 3, 4
 See also Sterling Vineyards
Rothschild, Baron Philippe de 33, 57
Rubicon Estate 58
Rudd Oakville Estate vi, x 106, 108
 Cabernet Savignon 108
 old vine Chardonnay 106, 107
 Rudd, Leslie 106
Rumi 88, 92
Rutherford dust 45
Rutherford Hill 4

S

sacrament 90
sacred rituals x, 75, 88, 90
salt 2, 20
 See also sodium chloride; Hanni, Tim
 changing wine taste 20, 23, 24, 34
 crystallization 21
 salty 20, 22-24
San Francisco Chronicle 105, 106
Sanskrit 99
Saracina Winery 72
Sauvignon Blanc viii, 5, 50, 53, 58, 66, 72, 73
See also Pattiana; Sterling
savoring life x, 41, 60, 103, 105, 109
Savory 20-23
sea salt 20, 21
secondary malolactic fermentation 30, 50
 See also fermentation; lactic acid; malic acid
seduction 56, 66, 68
sensory
 adaptation 24
 experience 11, 22, 38, 41, 108, 109
 pleasure xi, 9, 20, 41, 67
sensuality 64, 68
Shakked, Oded 68
Shanken, Marvin 57
shaping taste x, 19, 23, 32, 36-38
sharing wine 61, 62, 66, 68
Shrem, Jan 44

Sideways ix, 59, 85
Simon's, Pat, wine shapes 39
Sinskey 79
smell
 See also molecular shape
 dimensions 24
 language 24, 38, 39
 memory 24, 25
sodium chloride 2, 20
 See also salt; sea salt
soil 5, 35, 36, 68, 69, 71, 74, 76, 77, 79, 96, 102
soul, attributes of x, 77, 94, 98, 100
 definitions 77, 94
 language 99
 terroir 79, 96
 wine ix, x, 9, 33, 35, 92, 96, 97
 work x, 77, 94-96
sour 3, 20-27
 See also acidity
sparkling brut 100
spirit of the grape x, 18, 82, 92, 94
spiritual intoxication 88, 92
spiritual purpose 9, 84-86, 95, 96
Spoto, Joanne 3
Spurrier, Steven 48
 See also 1976 Paris Tasting
Stag's Leap 48
Steiner, Rudolf 71, 99
 See also biodynamics
Steinman, Harvey 38
Sterling Vineyards. xi, 1-5, 47, 48, 53, 60
 See also Newton, Peter
 Merlot 1-4, 60
 Sauvignon Blanc viii, 53
sugar
 See also brix; fermentation; wine and
 food pairing; sweet
 content 12, 13, 26-28, 54, 84
 glucose 26
 measurements 13, 27
 sucrose 20
 taste 20, 21, 23
sulfites 70-71
 See also organic wine
super (hyper) tasters 21, 38
sustainability x, 50, 60, 68, 69, 72, 74, 79, 96, 100
sweet 3, 12, 13, 20-28, 85, 86, 88, 95
symbolism, words and wine x, 15, 64, 77, 86, 90,
 91, 101, 110
synesthesia 108-109

T
tactile sensation 34, 41
tannic 3, 20, 23, 33, 34, 38, 44
tannins 33, 34, 64, 84
tartaric acid 26, 27, 30, 83, 84
See also acidity
taste
 buds 19-21, 23, 25
 changing 21, 23-25, 36
 sensitivity 21, 28, 70
 vocabulary 41
tasting
 Shape, the game xi, 36, 108, 110
 wine iii, x, xi, 23, 40, 41, 58, 106
Tchelistcheff, André x, xi, 5-7, 36, 44-46, 57, 109
 See also Beaulieu; memory
Tchelistcheff, Dorothy 36
 See also Chiarello, Michael
terroir 3, 5, 34, 36, 45, 71, 76, 79, 96
Thach, Liz 96
Thomas, Charles 57
Thompson, Bob 45
time capsule 96, 101, 108
toasts x, 11, 18, 40, 86, 94, 101-102
 See also blessings; Roman toasts
toast barrel 33, 34
toxic 20, 21, 75
transformation ix, 4, 5, 12, 13, 15, 18, 26, 53, 82,
 86, 89, 100
 See also fermentation
Trimbach, F.E., Riesling 69, 79
Turin, Luca, the Emperor of Scent 24, 25

U
Ueda, Kikumae 22
umami savory taste 21-24
 See also Hanni, Tim; Ueda
 food sources of umami 22
universal taste pleasures 23
University of California Medical School (UCSF) 2
University of Creation Spirituality 105

V
veraison 26
 See also ripening; sugar
vinegar 3, 21, 22, 70
vineyard ix, x, 8, 10, 11, 28, 35, 59
 See also terroir
 acreage, worldwide 85
 terrain 34, 36, 76
vitality ix, 5, 11, 13, 17, 47, 61, 98, 100

W
Wagner, Paul 66-68
 See also romance and wine
Watson, William 45
well-being 61, 62
 See also health
Wexman MD, Mark 62
 See also heart health
White, David 67, 106
 See also WineSpirit
wine.
 See also acidity; Bacchus;
 Dionysyus; memory; soul; toasts
 aging and maturation 13-17, 28, 33, 34, 46, 70, 96
 and the sacred xi
 as life 10
 blessings 91, 102
 consumption and health benefits 62, 64, 66, 70, 92
 corked 79, 81
 gods and goddesses x, 18, 88-90,
 history 9, 82, 84, 88
 Rorschach x, 58, 110
 styles xi, 30, 50, 53, 56, 57
Wine Industry Technical Symposium 7
winemaking practices ix, 3, 12, 30, 33, 57, 69, 70
 See also aging; fermentation
 kosher 91
Wine Spectator 5, 37, 38, 46, 53, 57, 96
WineSpirit 44, 67, 96, 99, 106
Wine as time capsule 96, 101, 108
Wines & Vines 7, 58
Winiarski, Warren 48, 57
Woodman, Marion 99
World Health Organization (WHO) 61
 See also health
World of Fine Wine 79, 103

Y
yeasts 12, 13, 15, 22, 27, 28, 61, 70, 96
York, Alan 76
 See also biodynamic

Z
Zinfandel 8, 35, 39, 104